ART OF
WEST TEXAS
WOMEN

This work would not have been possible without the generous support of The Helen Jones Foundation. The authors and Texas Tech University Press are deeply grateful.

ART OF
WEST TEXAS
WOMEN

A Celebration

KIPPRA D. HOPPER

LAURIE J. CHURCHILL

Introduction by Pamela Brink

TEXAS TECH UNIVERSITY PRESS

Photo credits–All photographs of the artists and
their art are reproduced by permission and are,
except as listed below, by Kippra D. Hopper.
Photographs of art in these chapters are courtesy
of the following: 1. all, Tina Fuentes • 3. all, Tracy
Lynch • 4. all, Sara Waters • 5. *Cecilia,* Maria
Almeida Natividad • 6. *Can We Go Now?,* Dale
Jenssen • 7. all, Robin Dru Germany • 9. *On
Golden Panhandle,* Mary Solomon • 10. *Belinda,
Pears on a Blue Table,* and *The Prophet,* Linda
Cullum; *Everything's Coming Up Roses, All the
King's Horses,* and *Mirror* . . . , Robly Glover • 11.
Asian Gifts, Meditation Garden, Santa Fe Gallery,
and *Ricky-dooed* . . . , Ashton Thornhill • 13. all,
Amy Winton • 16. *Gallo* and *Eppy Bir-day,* Marty
Snortum; *Miel Virgen* and *Mexican Elders Series*
(except details), Elias N. Jaquez • 18. *Hallie and
the Cowgirls,* Abby Levine; all others (including
photograph of Abby Levine), Laurie J. Churchill

This book is typeset in Monotype Scherzo. The
paper used in this book meets the minimum re-
quirements of ANSI/NISO Z39.48-1992 (R1997).
∞

Texas Tech University Press
Box 41037, Lubbock, Texas 79409-1037 USA
800.832.4042 | ttup@ttu.edu | www.ttup.ttu.edu

Library of Congress Cataloging-in-Publication Data

Hopper, Kippra D., 1961–
 Art of West Texas women : a celebration / Kip-
pra D. Hopper and Laurie J. Churchill ; introduc-
tion by Pamela Brink.
 p. cm.
 Includes index.
 Summary: "Celebrates the diversity of visual art
created by women living and working in the west-
ern half of Texas, far from urban art communities
and large national markets. Samples creative
expression and method; explores the influence
of the expansiveness and relative isolation of the
region upon the selected artists' work"–Provided
by publisher.
 ISBN 978-0-89672-669-7 (pbk. : alk. paper) 1.
Art, American–Texas, West–21st century. 2. Women
artists–Texas, West. I. Churchill, Laurie J., 1948- II.
Title.
 N6530.T4H67 2010
 704'.04209764–dc22 2009041594

Printed in the United States of America
10 11 12 13 14 15 16 17 18 / 9 8 7 6 5 4 3 2 1

Printed at Craftsman Printers Inc., Lubbock, Texas

I dedicate this book to my maternal grandmother, Maxine L. Shand, and to my mother, Linda S. Hopper, both of whom throughout my life have nourished my creative soul. My grandmother always has instilled in me an appreciation for nature that inhabits all of my being. My mother has been eternal in her support and encouragement that I should follow my greatest passions, whatever those might be. Both of these inspirational and creative women have offered me their generous love and have helped me to find my own ways of being as a human and my own voice as a writer and an artist. KIPPRA D. HOPPER

This book is dedicated to my maternal grandmother, Rose Barbieri Biondi, who taught me at an early age to appreciate all kinds of artistry and, from her home in Waterbury, Connecticut, and through her subscription to *Arizona Highways,* introduced me to the dramatic landscapes of the Southwest. The art and the land continue to nourish me as she did.
LAURIE J. CHURCHILL

CONTENTS

Illustrations ix

Preface xiii

Introduction xv

The Art of

1. Tina Fuentes 3
2. Marilyn Grisham 13
3. Tracy Lynch 21
4. Sara Waters 31
5. Maria Almeida Natividad 41
6. Dale Jenssen 49
7. Robin Dru Germany 59
8. Future Akins 69
9. Mary Solomon 77
10. Linda Cullum 87

11. Pat Maines 97
12. Lahib Jaddo 105
13. Amy Winton 115
14. Deborah Milosevich 125
15. Toni Arnett 135
16. Anna Jaquez 145
17. Doris Alexander 155
18. Abby Levine 165
19. Patricia Kisor 173
20. Collie Ryan 181

Index 188

ILLUSTRATIONS

TINA FUENTES 3
La puerta azul 2
Cruce y mujer #2 5
Crucificada 7
Cargo 7
Fruta de la vida 8
Cara con rayas 9

MARILYN GRISHAM 13
Lidded jar with crystal gypsum 12
Salt-glazed teapots 15
Celadon lizard jar 16
Salt-glazed bowls 17
Salt-glazed extruded vase 18
Copper red extruded vase 18

TRACY LYNCH 21
"Santa Elena Canyon" 20
"The Mother's Day Hailstorm" 23
"Dr. Black" 24
"Paul" 25
"The Desert Cradle" 27
"Young Girl Holding a Pear" 28
"Jett" 28

SARA WATERS 31
Loyalty (My Sister Geraldine's Table) 30
Offering 32
Resting 33
Utopia 34
Give and Take 35

Coming/Going 36
Fill/Empty 38

MARIA ALMEIDA NATIVIDAD 41
El Paso History—Lower Valley Pride 40
Christina 42
Adriana 43
Milagro Cross 44
Virgen de Guadalupe 45
Cecilia 46

DALE JENSSEN 49
Can We Go Now? 48
Bad Dog 50
Scalloped Lamp 51
Gear and Spring Lamp 52
Bundt Light 53
Red Sky in Morning 54
Pierced Armor 55

ROBIN DRU GERMANY 59
"Arteriole Barb" 58
"Carbuncular Brush" 61
"Rotating Sensor" 61
"Enlarged Nodules" 62
"Metastatic System" 63
"Ameboid Seed" 65

FUTURE AKINS 69
Fantasy 68
Bob's Book 71
Wanda May 72
Hiding Within 73
Dreaming Turquoise 74
Burning Heart 75

MARY SOLOMON 77
Spring Cactus 76
Deer Path 78
On Golden Panhandle 80

Nature's Remnants 81
Canyon Magic 82
Many Faces of Palo Duro 82
Prickly Pear Cactus Bloom 83
Palo Duro Sky 84

LINDA CULLUM 87
Belinda 86
Pears on a Blue Table 88
Everything's Coming Up Roses 89
The Prophet 91
Lottie the Girl 92
All the King's Horses 93
Mirror, Mirror 94

PAT MAINES 97
Asian Gifts 96
Santa Fe Cabin 98
Meditation Garden 99
Santa Fe Gallery 101
Ricky-dooed, Screwed, and Tattooed 102
Captured Thought 103

LAHIB JADDO 105
Hill of the Heart 104
Here 107
Sokak 24 109
Kindred Spirits 110
The Void 111
Where Everything is Music 112

AMY WINTON 115
Art in the Dolomite 114
The Ancient One 116
Flamenco 117
The Invitation 118
Show and Tell 119
Cochise and Me 120
Wolf Creek 121
Palo Duro Cave 122

DEBORAH MILOSEVICH 125
Desert Bride 124
San Vicente 127
Mater Dolorosa 127
Patsy Cline, Patron Saint of
 Honky Tonk Women 129
Crow's Collection 130
Earth's Protector 131
Stands with the Earth 131

TONI ARNETT 135
Quilt 134
Potted Amaryllis Plant 136
Wire and Wood Cross with Flowers 137
Cross with Twigs 138
Lush Garden 139
Self-Portrait 140
Cat in a Chair 141
Horse 142

ANNA JAQUEZ 145
Miel Virgen 144
Gallo 147
Mexican Elders Series 148-149
Eppy Bir-day 150-151

DORIS ALEXANDER 155
Apache Defiance 154
Hody 156
Ranchos de Taos 157
The Rose Window 158
Vallarta Vendor 159
New Mexico Gambler 161
Mare-lyn's Best Friend 162-163

ABBY LEVINE 165
Hallie and the Cowgirls 164
Golem 166
La Frontera III 167
Clown Time Is Over 168
Obreros 169
Hebrew School Blowback 170

PATRICIA KISOR 173
Surge Two 172
Roundabout 174
Three Zebras 175
Portrait of a King 176
Zebra Perspective 177
Hauling Ass 178

COLLIE RYAN 181
La chuparosa 180
Las mariposas primaverales 183
La culebra 184
Volando hacia casa 185
Café sabroso 186

PREFACE

lthough one of us is a native of West Texas and the other is a transplant to the American Southwest, together we found the inspiration to pursue a book that celebrates the contributions of women artists in this region. Steeped as we both are in women's and feminist studies and aware of the erasures of women's contributions throughout history, we have sought to capture the words and display the works of women who flourish in this unlikely setting.

Initially, our inspiration came from the variety and richness we witnessed in the art of women artists we knew in Lubbock, Texas, a city we both have called home at one time or another. Lubbock sits atop the flat vastness of the Llano Estacado caprock, set apart from the urban pulse of Austin, Houston, and Dallas. From Lubbock we expanded our reach to include other parts of West Texas, all of them at once sparse and rich, from the red rock canyons of the Panhandle, to the wild and primeval beauty of Big Bend, to the Chihuahuan Desert that meanders along the Rio Grande to El Paso. One place led to another; one artist led to another.

This selection examines creators of art in an area that has no major art market. These

women make their art off the mainstream grid. While all the individuals included in the book are professional artists, and many have received national and international recognition, others are recognized primarily through an enthusiastic regional audience. Some paint on canvas, others paint on hubcaps or tin cans. By juxtaposing these art forms, we invite people to celebrate the broad parameters of visual expression by women artists who pursue their own independent ways.

We posed similar questions to each of the artists, transcribed the interviews, then shaped their words into interpretive essays, often using the artists' words to accompany images of their works. In these essays we have sought to see through the lens of the artists' eyes their perceptions of their work, why and how they do what they do, and how this isolated place affects their art. Knowing we could in no way create a comprehensive study of the many women artists who live and produce in the region, we set out to examine the rich creativity that emerges from a selected few. The book itself is an assemblage and a celebration of the diverse and unique creative contributions of twenty women who make their home and find their inspiration in the vast spaces of West Texas. Just as these artists have blazed new trails through their art, we, as authors, have chosen to blaze new trails by exploring the process of their art making.

Some of these artists seek to portray the environment in one way or another while others do not, but all feel the freedom of a clear, linear horizon and the time and space to find their artistic direction, their own unique way of communicating with the world. In this abundance of unbroken space, where eclectic individualism is treasured, their art making is all their own.

This collection is neither exhaustive nor intended to present critical assessments of the artists' work. Instead, it showcases the work of a range of women artists who are as diverse in their media and methods as they are in their aesthetics and creative expressions. Similarly, we sought to make the works and words of these artists accessible to the general public to ensure that this collection is broadly visible.

An undertaking like this requires the effort, patience, skills, and generosity of many. We wish to thank the excellent staff at the Texas Tech University Press: Noel Parsons, former director of the press, who shepherded this project every step of the way; Judith Keeling, editor in chief; Joanna Conrad, assistant editor; Lindsay Starr, designer of the book; and our editor, Pamela Brink, whose insights and positive attitude came at just the right time. We are grateful to the Helen Jones Foundation of Lubbock for its generous contributions to our development and publication costs. We thank the artists for their patience and aesthetic contributions. Without them, we would have no book. Last, we kiss the bright blue West Texas sky for shining blessings down on all of us.

KIPPRA D. HOPPER, LUBBOCK
LAURIE J. CHURCHILL, LAS CRUCES

Art of West Texas Women: A Celebration is an exploration of the diversity of visual art created by women living and working in the vast, isolated, semiarid lands of the western half of Texas, far away from the dynamics of urban art communities and large national markets. This art book is not a comprehensive survey of professional women artists of the region, of whom there are many, many more than can be represented here. Rather, it is a sampler, a selective examination of creative expression nurtured by a place as distinctive and independent as the artists themselves, revealing a meaningful series of common artistic threads.

For the most part, the women artists represented here came of age during the first burst of the women's movement in the early 1970s. Many remember the days when, for women, having artistic talent didn't really mean ever using it professionally. Women were encouraged to dabble, but even then, some sneaked in serious creative expression, primarily through fine stitchery and traditional woman's work with textiles. Doris Alexander, Mary Solomon, Anna Jaquez, Pat Maines, Tracy Lynch, Amy Winton, and Future Akins all count sewing as

one of their first important creative outlets. Winton has patented a clothing design, and Alexander designed a whole line of women's apparel at one point in her long career as an artist. Besides being a proficient and talented printmaker, Future Akins has integrated all kinds of needlework and beading into a series of art pieces that are, in many ways, long meditations on interpretations of memory.

With many of these artists, weaving the past into the promise of new possibilities is an important part of their artistic statement, and found objects become elemental in their creations, almost an insistence that nothing should ever be cast away. For Dale Jenssen old metal pieces are transformed into an exuberant variety of lighting fixtures, so playful and geometrically distinctive in their surprising combinations that they defy all expectations of the decorative arts, except for their solid functionality. Marilyn Grisham lives close to the earth, working the family farm and creating functional pottery and mosaics that include shards, rocks, old pottery, and many other bits and pieces scavenged from the happenstance of everyday life.

To several, scale is inextricably related to reexamining the past and the use of found objects. Creating assemblages on a grand scale, Sara Waters fills her studio with installations, combining sculptured pieces, found objects, photographs, poetry, and realigned natural materials that challenge participants to reconsider their lives, relationships, and place in the world. Patricia Kisor paints big exotic animals with great excitement and energy. Her oils and acrylics of elephants, giraffes, lions, zebras, and other animals are rich and dramatic studies of the deep connectedness of all living things. She, too, recycles and reinvests in many of her artworks, creating metal and wire sculptures that call upon her welding and sewing talents and mixed-media sculptures made from industrial brushes discarded by street cleaners.

For Pat Maines, the miniature is inspiration for shaping whole self-contained worlds filled with found objects radically reinvented for her artistic installations. An elaborate earring becomes a wall hanging; a cork becomes the base of a lamp; a doorstop becomes a birdbath. Everything in this artistic world proclaims that nothing is too small or insignificant to claim its place on stage and be seen with new eyes. Anna Jaquez creates small, self-contained environments that are intrinsically narrative in style and often autobiographical, depicting stories of her Texas borderland heritage through undersized architectural forms made of combinations of clay, metal, stained glass, pencil, and other media.

The culture of the Texas borderlands and the American Southwest are an important influence on the assemblages of others as well. Maria Almeida Natividad celebrates her heritage in murals, scenes of domestic life, and mixed-media pieces that combine traditional elements of Mexican American culture in new combinations. The American Southwest and Mexican folk art have consistently inspired Deborah Milosevich's visual expressions. Her shadow-box shrines and raku feminine-form sculptures are mixed-media works with combinations of feathers, beads, stones, bones, and

tokens from the past, serving as devotional touchstones to memory and meditation. For Collie Ryan, old hubcaps are the foundation for her distinctive mandalas as she reinvigorates an ancient Asian symbol of the universe with themes and motifs deeply rooted in car culture and the American Southwest.

For these mixed-media artists, the sometimes personal, sometimes political, sometimes cultural past informs the dynamic present. They challenge us to revisit, reassess, re-create, and renew our place in the world. Abby Levine works in wood and mixed media. Cutting, carving, painting and layering three-dimensional artworks with objects from popular culture, she creates artistic statements that are often highly charged with contemporary political issues, sharp irony, and an intellectual call-to-arms. Linda Cullum surrounds her paintings of solitary women and pears

with strong, hand-forged frames that stand in combative juxtaposition to the deep quietness of her figures. Her startling contrasts in both medium and message speak to the constant struggle between gentleness and aggression. It is significant that she creates both, insisting on the rich complexity of the human condition.

The landscape of West Texas is integral to the story of these artists, whether they were born here and carry the spirit of the region in their bone marrow or whether they found themselves here, disconcerted by the vast loneliness and isolation of the place. West Texas has nurtured their artistic visions, helping shape how they see and what they have to say. As it did Georgia O'Keeffe, this land of wind and sky has liberated them from the cushioned verdure of the East, or other more bowered places, and engendered a sense of expressive freedom and artistic strength.

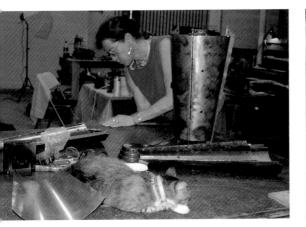 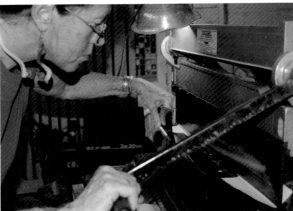

Dale Jenssen in the studio

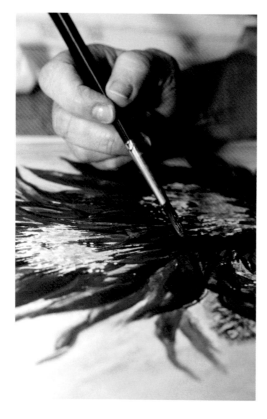

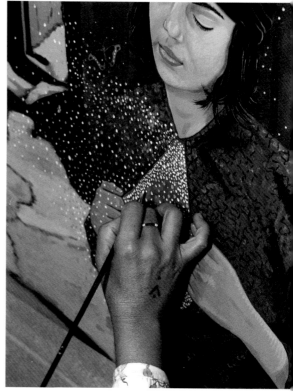

Many find their greatest artistic pleasure in helping others see the sometimes very subtle beauty of the terrain or understand the craggy drama of this rain-starved region. They paint their landscapes with great and constant celebration. Mary Solomon lives on the edge of Palo Duro Canyon and walks the land routinely for inspiration. She paints the canyonlands with a keen eye for the strong geometry of light and shadow playing off tough juniper trees, skittish whitetail deer, and striated canyon walls. Amy Winton also explores the canyonlands for inspiration and interprets their power in bold pastels to capture the canyons' pure, saturated colors and visual drama.

Palo Duro is always full of breathtaking surprises, not least of which are the ways it reveals itself. Opening out at unexpected intervals from the flatness of the Llano Estacado, a mesa 250 miles long and 150 miles wide, this canyon and a series of others create a dramatic vista sculpted by the constant sweep of wind and an occasional trickle of water that builds as it moves out of West Texas into three great rivers downstate. The Big Bend, El Paso, and the area around Eagle Pass have a similar ef-

The busy hands of
Mary Solomon FACING LEFT
Lahib Jaddo FACING RIGHT
Linda Cullum LEFT

fect on the independent eye. These are places shaped by wind erosion and defined by desert mountains. They are all places dominated by unencumbered sky and blasting sunshine.

Tracy Lynch has spent the past thirty years revealing the desert secrets of the Big Bend in photographs that celebrate the weathered geometry of the land and the drama of the sky. She also captures the spirit of the people of Brewster County through probing photographic portraits. Doris Alexander's portraits, created primarily in pastels, often explore ranch culture and history of the Southwest, revealing the ways of frontier life and the nobility and strength of the people in knowledgeable and meaningful detail.

For Lahib Jaddo the semiarid landscape of the region, echoing her native Iraq, has led her to express the cultural and environmental contrasts and similarities through distinctive, surreal narrative paintings that explore the passions and roles of women in her native and adopted lands. Tina Fuentes also explores the complexities of biculturalism through bold abstract paintings. Fuentes often investigates her Mexican American heritage from the

XIX

vantage point of an independent, professional woman, assessing her challenging position in the larger culture. She reconfigures and re-combines the cross, the nude, and the regional landscape in powerful abstract arrangements of color and white space that probe symbol and place in human experience.

Art photographer Robin Germany also ex-plores the landscape of the region, but, rather than seeking to capture the grand sweep of the place, she turns her camera to the minuscule, to the intricacy of design within plant life. She captures a phantasmagoria of luminous colors and shapes that speak to life at the deepest and simplest levels. She studies small, solitary things in arrangements that gain new signifi-cance through her discerning, artistic eye.

For Toni Arnett the solitary and seem-ingly insignificant are also elemental to her artistic vision. Arnett uses an impressionistic technique to build color and light into her oil paintings with a deftness that makes them appear three-dimensional. Her rendering of a twig cross strewn with flowers is so full of light and shadow that it appears to be a real object at a distance, although up close it is revealed to be discrete, precisely placed dabs of paint. The same is true of the folds and colors of her painting of a quilt and of any of her flowers or flower arrangements. Regard-

less of subject, her paintings are strong and dramatic rediscoveries of the ordinary made grand through her eye and technique.

For all of these artists, rediscovering and celebrating the ordinary is a part of their creative mission. They have chosen to pursue their art in relative solitude, far away from big-city life and glamorous art marketplaces. Their independent ways seem to engender distinctive works rooted in memory, apprecia-tion of what's been discarded, a deep affection for other living things, and abiding confidence in their own ways of seeing. *Art of West Texas Women: A Celebration* is an enticing introduc-tion to the artistic diversity and artistic energy of the region. Nurtured by West Texas and its intrinsically rural culture, these women thrive on solitude and the perceptions they find in quiet places. Through their many and varied talents, they insist that who they are and where they live offer important understanding for the rest of the world.

The women artists showcased in this book are only a few significant examples of a host of serious women artists living and working in West Texas. They serve here as a touchstone to a broad and scattered community of creative, freedom-loving women who find their inspira-tion in the liberating isolation of this lone-some place in the sun. PAMELA BRINK

ART OF
WEST TEXAS
WOMEN

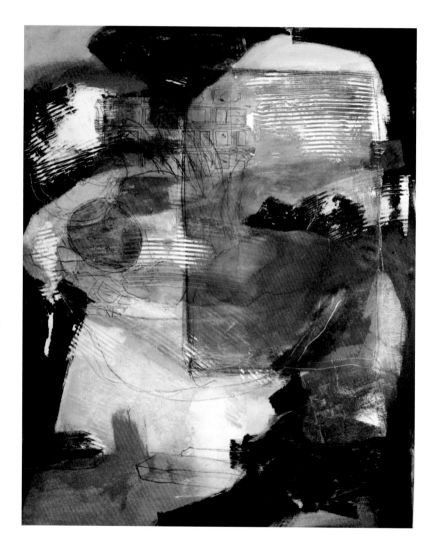

La puerta azul (The Blue Door)
2007, 60 × 48 in., mixed media on board

ONE

The Art of

TINA FUENTES

———

Tina Fuentes's art expresses a wide range of emotions: distrust, guilt, pain, love, joy, and laughter. Her ever-expanding body of work reflects her inner dialogue and discoveries about women's issues, symbolism, the cross, religion, and sexuality.

"I feel my way through the painting," Fuentes says. "When I'm painting, I find myself emotionally involved with my work. Incessant passions can arise, [from] feverish ecstasy [to] extreme annoyance. Sounds like a lover, no?"

Art transformed Fuentes's world when she visited the Dallas Museum for the first time at age twenty-one. "I stayed in the museum for hours and hours," she says. From a landing on a staircase, Fuentes looked up at a Franz Kline painting, *State Cross.* "I was already in a euphoric emotional state. I just stared at the painting, and I felt like it just grabbed me and put its arms around me. Almost religiously, I stood there and held onto the banister . . .

because I didn't want to miss a single step and I didn't want to miss a single stroke. . . . That was my first emotionally vibrant inquiry into contemporary art. Who would want to do this, and why, and how could one create such a powerful impact on the viewer? All I knew was that the painting was reaching out, sucking me in and pulling at me. As tears rolled down my face, I just stood there. I could not believe the impact and emotions of the work."

She remembers seeing much Southwestern art that day, including Remington's work. She wondered how anyone could paint so beautifully, in such a detailed, accurate, and photographic way. She cried from both joy of discovery and sadness in realizing what opportunities had been denied her as a youngster. "In the barrios, besides Latino music and dances, other cultural activities, like the visual arts, theater, classical music and dance, and museums, were not discussed or incorporated into our daily life. We were just trying to survive from day to day. As a child, I never knew that museums existed and that many did not cost to enter. Encouragement to explore the arts was not the kind of dialogue we had within the home environment."

Now, Fuentes's own art taps the deepest emotions. Black is her signature color. Texture is her visual theme. In pieces that ponder anger, aggression, frustration, elation, and energy, her bold, textural, and layered processes make two dimensions into a three-dimensional experience. She scratches linear or curved, broad or narrow patterns into thick paint. She intrigues amid the chaos with controlled pencil drawings under the blacks,

yellows, reds, whites, blues, and greens most prevalent in her work.

In *La puerta azul,* Fuentes marks bright colors and forms with scraping tools and sandpaper. Yellow dominates the black-framed composition, but patches of red seem to reverberate in motion, while a translucent turquoise doorway brings a mystique to the painting.

Often Fuentes's artistic explorations employ the human form, transforming figures from the literal into shadowed images. "Sometimes my human figures are defined by delicate, sensuous, and linear qualities," Fuentes says. "At other times the figures have taken on more ominous qualities, becoming dark, foreboding, and mysterious. The human figure is complex and phenomenal in its flowing lines, different angles, and muscle structure."

In the past twenty years Fuentes's fascination with the human figure has grown into examining the female form in connection with the symbol of the cross. The female and cross symbolism surfaced in her art as a metaphor for feminine strength and power. "To facilitate my exploration of the theme, I constructed an eight-foot cross and used it in conjunction with a live model," Fuentes says. "Revealed in three dimensions, the model and cross helped me to realize the potential for reinterpretation of a symbol traditionally linked to a male figure."

In provocative paintings of women on crosses, Fuentes has questioned the symbolic crucifixion of women past and present. In *Crucificada* a female nude, painted red, hangs upon an ochre cross. The three-quarters view reveals a woman's torso and partially

4

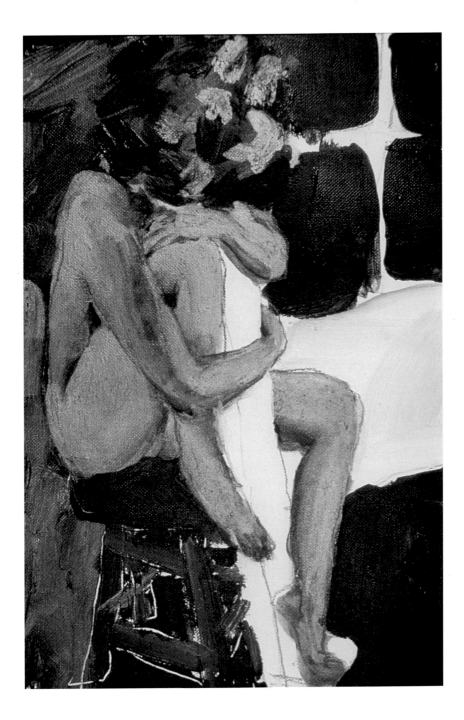

Cruce y mujer #2 (Cross and Woman #2)
1995, 12 × 9 in., acrylic on canvas

turned-away face. One extended arm forms the cross shape. Sometimes Fuentes's paintings make viewers uncomfortable as she questions the authority of the church and men's oppression of women. In *Cruce y mujer #2*, Fuentes depicts a woman who sits with one knee raised. The subject embraces a plank of wood that Fuentes left as a pencil drawing, a negative space for interpretation. The shape of the white cross is repeated in the background. In the painting *Cargo,* a nude figure carries on her back a white panel bearing another nude female. The perspective of the angular white space draws the eye to the larger figure's hands and arms, which form a cross.

Fuentes always has questioned Catholicism. "I am always examining and reexamining those religious issues," she says. "In this body of work I put these two images together to see how they would develop in my examinations of this Catholic arena. Many men got upset. They felt that I was being sacrilegious and sexist. It was amazing. However, a female art critic in San Antonio wrote a beautiful review, acknowledging that I was addressing issues that we all look at during some point in our lives. The work is about religion, about the burdens that women have had to bear, about trust, and about sensuality. From my perspective, I am addressing the suppression of the female figure within the church, contradictions within the church practices, the rituals, the faith, the fear, the power played upon this faith by the male priest figures."

The image of the female and the cross also has a more personal meaning, partially addressing Fuentes's Catholic upbringing

from the 1950s to the 1970s. Fuentes was born in San Angelo, Texas, and raised in Odessa, Texas, a petroleum-industry-based West Texas town. When she was six years old she dreamed of dancing her way out of the barrios, pretending to be a ballerina, tiptoeing delicately across old railroad ties near her family's home. Her grandmother and stepfather gave her a good work ethic and the sense to be grateful. Along the way she learned about survival and finding her own path.

Fuentes titles her works in her native Spanish language as a tribute to her grandmother, Francisca Losoya Flores, who had a strong and lasting impact on her. Fuentes spent her formative years living with her grandmother and as an adult always returned home to see her. "I would visit her first. That was home to me," Fuentes says. "When I started painting and getting my work exposed through more professional venues, I vowed to myself that the works would be titled in Spanish. My *abuela* is the one who reminded me to never forget my language. She would give me these words of wisdom, like little *chispas,* or sparks. My *abuela* and I would write letters, in our native language, to one another. Some of my fondest memories are of my grandmother and feelings of love, compassion, understanding, and independence. My grandmother had a mission for each day and accomplished that task no matter what, allowing nothing to interfere. From her I learned to focus and to follow through and move forward. That is what I do with my art now."

Fuentes began her study of art through her first delicate, gestural figure drawings at

6

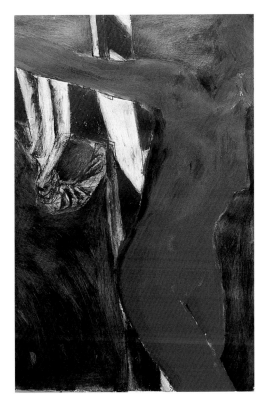

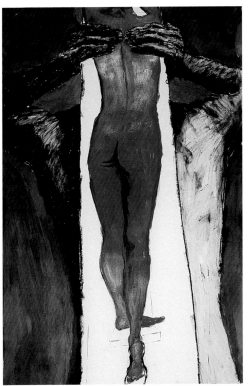

Cargo
1995, 42 × 36 in., mixed media on paper

Crucificada (Crucified)
1995, 48 × 36 in., mixed media on paper

Odessa College. One of her professors, Delmos Hickmott, told her that she had a natural ability, planting a seed in her mind to pursue art professionally. At North Texas State University in Denton she received her bachelor of fine arts degree in art education and master of fine arts degree in painting, drawing, and printmaking. While in graduate school, Fuentes says she was dedicated and disciplined. "I was searching for that niche to focus on, and it was really difficult, but it was a strong learning process for me because that really set the basis for what I do in the studio now." After moving to Albuquerque, New Mexico, Fuentes taught at the University of Albuquerque and at the University of New Mexico and set up her own storefront studio. For two years Fuentes worked furiously on her art without exhibiting. Finally, she began scouting out galleries to sell her work and drew the attention of Marilyn Butler, who had established galleries in Santa Fe and Phoenix. Fuentes also began receiving the attention of art critics in the Southwest. In 1986 Texas Tech University made Fuentes an

7

Fruta de la vida (Fruit of Life)
2008, 36 × 36 in., mixed media on board

Cara con rayas (Face with Stripes)
2007, 36 × 36 in., mixed media on board

attractive offer to teach in its school of art in Lubbock. She made the move and now lives in an adobe home she and her husband built, incorporating architectural details of the adobe homes she came to love during her time in New Mexico.

Fuentes's latest work is based on her interest in the Talking Crosses of Chiapas, inspired by her travels to the highlands of Chiapas, Mexico, near the city of San Cristóbal de las Casas. Visiting the villages of Chamula and Romerillo, she learned that symbolically for the Maya the twenty-one thirty-foot-tall crosses painted in turquoise provide the site where the spirits of the underworld come to pray to a conduit that speaks only to the female gender. Day of the Dead ceremonies involving the crosses are still a local practice. "The crosses are symbolic of the tree of life, and although they resemble Christian crosses, they have nothing to do with Christianity," Fuentes says. "These immense crosses are viewed as manifestations of both god and creator ancestors. At times they are either or both genders."

The crosses are painted turquoise, Fuentes posits, because the color is the medium between the green landscape and the blue sky. "I asked an old Maya gentleman if he could explain the crosses to me, and he literally grabbed me by the shoulders, and he said, 'Why do you need to know all that? Didn't you tell me you were an artist? Go into your studio and talk about the crosses through your artwork. You don't need to know the meanings.' I was electrified. I continued to work on the cross image with what I believe has been an even fuller sense of its potential meaning."

Fuentes still views the cross as a powerful symbol, but she views the cross more as a "life force" as the Maya believe.

Early in her career, Fuentes began layering colors boldly, usually in black and white with minimal color in thick, tough paint. Now, she builds upon that process by creating collages of drawings that are layered with thin, transparent acrylics. "As I get older, I am more transparent. I allow more of myself to show. I do not feel the need to hide that much. I think when we're younger we tend to be less revealing," Fuentes says. "In my earlier work, you see a broad mark that comes across, and then you see other qualities that start to exist underneath. My color vocabulary has expanded. The colors have always existed, but I seemed to suppress them, for whatever reason. The fact was that I did incorporate multiple colors into my statements, but they were not necessarily visible. Now they are more visible in green, ochre, orange, red, blue, and white. If the painting does not seem to develop correctly, I always black it out and start from ground zero. It's not a problem; I feel at home with the black surfaces."

The energy in Fuentes's compositions comes from her color combinations. Black, ochre, and red dominate her charcoal drawings on torn vellum or onionskin paper. She paints over the paper, leaving the jagged edges, as she layers images among the white spaces. Strong emotions come out in wild markings that at a distance appear untamed and uncontrolled yet upon closer examination make a definitive statement. She creates shapes in transparent blues, their forms

10

made of paper, paint, pencil, and scratches. The scratches show motion throughout the compositions. Often she hastily organizes the dominant colors and rectangular forms with charcoal or graphite. The subtleties relax her compositions as Fuentes mixes delicacy and strength.

Recently, Fuentes's work has embraced and integrated illustrations of space inspired by the West Texas land. "These artistic engagements with issues of geographical and atmospheric phenomena have led to a broadening interest in the vastness of the arid spaces of the desert corridor that extends beyond the boundaries of West Texas," she says. "These explorations have taken me to the Mexican Chihuahua Desert and the Sierra Madre Occidental. My journey has continued into the Sonora Desert near Tucson, Arizona."

In *Cara con rayas,* Fuentes paints a spot of purple in the form of a circle. Lines rush through the composition, revealing a plank with curves that outline apples, mangos, and pears. The gold is like the sun, and the white like the moon. In the painting *Fruta de la vida,* Fuentes leads the eye to the center, where a static, red circular form, a heart, creates a calm amid the incongruous motion in a composition dominated by the dramatic pairing of blue and black.

Fuentes wants to be remembered as a painter's painter. "That means that I really do push my media, my materials, and my ideas. I don't hold back—no reservations. I have tried to be true to myself. I want the viewer to feel the impact, not only of the texture on the surface but also of the visual experience, the type of painting that sucks you in and reveals my thought processes, energies, and ideas. My paintings do not give you all the answers, but they do provoke." Fuentes's reward is in watching viewers' responses. "Art is supposed to pull a string here and there; to make us taste, feel, touch, and to tune you in to parts of yourself that you may not have allowed to surface. Art is an inner spirit of truly listening to oneself. At times, we may find ourselves performing for all rather than performing for ourselves. Without the honesty, the voice weakens."

Fuentes is direct, bold, and assertive in her contemporary paintings. Her layered markings of aggressive strokes, intense colors, subtle drawings, and textural details reveal the physicality of her artistic process. In her emerging and evolving explorations, she questions the status quo, culture, gender, and religion. Sometimes abstract but always certain in her strokes, Fuentes dares to provoke the most visceral of responses. K D H

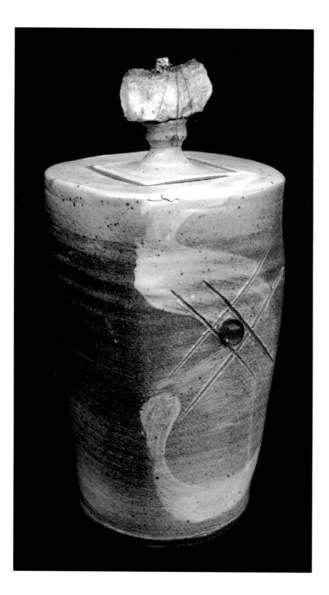

Lidded jar with crystal gypsum
2003, 13 in. high, high-fired stoneware

TWO

The Art of

MARILYN GRISHAM

———

Marilyn Grisham finds inspiration for her functional and sculptural art from living on the land and observing nature's patterns, whims, blessings, and beauty. Her pottery and ceramic pieces are expressions of the wide-open spaces of West Texas, the canyonlands of the Panhandle Plains, and the mountains of northern New Mexico.

The wheat fields Grisham harvests on her farm outside of Panhandle, Texas, provide inspiration for color, form, texture, and subject matter. The geological sites of Palo Duro and Tule Canyons emerge in her work through sparse strokes of color or intricate designs. She illuminates the canyonlands' inverted mountains in scenes of blue West Texas sky, horizontally layered walls, and greenery along the banks of the Prairie Dog Town Fork of the Red River. She also incorporates rocks into

her compositions. "The rocks are so beautiful. I am amazed at the patterns that form in nature," she says. "The colors in the rocks go with the colors of the glazes. I put things from nature in my work probably because I am truly close to nature out here. Natural objects are a lot more appealing than man-made objects."

Grisham uses other found objects, such as broken ceramic figurines, lamps, cups, or dishes, in her pottery and mosaics, often as reminders of earlier times. She assembles frames around mirrors from shards, ceramic figurines, her grandmother's broken china, tile, and cracked pottery. The rectangles form abstract scenes and landscapes. For Grisham, the art making process also involves using parts of farm implements to mark spirals, swirls, or linear forms on the surfaces of her pots. From decorative parts of furniture made by her grandfather she shapes intricate legs for her vessels, and she has saved the ashes of the old red barn that once stood on her property to use as a glaze.

In a mosaic on the outside walls of her studio Grisham includes Anasazi pottery shards found by a friend on a New Mexico ranch, a few pieces of her grandmother's broken china-painted lamp, and multicolored fragments of tiles to form swirls of color and a circle within a star. In her studio, Grisham sorts ceramic shards and other materials by color for her mosaics and pottery. She links black-on-white shards with black-on-terra-cotta fragments of ancient pottery with a deep black border. "Sometimes I will buy some dish or other ceramic thing, and it will be a couple of years before I figure out what I can do with it, but I don't let anything go," she says. "Potters are the best recyclers."

Grisham fashions knobs and other elements of her pottery from rocks and gemstones. For one lidded jar she creates a crystal handle of gypsum, a common mineral of Palo Duro Canyon. In the intersection of two pairs of parallel lines she centers a piece of amber. The colors of the tall vessel echo not only the gypsum handle but also the sandy creek beds along the canyon floor. To the curved lid of a salt-glazed teapot she attaches a black and gold agate, framed by an arched handle, that complements the colors of the round base. The pot's pearly white glaze sets off the polished opacity of the sharp-edged agate, both elements capturing light. The pot's browns, greens, and blues recall a summer horizon, as if a powder-blue sky were reflecting the fields below. To the lid of a celadon jar Grisham attaches a delicately carved piece of Asian jade, which offers perfect camouflage to a bas-relief lizard that appears to be crawling around the surface of the pot.

In other pieces Grisham contemplates the cuisine of Taos and Santa Fe in spicy colors, the mountains of northern New Mexico in columnar vessels, and the region's architecture in rounded pots whose texture resembles the straw and mud of adobes. Grisham's stoneware pieces are sometimes utilitarian, functional, and personal objects for the home, yet the sculptural aspects and the intense colors of her plates, cups, and teapots make the setting for a meal an artfully layered and pleasurably textural experience. Her control of

14

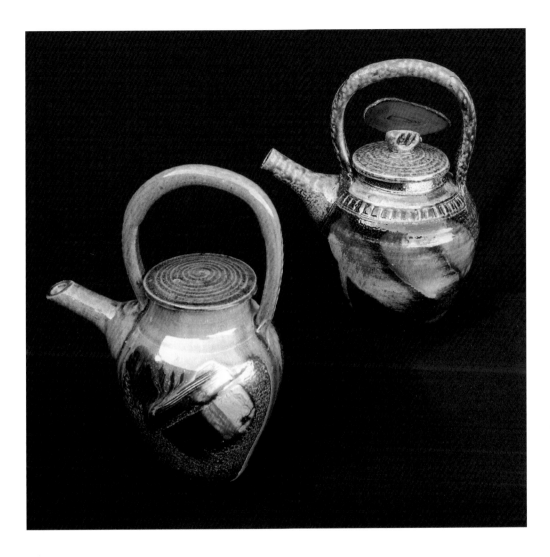

colors, lines, and intricate forms is evident in two salt-glazed, footed bowls that are square with rounded corners, like adobe walls. On one bowl she made sharp distinctions through forceful markings between the deep blue and beige that rest on a rich brown background. On another, she incises broad, diagonal, red marks across a green circle, adding an echo of a line outside the circle to give the piece movement.

The myriad possibilities of working with clay, Grisham suggests, offer a never-ending learning experience. In glazing and firing, she does not rely on serendipity. Instead, she

Salt-glazed teapots
2007, 11 in. and 10 in. high, wood-fired, salt-glazed stoneware

MARILYN GRISHAM

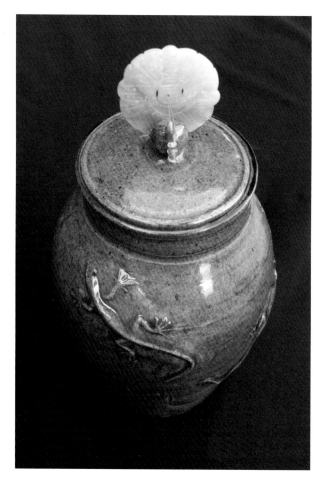

controls the process to determine colors and patterns. "There are happy accidents sometimes, but not very often," she cautions.

Grisham is adventurous and finds inspiration in exploring other places. She rides on the back of a Harley-Davidson behind her partner, Tom Glover, coowner of an art gallery in Taos, New Mexico. She loves to dress in black leather and feel the wind on her face as the couple climb through the mountains of northern New Mexico or the canyonlands of the Southwest's national parks. Relishing independence, Grisham is a little rebellious, yet she is rooted on her farm, where she grows wheat and grazes cattle. The land she works has been in her family for generations and is the same acreage her late husband, her father, and her grandfather each farmed. Grisham recalls her own first wheat crop and how moved she was to watch the combine harvesting the fields with the dust rising.

Like many immigrants to the region in the 1880s, Grisham's maternal grandparents chose to settle in West Texas because the land is level and the grass thick and beautiful. Proud of her farming heritage, Grisham says, "I don't just worry about my land; I worry about all land. It's a big deal around here to take care of the water and the land." In Grisham's family art has always been a big deal, too. "Everyone was always doing something or making something. It was just part of normal, everyday life." Both of her grandmothers painted china in freehand and did needlework. Her grandfather crafted wood marquetry into furniture and other practical objects. Her other grandfather designed and

Celadon lizard jar
16 2005, 12 in. high, high-fired stoneware

built homes in nearby Amarillo, Texas. Her father started out as a tailor. Grisham's brother, Mike, became an architect in San Diego, California. "I have always been surprised at people who don't make things or create art," Grisham says. "I thought everybody made furniture and painted pictures. When I spent time with my grandparents in the summer, everybody was always busy making objects of art. Somebody decided that I might want to be an artist, so I took drawing lessons after school. I remember a lot of advertisements in the newspapers were drawn back then, and my teacher, Nell Lill Lemons, my granddad's sister, had me draw the same images in different sizes for practice. I liked that, but I wasn't really good at it. In high school, I wanted to be an advertising artist." When she attended West Texas State University in Canyon, she studied English and education because she knew

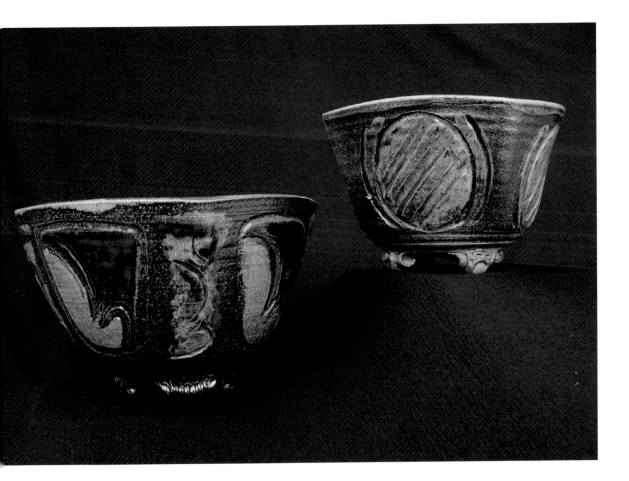

Salt-glazed bowls
2007, 6 in. high, wood-fired, salt-glazed stoneware

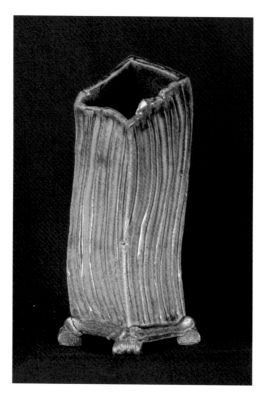

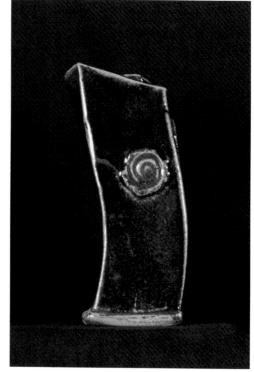

Salt-glazed extruded vase
2007, 9 in. high, wood-fired, salt-glazed stoneware

Copper red extruded vase
2007, 9 in. high, high-fired stoneware

she could teach while rearing her daughter, Michele, and son, Scott. For the next thirty-two years she taught elementary school classes in Panhandle's public schools.

Today, Grisham is content to make art. She often uses earth tones in her pieces, which she throws on a wheel, builds by hand, or constructs by extrusion. Her containers are typically geometric in form: circular, square, hexagonal, or columnar shapes that retain their organic heritage in color and texture. Putting clay through a squeezing and mold-ing process like pasta in a machine, Grisham makes die cuts for her formations, which have perfectly balanced sides in fours, sixes, or eights. Yet her squared pieces have the whimsy of curvature, a play on balance, and delightful contrast. On a salt-glazed extruded vase, etched parallel lines follow the form itself, like earthy cultivated rows. Intricate feet intensify the balancing act of the piece. On another salt-glazed vase, spirals glazed in deep red form a medallion against the stark and smooth walls of the container. By bending

both of these vases' straightforward, symmetrical forms, Grisham creates a perfect balance of imbalance.

"Each piece of my art is a new experiment," she says. "Some of my work is utilitarian . . . , but each piece is unique. My work is changing from just making things that people can use to making things that have a story with them." Grisham's stories are often humorous. "One time, I picked out this rock that I thought was real interesting looking. It kind of had an iron look to it. It was coprolite, but I didn't know what that meant. I put that on a pot, and my partner, Tom, told me that it was fossilized scat. The pot sold as a wedding gift, and I was at the shower. I said to the bride, 'I'll tell you what this is, and when somebody asks about it, you can say, 'Oh, this is just a piece of shit!' The bride was kind of a feisty little thing, and she had some fun with that," Grisham laughs.

She also laughs about a lesson she learned in glazing one day when she had a loaded kiln ready to fire. Before shutting the door, she saw a little hump out by the road and found one of her six-month-old kittens dead. "I was holding the dead cat and thinking, 'Out here, if you bury something, you have to bury it really deep because the coyotes will dig it up.' So, I decided to put the cat in the bottom of the kiln under the shelf and cremate it. But what I wasn't thinking about is that cremation happens at maybe 1,500 degrees or so, and turns stuff into ash. If you go past that, up to a high fire, the heat turns that ash into glaze. So out there in the kiln is the outline of the backbone and skull of the cat where it turned into glaze. I made a little mental note that if I ever dump a body, don't fire it that high!"

Grisham's earthy, spirited, and adventurous personality gives her the tenacity needed to be a potter in West Texas, a tough task, she says, because of the wind and elements that challenge her outdoor work with the kiln. "You have to be tough to live, farm, or ranch here. There's some good weather, but it's pretty extreme." Grisham is committed to her land and to her art. "I have been here so long, and my family is rooted here. I love everything about this place," she says. "Here, you get every season. You get winter with snow, you get fall with the colors, you get spring with rain, and you get summer with thunderstorms and warm days. You don't get bored with the change of the seasons. In the evening there's not a prettier place to be than out here. It's so quiet, and the sunsets are just amazing. I see every bit of a sunrise and a sunset. The vegetation—even weeds—holds beauty for me. My farm is my sanctuary."

Like a good conservator of the land, Grisham respects the environment, never taking its bounty for granted. In her hands, waving yellow stands of wheat yield seed for inspiration as well as next year's crop—food for thought and body alike. K D H

19

"Santa Elena Canyon"
1987, 6 × 7 in. color transparency

The Art of
TRACY LYNCH

———

Passionate about the terrain of the Chihuahuan Desert, Tracy Lynch has spent the past thirty years photographing the land and inhabitants of southern Brewster County, Texas. "I adore their stories, how they got here and why they are here. I'm just as much interested in their stories as in their pictures." Lynch knows firsthand the difficulties of desert life and the remoteness of the Big Bend area of Texas. During her first ten years living in Terlingua she had no running water or electricity; for the first five years, she never slept inside a building. She is acutely aware that everyone who lives here must be determined to do so.

Like Lynch herself, they may just crave the dramatic vistas and the fullness of empty spaces. Whatever the reason, the land and the stories have driven her development as an artist, her life's work in color and black-and-white photography of the places and people of the Big Bend.

A turning point in the development of Lynch's creative development came in 1975. A friend of a friend told her about Desert Dance. Groups of ten adults, guided by a former Outward Bound leader, David Sleeper, would spend an entire month in the desert of Big Bend National Park, taking all their food and gear with them. The program was meant to expand their horizons and provide respite from the demands of urban life. So Lynch, her friend, the leader, and eight others met in Alpine before setting out into this stark landscape populated by no more than fifty people. The Desert Dance experience transformed her. "I thought it was the most beautiful place I'd ever been. I'll never forget that moment of just getting here and going, 'Oh my God' and having that feeling of, 'I know this place. This place knows me.'" Completely taken with the surroundings, Lynch decided to pack up her life in Albuquerque, where she was attending the University of New Mexico, and return for another month-long desert encounter, this time on her own. She walked the ridges of the Chisos Mountains and then descended fifteen hundred feet to Santa Elena Canyon on the Rio Grande. She was twenty-five years old.

For the next five years Lynch worked with David Sleeper. She did the advertising for Desert Dance and arranged the food and equipment for about three trips a year. The clientele came from throughout the United States: professionals, dreamers, loners—a cross-section of cultures. Desert Dance not only gave Lynch a new direction in a landscape she loved, but it also led to her initiation into photography. Nancy Jane Reid, who had been a student of

Russell Lee at the University of Texas at Austin, had participated in Desert Dance, and her pictures were used for promotion. Eventually she lent Lynch her camera and became her mentor. Lynch recalls that the camera was "an Olympus, garden variety," and she had only a few days to prepare to become the photographer for the trip. She shot about fifteen rolls of black-and-white, and when she returned, she went to Alpine, where Reid had a rudimentary darkroom. "We developed the film and that was it. That's all it took. I just went, 'Oh my God. This is magic.'" Lynch explains that this is "what happens to most photographers. That's how they get hooked in, especially with black-and-white. That first time they develop their film they just go, 'It's magic. It's amazing.'"

Reid left the area two years later, and Lynch, without access to a darkroom, decided to try color slide film. "In those days it was Kodachrome. I marched into the desert on the next Desert Dance and, lo and behold, on that trip was a photographer named Bill Parsons, from Little Rock, Arkansas, and he gave me my first lessons in color. Serendipitous!" From that point on Lynch shot primarily in color and began putting together promotional materials and slide shows for Desert Dance. She made the transition to color without a lot of experience in black-and-white, a self-described "complete amateur." Yet shooting color slides forced her to observe natural light carefully. She explains that with black-and-white film, darkroom printing is where the manipulation of light comes into play, but with a color slide the photographer knows immediately whether it's right or not.

22

One of the biggest challenges Lynch faced was the lag time between shooting and seeing the finished product, "I'd load up with film, go out for thirty days, and then get back and mail it off." Anticipating the delayed gratification and knowing that she wouldn't have the same visual opportunity a second time forced Lynch to pay close attention in the moment of the shot. According to Lynch, "There's a little saying that you're just 'sweeping the garden.' It's being in the present moment, as if that's the only thing. . . . And that's how I do my work. I'm completely absorbed in the moment." The conditions under which she photographed made her more exacting and precise. Because she knew the chance wouldn't come again,

"The Mother's Day Hailstorm"
1983, 35-mm color slide

T R A C Y L Y N C H

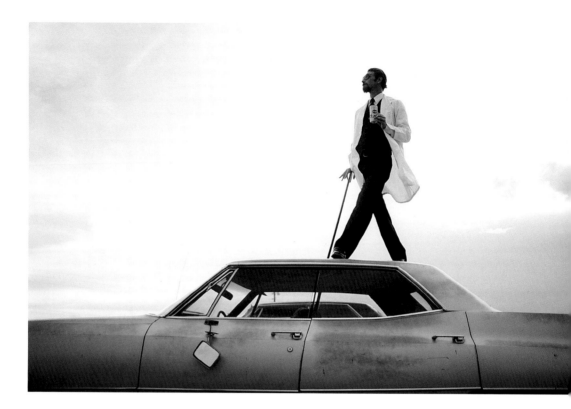

she had to make sure she got the shot at the moment. Lynch became obsessed with being the best 35 mm photographer she could be with no artistic aspirations beyond what she was doing at the time. "I was so obsessed people didn't really quite understand me. There was no room for them! I'd kind of get inside that box."

By the time she and Sleeper parted ways, the first of the rafting companies, Far Flung Adventures, had arrived in the area. Lynch began taking pictures of rafting trips, intrigued by capturing light as it bounced off the water.

At thirty-five, Lynch became pregnant with the first of her three children. Realizing that pregnancy and parenting would affect her access to rock climbing and rafting, she began pursuing various kinds of commercial work. She shot photographs for magazine articles. One publication led to another, and her adventure photography flourished. She also sent out stock photographs of desert landscapes, of climbing or rafting—anything to do with Big Bend.

Some days she would simply pack up her baby, along with her tripod and camera gear, and "just go." Mother, son, and work were

24

"**Dr. Black**" FACING
1986, 35-mm color slide

"**Paul**" LEFT
1986, 35-mm color slide

portable: "He did almost all the assignments with me for years. I was carrying him in the backpack when he was two years old. I did mostly magazine work for a really long time." Her pictures of Big Bend appeared in *U.S. News and World Report, Texas Monthly, Texas Highways, Texas Parks and Wildlife,* the *New York Times,* and *Parade.* She worked for about thirty different magazines over those years, shooting almost entirely in color.

Always enterprising, Lynch soon branched out into the postcard business. These images also convey her love of the land and its inhabitants, the lonesome and gentle character of

the desert and its inhabitants. One postcard, titled "Dr. Black," depicts an elegant and offbeat figure, poised with a cane, standing atop a vintage and slightly rusted Cadillac. His white lab coat floats in the breeze over a dress suit. He holds a cigarette and a can of beer in his hand. Lynch explains that this was the first portrait she ever shot. Similarly, in the image entitled "Paul," one of Terlingua's triumphant personalities holds a stick of sotol and some firewood. "Santa Elena Canyon" depicts light bouncing off the sheer, red cliffs rising above the Rio Grande. The postcard "The Mother's Day Hailstorm" captures the power and beauty

25

of a desert storm in all its majesty and drama, showing in crystalline clarity Lynch's ability to catch the moment in this desert place.

Although for the most part self-taught in this area, Lynch did have some help for the postcard series. Betty Moore, who had done production for *Texas Monthly,* gave her some invaluable pointers. Lynch did everything from layout to pasteup, winging it through the first printing. Eventually she found a printer in Mexico City, where she was welcome to hang around. "What they taught me was immeasurable. I don't think I could have found anybody (in the United States) who would have taught me the way they did."

Lynch also appreciates the experience she gained setting up locations for commercial photography sessions, an assignment very similar to her work with Desert Dance. She was in charge of finding the location, doing all the mock-up pictures and getting the releases, finding the talent, and arranging for the meals and sometimes the transportation and sleeping accommodations. The photographer and art director would simply arrive for the photography session. Lynch liked this assignment because it paid well, and she had the opportunity to observe top-notch photographers at work. Bruce Dale was the first to hire her to set up a location for a *National Geographic* story on roadrunners. She did two stories with him and values the learning experience, guiding him through her familiar terrain for weeks at a time. For Lynch *National Geographic* set the standard for nature photography, and because she had no formal training, these were the kind of images that influenced her most.

Dale wanted to recommend her for a position with *Geographic Traveler* as a way of launching her career, but she had two children at the time and wanted a third, so she passed up the opportunity.

Instead, Lynch supported herself with editorial and commercial work and continued to document her sense of the desert through her images. "The Desert Cradle," for example, depicts a baby nestled in hollowed-out rock. "Many people come here and find this a very harsh, inhospitable environment," she says. In this photograph Lynch conveys the comfort and safety that one may find in the desert, along with the possibility, even the desire, to meld into it.

Lynch was raised in Miami, Florida, with no inkling she might become an artist. In hindsight, however, it seems that the signs and "the ooze," as she calls it, were all there. Although her parents didn't encourage art and their home was "artless . . . and rather musicless," she recalls that her mother sang harmonies with country and western songs and old standards. She was also good with her hands and sewed all the time. According to Lynch, her mother "could tailor anything and was a very good seamstress." Wanting to emulate her, Lynch sewed constantly. Not surprisingly, one of her earliest memories of creativity is of fashioning clothes for her Ginny dolls. In particular she loved the saturated colors of felt. "My mother would just give me a whole pile of felt and scraps and lace, and I'd just go nuts!" Her mother also fed Lynch's creativity with the gift of a scrapbook with large manila pages and stacks of old magazines. "I would

26

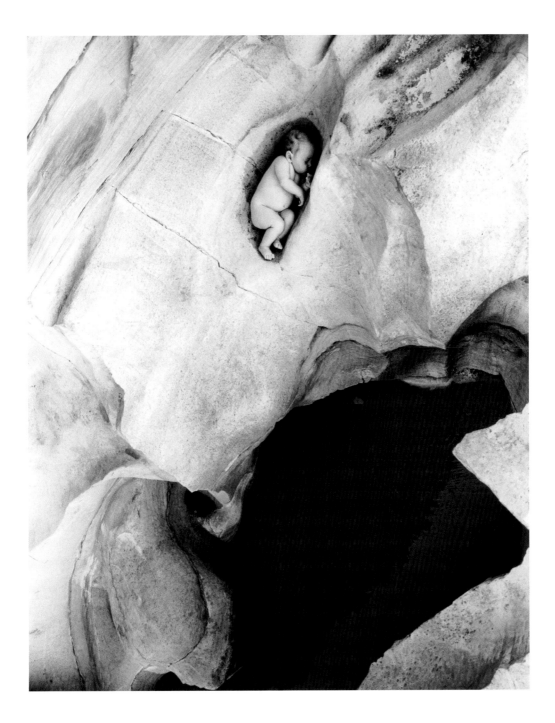

"The Desert Cradle"
1995, silver print

"Young Girl Holding a Pear" ABOVE
2006, toned silver print

"Jett" BELOW
1995, toned silver print

take all those *House Beautiful* magazines and just cut and cut and glue and cut and glue." She made all kinds of collages, "abstracts and stuff that was literal. I just about filled these scrapbooks." According to Lynch, this was where she developed a sense of color and composition.

Other early influences also had an impact on Lynch. Her father was a pilot, an innovator in aviation, and an electrical engineer who "broke new ground constantly." According to Lynch, she "felt (the) vibration of his incredible creativity. But it was a different kind—it wasn't art. He didn't even pay attention to art. Nobody fostered any kind of high art. They didn't even know what it was." Her father's influence also came in the form of worldwide travels and the experience of staying in magnificent hotels like the Marco Polo in Hong Kong and the Imperial Palace in Tokyo. As a teen she asked her father to take her to Paris to visit the Louvre, where she had a whirlwind tour, visiting with only an hour left until closing. As soon as she was old enough to drive, Lynch began to chart her own path and develop her own aesthetic. She discovered the University of Miami Lowe Art Museum and its theater, where she was introduced to foreign films. "I think the thing that probably set the course of my life, in terms of my own personal vision, [was the films of] Buñuel and Antonioni and the way that they composed in black-and-white," she muses.

Lynch was unaware at the time of the impact of these influences and her own visual acumen. Throughout high school and college she never took an art class. Instead, she sewed

the costumes for the high school plays and did the advertising for the yearbook. She excelled in math and loved reading science books. In college she focused on math and science, geology and anthropology, and still took no art courses. Despite her lack of formal training, over time several key elements—talent, a visual storehouse, and being in the right place at the right time—would coalesce and bring Lynch behind the camera's lens.

In recent years, Lynch has divided her time between her desert home and Boerne. After spending several years care-giving for her elderly father and having little time for photography, she has recently turned her attention to portraits, a medium she regards as timeless. In "Young Girl Holding a Pear," Lynch again explores of the craft of black-and-white in terms of its tonalities and composition, blending portraiture with still life to convey grace and wonder.

At every turn Lynch has taken advantage of the opportunity to nurture her talent and share her understanding of the culture of Big Bend. Her personal journey to this desert place and her innovative response to the personal and professional opportunities it has offered her are a testimonial to her confidence, independence, and creative entrepreneurship. L J C

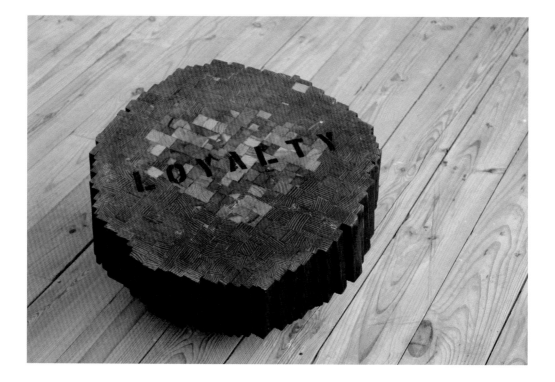

Loyalty (My Sister Geraldine's Table)
2004, 12 × 21 × 23 in., graphite, urethane on wood

FOUR

The Art of
SARA WATERS

———

S ara Waters's art reads like a book. She selects her words and images with care and intent, constructing environments that tell a complete story. During the past twenty years her work has moved from figurative and metamorphic to participatory, inviting the viewer into the process of experiencing her paintings, sculptures, mixed-media work, and music. Today she creates installations of detailed, layered sculptures that reveal her tenacity, filling vertical and horizontal spaces with visual and verbal symbolism.

In one installation Waters punctuates her alternative environments with sculpted hands and fists that suggest classical Greek statues, beautiful in their realism and historic symbolism. In another, she creates vessels of softly curved lines from layers of wood melded together with precision and complemented by angles in iron. She also recycles rusty tools, metal buckets, and other found objects that

add visual irony to her work. In her written art she incorporates pages and photographs from old books that address the choices and dichotomies of life. Visually, Waters presents clarity in clean lines and order, and intellectually, she asks the viewer to contemplate the essence of time and relationships. Her artistic constructs are not realistic in style, but through their positioning and inventiveness they point to hidden realities.

Waters's source of creativity is personal history, keen observation, and a sensitivity to the human experience. She recycles pieces of her life into her works, in a process she calls "repositioning," to address the concept of time and history. "I really do like the notion of history as it existed. It cannot exist that way anymore, so I have taken history and repositioned it into beautiful forms." In those visually complex and dynamic forms Waters revitalizes the commonplace. "This investigation," she says, "has led me to think about the way in which we, as human beings, maneuver throughout our days, attempting happiness while negotiating our surroundings, other people, and ourselves."

Waters makes tools as implements of assistance; troughs as places for nourishment; ground covering of pecan shells, clumps of earth, and split wood as foundations for place;

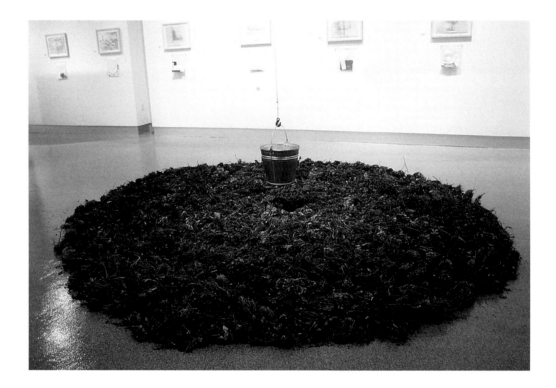

Offering
2002, 12 × 14 ft., suspended 12 ft. varied media

gutters, pitchers, buckets, funnels, and carriers as devices for gathering and distribution. Growing from those forms, the concept of give and take emerges in her work. Her classically inspired fists, for example, are reminders of the daily reality of negotiation and compromise. "Time and time passing are integral components to this concept," Waters explains. "Giving and taking take time. Using tools, finding nourishment, gathering supplies, and tending to our internal and external needs also take time. We have to make and find time as a means of survival."

Using recycled materials, Waters brings personal history to her works. In her sculpture *Loyalty (My Sister Geraldine's Table),* she reconfigures a table her sister gave her. The word LOYALTY is stamped like signage over rectangular pieces of wood that have been fitted together to look like a sawed-off tree trunk. The circular form has ragged, barklike edges, and the inner layering of wood suggests the passing of time. Through the construction of the sculpture Waters indicates that loyalty takes patience, intention, pattern, and commitment. The wood sculpture sits on the floor, and she explains that viewers become participants in her installations as they walk back and forth creating sounds of determination and indecision in much the same way

33

Resting
1998, 30 × 44 × 25 in., stabilized adobe, wood, lathe, acrylic

SARA WATERS

Utopia
1999, 5 ½ × 8 × 6 in., plaster, pigment, wax

she paces back and forth, speaking about the accumulation of things, over and over, again and again in her musical performances.

Waters's sense of irony and humor can be seen in *Offering*, a work composed of a circular mound of wood mulch beneath an empty bucket that hangs by a hook and wire overhead. Piled high, the mulch is a soft landing place under the bucket lingering lightly in the air, still and moving at the same time. The visual relationship of the organic and the mechanical fills a clean gallery space with nature and industry in suspension. Maintaining a tenuous balance is also the effect of *Resting,* a rounded form reminiscent of a large unshod horse hoof, with a textured, brown wood finish

punctuated by a sharply angular graphite side. The sculpture balances on its central dimensions, displaying both soft curves and clean, sharp planes.

Stemming from internal regions, Waters's sculptures are visually abstract and conceptually real. "The construction of my work is literally invented space or territory," she says. "I believe these places to be real, to exist on a plane beyond the physical dimension. The content of my work comes from an intense interest in dialogue—the dialogue within one's mind—the dialogue provoked by relentless contradiction. The work expresses the paradoxical dynamics of calmness within chaos; anger within serenity; passion within constraint. Visually, I use all that terminology in my work. That idea becomes hinged to survival through the notion of give and take."

In her sculptures of hands, Waters creates the details of fingernails and wrinkles, revealing the sensuality of the human hand in concentrated studies. "I am working with the notion of give and take in relationships," Waters says. "So, the hand would be asking, 'Are you just closing and taking, or are you just giving? Are you holding onto something or someone? Are you just receiving, and are you ready to give?'" The marble-like hands in *Utopia* reach toward the viewer, representing acceptance and rejection. In the installation *Give and Take,* Waters continues the visual motif with numerous hands aligned on a wall with natural shadows adding emotional depth. All of the delicate hands are closed in pale, white fists clenched in varying intensities. The center hand exudes anger and threat, while

34

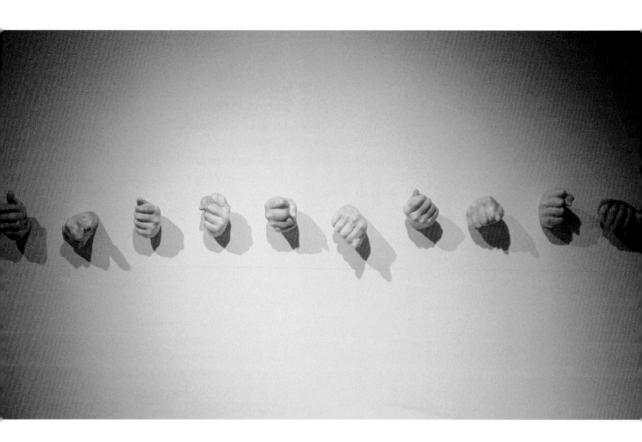

other fists are closed in self-protection. The continuum of hands, combined with the light and shadow of the space, create a complex visual sign language of human emotion.

In *Coming/Going* Waters studies symmetry and asymmetry through an intricate wooden sculpture. Climbing out from a balanced vessel, a column of wood is off-center, resembling an unfortunate distortion from a potter's efforts on the wheel. The piece offers sculptural meditation on balance, calm, and energy. In *Fill/Empty,* another study in contrasting forms, rounded cones are complemented by lines of metal in a union of sharp angles and soft contours, joined in two-part harmony.

Waters is also a distinguished musician who incorporates performances into her installations. Her lyrics address self-realization, life, and honesty. "Music is an easier way to hear real or harsh things," she says. "The format of a song allows me to say things that can be apart from me. My music is simple and raw, like my art." Waters's integration of music and art creates a dynamic exchange between the abstract symbolism of her visual work and the directness of her music's lyrical content.

Give and Take
2000, 6 × 72 × 5 in., plaster, pigment, wax

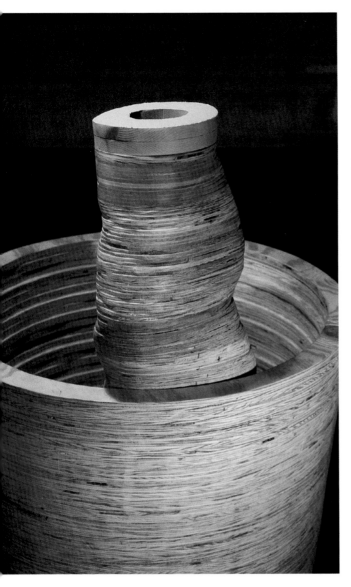

Coming/Going DETAIL
1996, 64.5 × 30 in. diameter, wood

"The words are the essence; the voice is the vehicle; and the piano or guitar is the facilitator," she says. "My sculptures portray invented spaces occupied by energy where thoughts are exchanged. The music supplies or suggests the verbiage, the dialogue."

Waters became very serious about her music after her Aunt Edith died, leaving her piano to her niece. *Out of Range,* her first musical album, released in 1989, is dedicated to her aunt, who brought music into her life. Waters released a second album, *At Water's Edge,* in 1992. She began writing music as a senior in high school when she played rhythm guitar and sang in a group with other friends. Edith was a very strong role model and gave Waters one of her first centers of creativity. "When I was in about second grade, Edith said I should take piano lessons. Then she said it would be good if I had violin lessons," Waters says. "I stuck with piano, and I hated it, but it allowed me to have a special relationship with her. She was involved, and she was extremely supportive."

Waters lived in the small town of New Albany, Indiana, across the river from Louisville, Kentucky. Her father was a traveling salesman, and her mother had five other children to tend. Waters says she was often on her own as the middle child and youngest daughter and remembers growing up playing sports, particularly competitive swimming. "Swimming taught me discipline, gave me an escape, and gave me something to obsess over," she says. She attended Catholic school, with its rules to memorize and its charity nuns to mind. The themes of Waters's art, as well as her musical

performances, often come from her childhood.

Her pursuits turned to art after she entered college as a philosophy major in 1966. Drawn to writing and thinking, Waters found her real calling one day while she watched her roommate work with balsa wood to make a three-dimensional design piece. Waters was mesmerized by the process and proceeded to earn her bachelor of fine arts degree at Spalding University in Kentucky, then trained in painting and sculpture at the University of Louisville School of Art. She studied with Tom Marsh, who encouraged her to earn her master of fine arts degree in clay at Indiana University. "I was actually kind of gutsy in that I did not come into clay with any baggage of what clay was going to be," Waters says. "I had a lot of freedom for what clay meant to me. I immediately became mixed-media. Almost just—bang—right out of the gate," Waters remembers. "I would do these big glass pieces with wet clay and panes of glass. We were in the time of process art and participatory work. That was very much what I was being influenced by."

In 1977, as she finished her graduate work, she moved to Lubbock, Texas, where she continues to work as a professor in the School of Art at Texas Tech University. Predictable people who live quiet lives remain a primary influence on Waters's artistic work. "That's how I feel in my life," she says. "The sense of being alone and being quiet is the ultimate influence for me."

Waters loves to travel, relishing time spent keeping a journal, sketching, playing her guitar, reading, and thinking. On one pivotal trip Waters visited the Shetland Isles. "I went prepared with my recorder. I had my guitar, and I had some drawings. I was going to write and reflect and see what the heck happened," Waters says. She began collecting objects on her walks and then staining images of the objects with tea instead of drawing them as still lifes. The process of collection, rendering, and tinting made the objects a part of the process and the outcome of the art. "I do not need to do the illusion or the imitation of the object, because the object itself creates parts of the art," Waters says. She also used a 1965 geography book she found on a visit to a Shetland Isles bookstore to create a seven-foot by five-foot compilation of five hundred small, various-sized photographs in a random collage. Being in the Shetland Isles was a transformative time for her. "I did not need anything fancy to make the art. For example, sheep waltzed along the street with me as I walked. It was incredible. Their lost teeth were all over the place. I washed them with some bleach, put them into little jars, and brought them home with me to use in making art."

Even as a child, making her first artwork near her parents' cabin on Blue River in Indiana, Waters engaged others with her visual messages. "I grew up going to my parents' cabin in the summers. When I was probably eight or nine years old, in the forest next to the cabin one summer I made a meditation place," she remembers. "I dug up ferns and put them around in a circle. Then I made everyone in the family go there and say a rosary. Looking back, that was my first art piece—my first earth work—without knowing anything. I

37

initiated myself. I just thought about it and did it. It took me a long time to build, and everyone obeyed me. We went in my circle, and we said the rosary. We still go back to that spot all the time. It's beautiful."

Still inspired by wild nature, Waters spends her summers teaching drawing and painting in the rustic atmosphere of the Texas Tech University Center at Junction, Texas, located in the state's Hill Country. She is a dedicated teacher throughout the year and shares her gallery space and studio with her students. In Slaton, Texas, an old railroad town southeast of Lubbock, Waters has renovated two large storefront buildings on the town square. She has carved out her living space, a large studio,

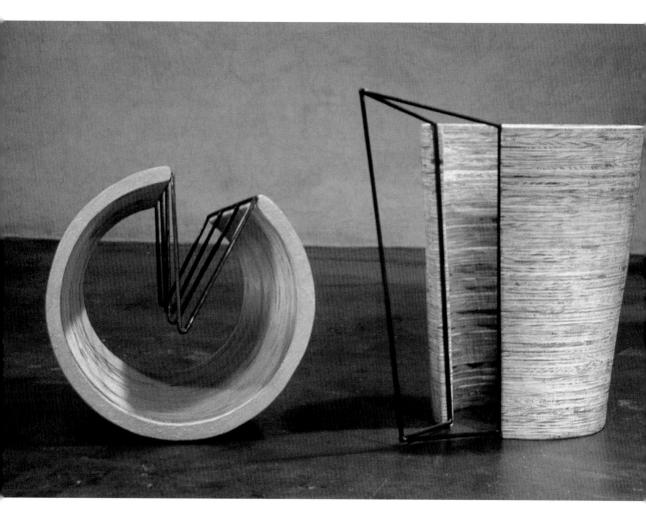

Fill/Empty
1998, 30 × 60 × 30 in., wood, steel

and two galleries in the two-story brick structures. The galleries, Waterspace North and Waterspace South, give her students a place to work, to exhibit, and to create, bringing to the small community of Slaton an energetic boost of visual arts culture.

Waters's offerings to the world are multisensory, combining her talents in art, music, and the written word. She is expansive and genuine in her mixed-media artistic style that reflects her independence and self-knowledge. "I am clear about what and who I am," she says. Waters is persevering in the process and the outcome of her art. She works painstakingly to achieve details and nuance in her sculptures and music. She declares herself to be a low-tech, process person: "Obviously I am about process, or I would not spend hours banging those old pieces of wood together."

Waters has the forethought of an engineer, the design sensibilities of an architect, the exactness of a mathematician, and the dedicated heart and soul of an artist and musician. Her

work is rhythmic and repetitive. Her creative patterns have developed into a metronomic regularity of thinking and doing, acting and reacting, and finding the still points in between. She explains that conversations with her musician son, Zachary, have yielded the "Notation Series," an ongoing study about the look of sound. "I am engaged in discovering a renewed interest in multiple parts, intangible goals, impermanence, the position of the ordinary as extraordinary," Waters says. "I now am more interested in the documentation of our maneuvers than in their symbolism."

Waters is determined in her art. "We are on earth to be creative, to plug energy from a greater source, and to let it flow," she says. "I do not have a choice about being an artist." Her work seeks to make sense of the world by fitting parts together in new alignment. Through her visual, literary, and musical art, Waters layers her creations like pages in a book full of rich form and meaning. K D H

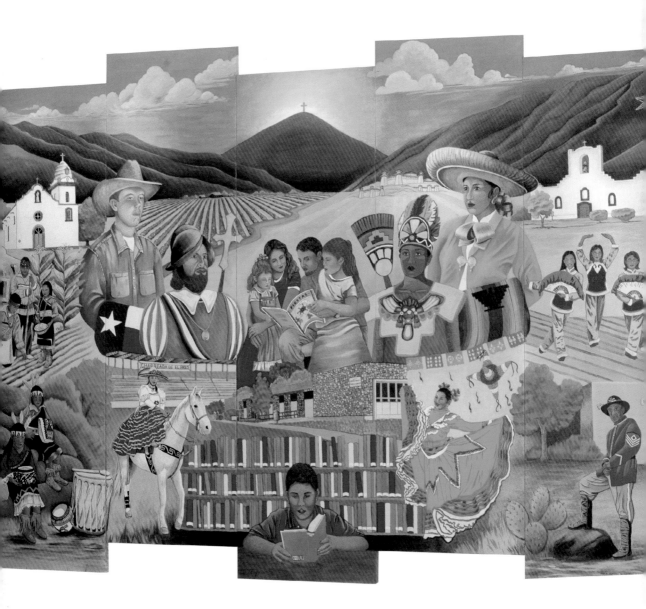

El Paso History—Lower Valley Pride
dedicated on December 8, 2006, 15 × 6 ft., acrylic

The Art of

MARIA ALMEIDA NATIVIDAD

——

Maria Almeida Natividad celebrates her culture by conveying through her artwork the importance of traditions in nurturing fundamental values and meaningful connections. "Through my art I try to share with others the beauty of our culture," she says. "My parents taught us about our culture, our heritage, and our traditions. I want to do the same with my children so that they too can continue the traditions with their children. I think art is a celebration of cultures, a celebration of life. I hope that my art enriches other people's lives. Art is my way of giving back."

Natividad is enchanted with her native homeland of El Paso, Texas, where the vibrant colors in desert plants, flowers, and sunsets influence her palette. In her brightly colored world, Natividad paints with watercolors, acrylics, and colored pencils. Through her

Branch Library, dedicated in 2007. The mural, titled *El Paso History—Lower Valley Pride,* explores the multicultural heritage of El Paso. Natividad paints the Aztecs, the Tigua Indians, the Spanish conquistadors, missions, early settlers, traditional celebrations, and mountainous landscapes with Guadalupe Peak looming large. Over the pass and down into the valley, El Paso sprawls around Mount Franklin on the border with Mexico. Natividad celebrates El Paso as a city that mixes Native American, Spanish, Anglo, and Mexican cultures in its populace, architecture, culture, and art. She includes renderings of the region's elegant Spanish missions, which continue as living testaments to the history and blending of El Paso cultures.

"The library mural is a history lesson, a geographic view, and an honoring of the diversity in the community," Natividad says. "The figures in the mural are painted in a variety of colorful hues and reveal the cultural dimensions of the people and land." At the heart of the painting is a boy who is reading a book in a library. Natividad, who also is a former public school art teacher and a current university art faculty member, has dedicated her life to teaching others about their cultures so they will not take their lives for granted.

Natividad was born and reared in El Paso, and her childhood was flavored with the experience of being both bilingual and bicultural. She grew up on a farm in the Rio Grande valley, where her grandfather built the family home on a fertile plot of land. After her parents were married, they built another house on the same land. Natividad grew up

realistic portraits, murals, and mixed media work she is determined that her community roots will continue to educate and inspire. In her mixed media work she makes small *retablos* of saints and Catholic icons, and she creates cutouts of individuals in life-size dimensions—large paper dolls that reveal personality through stance, body language, clothing, and facial expressions.

Natividad has gained a reputation for the power of her public art. Among the few female muralists in El Paso, she has been involved in several community art projects, including a mural for the Judge Edward S. Marquez

42

Christina
1994, 40 × 66 in., watercolor and colored pencil

Adriana
1994, 40 × 44 in., watercolor

Milagro Cross
1993, 11 × 14 in., pencil, watercolor,
colored pencil, ink

surrounded by cotton fields, fruit trees, and farm animals. Her grandfather cultivated a variety of fruit trees, including quince or *membrillo* trees. From the fruit of the *membrillo* her grandmother made empanadas, pies, and jam. Her mother planted corn, tomatoes, and other garden vegetables. "Growing up in a rural environment was a wonderful experience," Natividad says. "I developed a love for nature from my childhood that is still a defining force in my life. The importance of respecting nature and conserving our natural resources and beauty is a topic that I continue to promote in my teaching and in my art."

When Natividad was a child, she spent her time making paper dolls, an activity she has transformed into life-size cutouts of people. In *Adriana,* Natividad portrays a young girl riding a bicycle with training wheels across the grass. To create the form, she builds up transparent watercolor on watercolor paper attached to foam core board that she cuts with a craft knife. This life-size cutout creates the effect of timeless youth in summertime freedom. Natividad says, "When I started doing these cutouts, I thought to myself, 'This is what I used to do when I was a little girl; now my paper doll cutouts are life-size paintings.'"

Natividad's artistic focus has come about through an evolution of her own life and her educational experiences. While earning her associate's degree in art in California, she took a class in Chicano studies, a course that had a strong influence on her art and her life. She lived in the Central Valley during the time of Cesar Chavez and his movement for the rights of farm workers. "That Chicano studies class and the United Farm Workers' struggle for justice influenced me quite a bit," Natividad remembers. "That is when I started thinking about who I am and came to the realization that I am a Chicana. I'm not just a Mexican American . . . I am an American and proud of it, but I am also a product of my heritage and equally proud of that. In California, the seed was planted, and the character and formation of my work took a different path. From that point on I began to focus on creating a body of work that represents my culture and heritage."

In her cutout titled *Christina,* Natividad

44

Virgen de Guadalupe
1998, 18 × 26 in., pencil, watercolor, acrylic,
colored pencil, metal *milagros*, ceramic beads

celebrates the strong, modern Chicana. She paints a long-haired woman in jeans and a tank top with her hands confidently on her hips. At her feet is a single red rose. Sporting brown leather boots and an independent stance, the woman personifies modern Chicana freedom, strong in her heritage and at home in her contemporary space. The rose of Catholic faithfulness and the rose of earthly love join in symbolism at the feet of this liberated woman.

Natividad took her first drawing class at the University of Texas at El Paso, where she

was inspired by Sally Segal, an enthusiastic young art instructor who took Natividad under her wing, encouraging her to take more art classes. While still at the University of Texas at El Paso, Natividad married, and she and her husband moved to California, where she enrolled in Modesto Junior College to further her art studies. There, Natividad was introduced to watercolor painting and was immediately attracted to the medium. "California artists were experimenting with watercolors and were leaders in the field," she says. "I took workshops with some of the leading watercolorists of the region, such as Gerald Brommer and Tom Hill. I since have become a master in the use of the watercolor medium and use it in pure form and also in mixed media pieces," she explains.

After several years of living in California, Natividad, her husband, and three children moved to Tucson, Arizona, where she continued her art studies at the University of Arizona, experimenting with oils and acrylics while keeping her concentration in watercolor. Ultimately, Natividad earned her bachelor's degree and master's of art in art education from the University of Texas at El Paso and began teaching in the public schools. Natividad retired from the Ysleta Independent School District in 2007, but she still teaches art classes at El Paso Community College and is the artist-in-residence for Chicano studies at the University of Texas at El Paso.

After returning to El Paso, Natividad continued exploring and reflecting on her life and her own experiences. "When we returned . . . , I really appreciated what we have here. I realized

45

Cecilia
2008, 26 × 36 in., watercolor, colored pencil

that our missions were more historic than those in California and elsewhere. I discovered the beauty of our culture and traditions and how these things define who we are. I learned the benefits of being bilingual and the importance of having an appreciation, acceptance, and understanding of other cultures."

In another celebration of her roots, Natividad explores Catholic religious symbolism by creating *retablos* in mixed media. In *Milagro Cross* Natividad composes a cross upon a cross, arranging the small amulets or *milagros* as puzzle pieces. On a bright orange background, the crosses are highlighted by a heart resting at the intersection of vertical and horizontal lines. The saint in her colored pencil work *Virgen de Guadalupe* also is framed with *milagros* at the top and bottom of the mixed media painting, done in watercolor and colored pencils. She holds rosary beads and a cross in her folded hands, and her crowned head is bowed in reverence. The deep aquamarine of the Virgin's drape is detailed in its textile patterns. To honor the Virgen de Guadalupe as a strong iconic figure in Mexican culture, Natividad often incorporates the image in her work.

In *Cecilia,* a portrait of a young woman, Natividad focuses the painting on the young woman's beautiful face, with intense and clear eyes and a scarf over her head under a crown of vines and flowers. The rich colors of blue and purple, combined with the transparent veil and its floral pattern, give the work a soft energy. The woman's brown eyes and long, brown hair are created through narrow strokes of colored pencil. The composition is an idealized view of young womanhood and just one example of a series of paintings celebrating the rituals of youth in her culture.

Once Natividad started looking at her own culture, her own experiences, and her own life, she discovered that her best work is inspired by what she knows best. "It took me years to discover who I really was and to appreciate the richness of the traditions we have within our own families and those that we share within the community," she says. "Through art, we can acquire a greater understanding of other people. I don't want to just create a beautiful painting; I also want to send a message of hope and for my art to be a celebration of shared life. We can learn much about other cultures by studying their art." Natividad values her connections to community and often uses her family members as subjects in her work. Because she exposes her attachments and emotions through her art, initially she was hesitant to sell her works. "You give birth to your children and raise them, and it hurts your heart to let go, but you have to. I think my maternal instincts really come out in some of my work. I feel like I am giving birth to these works of art. I have a very strong attachment to them," she says. "But I have learned that art is to be shared, and that through art, we reveal our shared realities and our humanity."

In her desert home of El Paso, Natividad has become a master at capturing memories of events that cross generations and celebrate community. Her public works are a documentation of cultural diversity in theme and effect, and her art tells the story of her life, her people, and her place in the world. KDH

47

Can We Go Now?
1999, 72 × 36 × 36 in., aluminum, steel, copper, plastic, lights, mirror

The Art of

DALE JENSSEN

—

Dale Jenssen forms galvanized steel, copper, aluminum, and brass into lighted artworks. Through adaptation, construction, and invention, she recycles materials into geometric and whimsical illuminated sculptures. As an artist with a penchant for details and problem-solving and with inclinations toward science, engineering, and mathematics, Jenssen is inspired by her interest in the process of construction. To create her artwork she cuts, welds, bends, polishes, grinds, and drills flat pieces of metal, then arranges bolts, screws, and rivets into exacting patterns that she blends together aesthetically as well as mechanically. Her art-making materials inspire her to take parts of things, items people have given her, even junk, and remake them into witty, artistic, and functional art objects.

In one of her humorous illuminated sculptures, *Bad Dog,* the spiked and circular ring around the center of the lamp is the dog's

Bad Dog
2004, 23 × 13 × 13 in., aluminum,
steel, copper, brass, paint, lights

50

collar made of rough and rusty steel, which
she has welded, leaving the beaded edges of
the metal highlighted in red paint. The electri-
cal wiring is hidden inside a chain, making
the lamp resemble hanging lamps from the
1970s and suggesting an aggressive dog on
a leash. The conical forms of the piece are in
brushed aluminum tapered to fine points at
each end. Red lights beam from inside the
lamp through tiny holes she has drilled into
the metal with exacting measurements. One
must disassemble the entire lamp sculpture
to change the light bulbs. In Jenssen's pieces,
visual form always joins with practical func-
tion to create dramatic interior illumination,
but form trumps function every time.

Jenssen has equipped her studio with a
table saw, drill press, two welders, a shear,
a metal bender, large drills, and a multitude
of hand tools. "I consider myself a 'Jill of all
trades,'" she laughs. Jenssen's father was
a draftsman, architect, and accomplished,
talented carpenter. Growing up during the
Depression, he became very inventive. Jens-
sen picked up her father's carpentry skills
and mechanical knowledge. Her mother was
an interior designer and a colorist, influenc-
ing her daughter's love for making delightful
assemblages for the home. "We were a work-
ing class family," she says. "Everything was
valuable and might some day have a use. So
my father saved all manner of materials in his
workshop, and to a great degree, I ended up
being like that, too."

Evident in all of her work is Jenssen's at-
tention to detail and her fine craftsmanship.
She manipulates metal in all kinds of ways

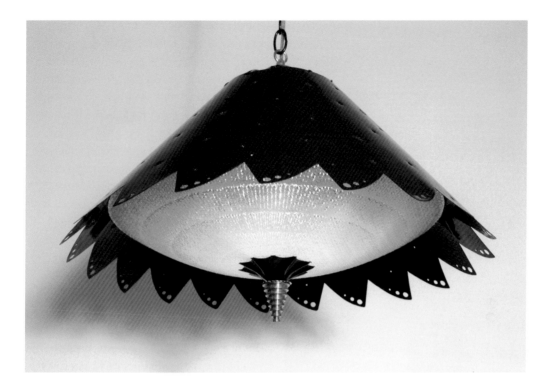

to construct artworks that reflect her skills and her imagination. "Many people separate artisans and craftsmen. I think my goal is to truly meld those two spheres and have them become one," she says. "On a very basic level, I just have a love for making things."

Jenssen is especially drawn to circular shapes and might use a machine gear to make a sundial, a heavy truck spring to make a lamp base, or a piece of crimped copper sheeting to make a large wall piece. In *Gear and Spring Lamp* she uses a gear as the base of a lamp made of a large truck spring, both painted black, and fashions the lamp shade of galvanized steel painted gray. Holes drilled through the metal give a starry-night effect, and she hangs appendages to the bottom edge of the lampshade, adding a whimsical flourish to the harshly mechanistic materials. The art deco brown and green polka dot finial adds to the spirit of the piece. In another hanging light design, *Scalloped Lamp*, Jenssen celebrates mid-twentieth-century modern design in red scalloped and bent metal with a decorative, curved glass cover and streamlined shade holder. The exuberant red elements of the lampshade are folded onto one another like a deck of cards spread in a hand.

Jenssen calls her process of making art "imagineering," the same term used by Disney

Scalloped Lamp
2004, 22 × 22 × 15 in., powder-coated steel, bicycle gear, glass, paint DALE JENSSEN

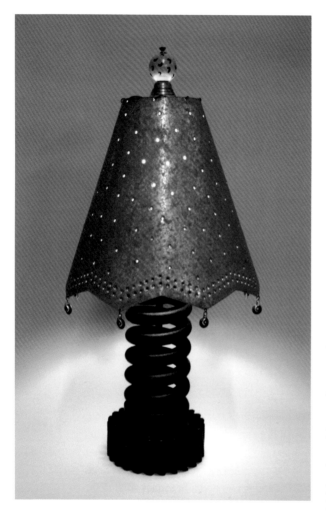

animation and robotics makers. Her studio is a laboratory to remake parts of throwaway items, creating lighting art that, in the end of the construction process, becomes an interior architectural element. "I have to do a lot of brainstorming about ways to join the materials together," she explains. "Sometimes I do not particularly choose the materials; they almost choose me. I often make mistakes that turn out to be creative opportunities. I experiment with chemicals and patinas, paints and finishes, different textures, and diverse materials." She cuts the metal outlines of her various works in spiked, jagged, or scalloped edges. Jenssen is very attracted to texture and objects she finds all around her. In *Bundt Light* she turns a Bundt cake pan upside down, attaching the purple body of the light to a black clutch plate from a vehicle. The round metal base with distinctly geared edges complements the vertical curves of the pan. The effect of the illuminated sculpture can easily be changed by replacing the red holiday lights with a different color to suit the fancy of the moment. The gold band that links the body and lamp base is repeated in a golden, pointed crown above a misty glass form that looks like a genie's cap on top of a UFO.

Jenssen's lighting works emerged from an offer to make sconces for a bed and breakfast near Big Bend National Park, where Jenssen lived for years. "I'd never bent metal before; I'd never made sconces before; I just did it," she says. "I tend to be fairly skilled when it comes to doing things. I think, 'Well, I can figure out how to do this. I'll make it work

Gear and Spring Lamp
2000, 22 × 10 × 10 in., steel, wood, copper

somehow.' So I do." Her willingness to try to accomplish anything is another characteristic of her scientific and engineering talents.

The sconce project moved Jenssen into making more light fixtures and other decorative works for the home. "While some of my works are not what I think of as 'fine art,' they are most certainly artistic," she comments.

The organic lines in a wall sconce are elegant, with scalloped edges of galvanized steel suggesting a seashell. Bent in an angular shape, the copper triangle in the center is drilled with tiny holes that project points of light. The rust-colored copper complements the galvanized steel, and each piece of metal is an individual sculpture unto itself. All combined,

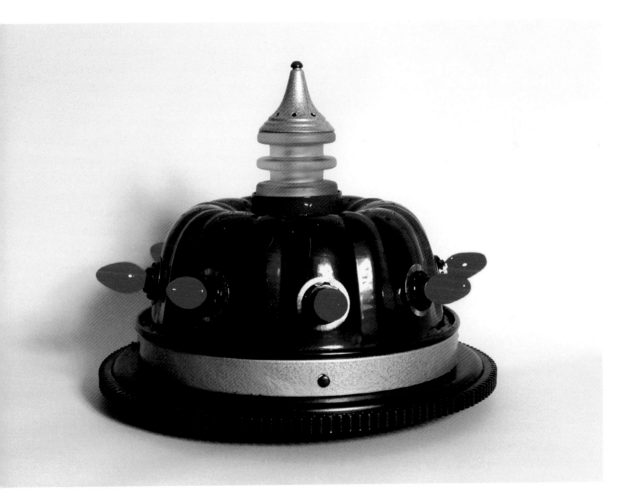

Bundt Light
2004, 13 × 13 × 10 in., powder-coated steel, glass, paint, lights

Red Sky in Morning
2006, 26 × 17 × 8 in., galvanized steel,
acrylic paint, and lights

the work becomes a coherent visual form with a red half circle emerging like a sunrise.

Jenssen's art materials are plentiful in a throwaway society and, in their very nature, suggest her concern for the environment. "My bigger pieces are a little denser, some with sharp edges, and they are a little harder, a little more ominous than my smaller pieces," she says. "They suggest a little apprehension about how we're all doing here on our planet. I am interested in the big picture, the whole world, and how that translates into what we do to the earth, because destruction is happening everywhere. Many of my pieces allude, albeit obliquely, to problems we are facing here on earth regarding pollution, overpopulation,

war, and the like." In one of her more strident pieces, *Pierced Armor*, Jenssen forms a wall sconce that looks like a shield with arrows sticking through in extensions tipped with red holiday lights. The lights are complemented by the softer yellow light coming from behind the grilled center of the shield.

In 1981 Jenssen ventured on a raft trip down the Rio Grande, arriving in the Big Bend National Park just as the sun was rising and the skies were bleeding their pinks, oranges, yellows, and blues onto geological formations that reflected the light. Rafting through Santa Elena Canyon, she was in awe of the sheer limestone cliffs cut by the river over time. Finally, after several years of regular visits to Big Bend from her home in Houston, she bought property overlooking the ghost town of Terlingua, Texas, and found work there as a river raft guide. Jenssen is a New England native who grew up near an abundance of lakes, ponds, and streams, and sailing was always part of her life. "Home was fairly rural," she comments, "but not isolated in the way Big Bend is."

In her metal works she captures the luminosity and textures that project the light and shadow of the desert. "I am forever amazed at how things look—the light is magnificent here," she says. She also acknowledges that the stark landscape inspires her to create complexity. "I think that my work is something of a visual antidote for the desert and its starkness," she observes.

Jenssen is comfortable in many art media. She first moved south in 1975, accepting a scholarship to the Alfred C. Glassell School

54

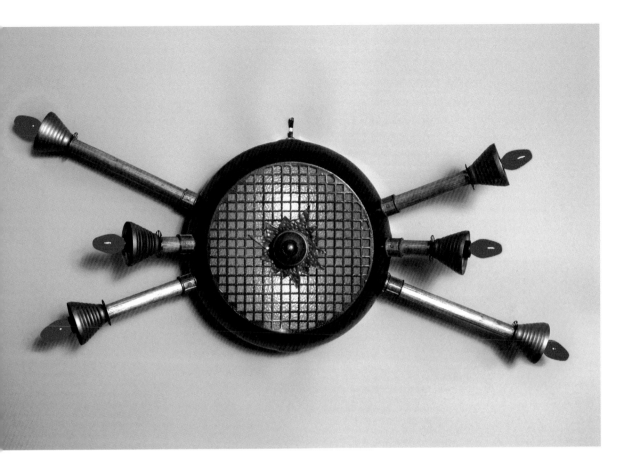

of Art in Houston, where she studied jewelry making and ceramics. Before focusing on metal constructions, she moved to Taos, New Mexico, and created a line of whimsical plastic jewelry that she sold nationwide until 1991. In Terlingua, Jenssen has used old mining objects that pose questions about land use, labor issues, and immigration. "I wanted to explore the mining, the nastiness of it, and the hard lives that the miners lived in Terlingua," Jenssen says. In one of her works she created

a large altar to a dead miner. "So many miners died here, and I felt that those unnamed men deserved remembering."

Jenssen, who has since moved to San Antonio, Texas, leaves behind distinctive public art in Terlingua. On the roof of the Diva Terlingua gallery, which Jenssen built in 1997 and ran until 2004 as Jenssen Gallery, is a sculpture titled *Can We Go Now?* Standing six feet tall, the work looks like an alien spaceship about to lift off. The work incorporates lights and a

Pierced Armor
2003, 35 × 17 × 9 in., steel, acrylic paint, copper, lights

top section that rotates. A landmark in the tiny village, the sculpture offers a glimpse of the community spirit she shares with fellow Big Bend lovers, who all understand the sensation of living on the face of the moon.

Jenssen brings the drama of the desert—its light, textures, and history—into her sculptural pieces as strong reminders of place. The light of each piece moves, like the clouds and sky that reflect the desert landscape. Her sculptures are like huge night lights, each one guiding us after the sun sets.

Jenssen's early artistic mentor, Eleanor Duby, a graduate of Yale University who taught Jenssen at the University of Massachusetts in Amherst, has had a long-lasting influence on Jenssen's artistic development. Duby helped her formulate a general sense for the kind of hard preliminary work an artist must do to create a finished piece. "She was a fascinating woman with tons of energy; she was young; and she had a very open kind of idea about what art was and how it was created," Jenssen recalls. "Her definition of drawing was any-

thing you did in preparation for a painting or a sculpture, whether it was a collage or even a small maquette. Drawing was preparation for making the bigger piece. Drawing was exercising, like musicians practice their scales." Jenssen's love for drawing comes through in the architectural details of her mirrors, where she repeats her use of galvanized steel and copper and creates details and patterns of shapes and forms through punched holes and rivets, giving each piece a distinctive geometry.

The control that results in Jenssen's work is a combination of her ability to conceptualize the specifics of a drawing, to incorporate disparate, seemingly incompatible parts, and to engineer her way through technical challenges. The work emerges through the creative process and is not always premeditated, but the forms come to Jenssen as she constructs, deconstructs, and instructs herself in solving aesthetic problems. In her illuminated metal works, Jenssen celebrates light and gives structure to shadows. K D H

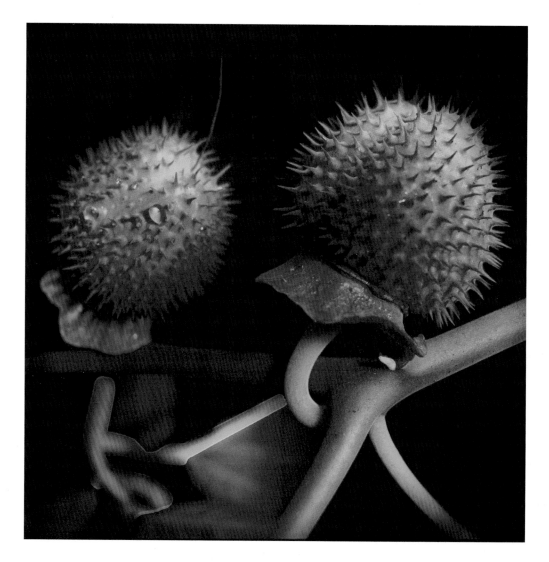

"Arteriole Barb"
2006, 24 × 24 in., Lambda prints face mounted on Plexiglass or inkjet prints

The Art of

ROBIN DRU
GERMANY

———

Art photographer Robin Dru Germany focuses on natural flora for shapes that suggest the essential forms of life, creating photographs saturated in color to ponder reality from multiple viewpoints. She explores the act of seeing through images that look like laparoscopic views of veins and arteries as a magnified perspective of internal anatomy, adding insight into cells, viruses, and biology. Her photographs reveal hidden patterns of plant materials or strange intersections of life lines in plant and animal alike. The images look like plants and planets, sea urchins and veins.

Germany captures the perspective of microscopy and the outer cosmos at once, creating a complex phantasmagoria.

In her abstract nature photographs Germany controls and changes what she sees to create alternative realities using studio

photography with a colorful combination of gels, careful lighting, and digital manipulation. Her work is more spontaneous than that description would imply, however. Sometimes she seeks surprises in the night by taking photographs in the dark with a flash, without controlling the focus. "I always have set up things, to collage, arrange, and control," Germany says. "So, going out into the woods and making pictures when I can't see what I am shooting and can't know what is going to happen really has been a nice way to counter that control with complete lack of control. I've gotten a lot of great surprises."

Using a twin-lens reflex Mamiya C3 camera and varying focal lengths and depth of field, she experiments with technique, color, and form. From large and realistic images of seeds, blooms, branches, and leaves of plants she creates images that resemble slides showing cellular anatomy. Having collected and studied human anatomy books for years, Germany adds meaningful color to the plant parts, making them look like anatomical structures. "I love looking at human anatomy illustrations," Germany says. "I decided I would start coloring these images in such a way that they started to look like veins and arteries, with darkness around the edges. I created a sense of looking into a space. Actual laparoscopies are a lot flatter than my photographs."

Germany creates an optical effect that is like modern-day animation with features that seem unreal yet vividly alive. In "Arteriole Barb," neon blue vines intertwine with the thicker arteries of fluorescent orange burrs. The sharp projections and patterns of the plants are distinctive close-ups. In her work she often darkens the background to shadows that form a central, circular frame. The formation in "Carbuncular Brush" resembles a drop of water just hitting a surface. In hues of purple, blue, and brown, Germany shoots with a limited depth of field, blurring the background and focusing on minute details within the lighter circle. The image is a study in abstract form and color. In "Rotating Sensor" she highlights the tips of the pink needles of a plant in blood red with the tips imparting a vibrant energy that bursts from the blue neon background.

Germany's current work about the natural world is a departure for her. She admits she has never really connected with traditional nature photography. "To me the nature photo never looks the way that the experience of nature feels. In my current work," she explains, "I am thinking about the idea that the same blood that flows through us is the fluid that flows through nature. I have been thinking about those connections, which probably comes from having had a child and thinking more about connections between people, about nurturing each other, and that whole process."

In several earlier bodies of work, Germany examines what being a female means in our society. "I think it's just very interesting to me how being a woman is still an issue in teaching and in art," she says. "I continue nurturing my exploration of feminist literature and trying to understand how that fits into my work. I also realize that exploring the roles of both women and men, not just women, is important for having a balance."

"Carbuncular Brush"
2006, 24 × 24 in., Lambda prints face
mounted on Plexiglass or inkjet prints

"Rotating Sensor"
2006, 24 × 24 in., Lambda prints face
mounted on Plexiglass or inkjet prints

"Enlarged Nodules"
2006, 24 × 24 in., Lambda prints face mounted on Plexiglass or inkjet prints

"Metastatic System"
2006, 24 × 24 in., Lambda prints face mounted on Plexiglass or inkjet prints

In one series of her incongruous combinations, however, Germany concentrates on women and disease at the elemental level, with seeds and veins creating patterns and aberrations to the patterns that suggest deep physical problems. In "Enlarged Nodules," Germany exposes small masses of rounded seeds protruding from the shells of mesquite tree beans. The long and tubular veins crawl throughout the composition, like a mess of cellular highways. In "Metastatic System" blue veins spread out like a spider's web that crawls behind and around the spherical form of a luminous pale lavender dandelion in bloom, invading the bloom in random and aggressive order.

Pondering the idea of looking inside the body at a magnified area, Germany sometimes uses a bit of soft focus to emphasize the big and detailed veins and intersections of the arteries to suggest injured tissue. At other times a photograph may suggest fungi or microorganisms that live within the surface of the earth, the burying ground for the substance of the human body. In "Ameboid Seed," Germany explores the idea of plants and plant matter as abstractions that could be either viruses or electrons seen through a microscope. Small propagating seeds also seem to be tiny organisms floating in and out of the visual space, with the highlights revealing veins or branches of a cell.

Germany often contemplates her first serious photograph, which she took in junior high school. "I remember being with my friends at a county park near an old bathroom with a broken window," she describes. "I asked my friend to go inside the bathroom and stick her hand out through the window. There was a reflection in the window, and you can see her hand, just sort of unattached, sticking out. Now, looking back, I realize that I always have liked manipulating the space when I take pictures. I have to stick something in there, change something, or manipulate something—that's really set the tone for my work all along." Growing up in Friendswood, Texas, near Houston, Germany was greatly influenced by her parents. Germany's parents both are photographers, and her father had a darkroom in their home where he created black-and-white images. Her father is a chemical engineer, and her mother is a poet and writer.

Germany's artistic vision is also influenced by philosophy and science. In college she studied philosophy, graduating in 1980 from Tulane University in New Orleans. Through philosophy she made some homage to the sciences and engineering she originally planned to study. "Philosophy joins my latent desire to be creative with my need to feel like I have some kind of logical control," Germany says. Attracted to the science-logic edge of the field, as well as its requirement for creative thinking, Germany has been influenced by the French existentialist Maurice Merleau-Ponty and his use of the onion as a metaphor for experience. "Merleau-Ponty wrote a lot about painters and about the relationship between the way we perceive, the way we see, and how that affects our thought processes and our experiences. He really analyzes our senses and how our senses contribute to who we are," Germany explains. "I am intrigued with the

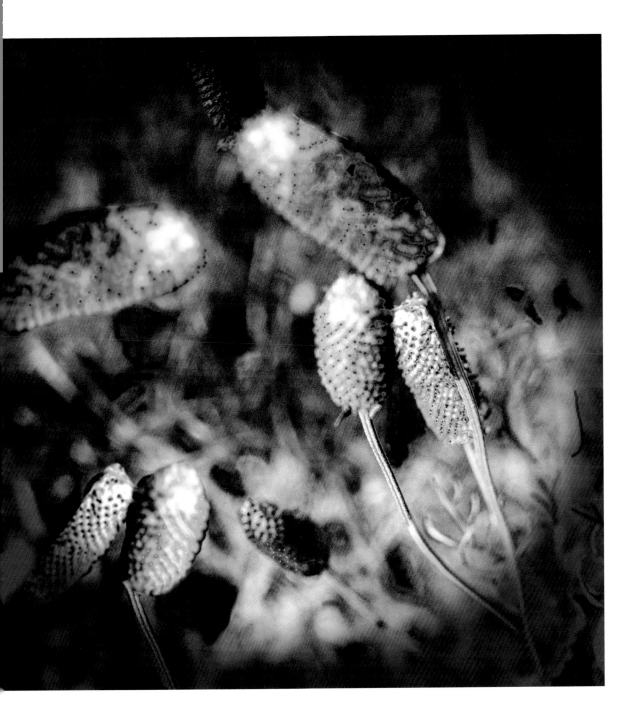

"Ameboid Seed"
2006, 24 × 24 in., Lambda prints face mounted on Plexiglass or inkjet prints

way he breaks down the process of looking at a piece of art or looking at the world according to how we see and experience those things."

One of her teaching assistants at Tulane, Jan White, was a printmaker and photographer who taught Germany about photography and let her use her studio. "She was a very nurturing and wonderful woman. In some cursory way, she said to me, 'You know, you're pretty good at this. You should consider getting an MFA.' In my philosophy program at Tulane's Sophie Newcomb College, the all-women's college where I was an honors student in philosophy, no one ever said, 'You know, you should think about graduate school.' I guess they figured I was going to get married. So the only person who bothered to give me any mentoring was this graduate student who suggested I get a master's of fine arts degree. It was totally an accident that I studied photography," Germany explains.

In 1996 she earned her master's degree at the University of North Texas in Denton and moved to Lubbock, where she accepted a faculty position in photography with the Texas Tech University College of Visual and Performing Arts. Germany lives near Yellowhouse Canyon in an old storefront, formerly the Guest Drug Store, on the city square in Slaton, Texas, with her husband, Jim, a documentary filmmaker, her daughter, Aurora, and her blond Labrador, Runner.

The Llano Estacado caprock has expanded Germany's appreciation of nature as she reflects upon the woods and beaches of her childhood near the Gulf Coast of Texas. Germany grew up close to nature. When she

was six years old, her parents bought a piece of heavily wooded land on Chigger Creek near Friendswood. "My mother made a little, tiny hole in the woods and dropped a house there and let the woods grow back over it. So I grew up in a house completely surrounded by dense woods, having spent the first years of my life in the city. It was a challenge for us . . . to move out to the middle of the country."

Germany believes that where a person lives affects everything he or she does. "You cannot separate the things that happen from the places where they happen," she insists. The flatness of the Llano Estacado offers her the chance to assess what she finds important. "In a way, being in Lubbock has made me think more about what I value in nature and why," Germany says. "That ties directly into the work I'm doing now."

In all of her projects, Germany presents visuals that make sense on many levels at once, sometimes in contradictions and other times in collaborations, like Merleau-Ponty's onion. "My sense is that once I understand something about what I am doing, it is time to move on, to make it more complex, and to take it to another level," Germany says. Aiming for an immediate response of recognition in her work, then a latent sense of the complexity of meaning, Germany explains: "I hope that from experiencing my work, people will think about the fact that everything and everyone is multi-layered and that you do have to look a second time, or ask questions, or think about pretty much everything in your life to really understand it on more than one superficial level."

66

In her photographic images, combining
natural objects together in harmonious ar-
rangements that evoke the elemental stuff of
life, Germany encourages a new way of seeing
and being. Her art is like a carnival ride into
tunnels of bright colors and shapes that simul-
taneously look like two divergent elements—
vine and vein, plant and neuron, earth and
body. K D H

Fantasy
2006, 35 × 32 in., linocut

The Art of

FUTURE AKINS

———

Future Akins celebrates the passing of time and the journey of aging in autobiographical narratives that chronicle her transition from youth to middle age. She creates Haitian-inspired, hanging textile self-portraits in sequins and beads, cloth books, and linocut prints. Through her art she shares the stories of her relationships, honoring the women in her life. Her works are personal messages of the heart. "My work is about the seasons, death, life, and work. My art is about interpersonal relationships and sometimes relationships to a place," Akins says. "Relationships become art. Life becomes art. Time becomes art."

In her sketchbook she draws images that lead to finished textile works through a process that equals an endurance marathon. Her textile art is tedious, time-consuming, and unforgiving, requiring an exactness of thread, beads, sequins, and cloth. In her black-and-white linocut prints with hand coloring, Akins

creates bold and dynamic statements on life's passages. In her printmaking, Akins relishes the whole process, from initial concept to drawing to cutting to printing the linocuts.

Akins took up printmaking after she became a widow at the age of twenty-three. Her husband, Hank, died when a drunk driver hit the motorcycle he was riding. "My world was turned upside down," she recalls. "My life was marked from that moment on, because I knew that life was precious. At my core, I learned that we do not have time. We have the now. Life is unpredictable. My art is a journey to celebrate the moment, whatever the moment may be."

The grief and sadness from the death of her husband motivated Akins to dedicate her days to making art, and her sensitivity to the fleeting nature of time has inspired a series of linocut self-portraits capturing the phases of her life and exploring honest aging. The series visually interprets her transition from innocent and hopeful college student to defiant and disappointed young woman to confident adult with graying hair and calm face reflecting adaptation and survival. In the linocut *Fantasy*, Akins celebrates independence and strength of spirit. With wrinkles on a confident face and aging legs exposed under denim shorts, the figure projects inner strength and comfort with the here and now.

Some of Akins's multimedia work incorporates printmaking with sewing. In *Bob's Book*, covered with black lace, shells, beads, and ornate cloth, she prints images on handmade paper to show life's small blessings,

including cats, small mice, falling leaves, and empty boxes. In some of her cloth and beaded books Akins also creates tactile pieces that evoke memories of her family and other relationships. In one book she creates pages made with cloth used by family members, including an old tea towel, a cocktail napkin from her mother and father's courting days, a tablecloth from Guatemala, a bandana and a tie-dyed hippie top, and her father's Pendleton shirt with cigar burns. In another book, created in black-and-white with beads forming images, Akins focuses on fixed love patterns that trap people; she explains that it is "about letting go of those archetypes and instead of falling in love with a type, to look at the person."

Akins realizes that her sewing art is a tribute to the women in her family who sewed and took pride in their lace and embroidery flourishes. Akins began working on the textile pieces soon after her mother died and her father suffered a stroke. She cared for her father for more than eight years. "I actually started doing my beadwork because my dad wanted to be able to see me. If I was in another room, he got a little frightened. He watched me work for hours and throughout the years, and finally one day, he said, 'I never knew art was so much work,'" Akins laughs. "We had these great conversations because we were stuck with each other, and that was a great new journey. I always will be grateful for those years. I learned about courage and honesty. My dad said 'thank you' every day for every meal and told me once a day how he did not know

70

Bob's Book
2006, 35 × 32 in., linocut with mixed media

Wanda May
2006, 35 × 32 in., linocut

how he would survive without me. The time together was an incredible blessing."

Akins's father was a highly decorated fighter and reconnaissance pilot, squadron commander, lieutenant colonel, and base commander with the U.S. Army Air Corps and, subsequently, the U.S. Air Force. Being in a military family, Akins traveled throughout the world, finally moving to Lubbock, Texas, in 1967. Early in life she discovered that everyone did not look and sound like her. "The world was filled with exotic smells, foods, and colors. We didn't know where we would go next; who we would meet next; or where they had come from. My childhood was a great educational adventure," she says.

One of her best memories comes from living in Blytheville, Arkansas. "This is such an American story. I would come home from school and get a TV dinner and get my paint-by-numbers set and turn on the *Mickey Mouse Club* and *American Bandstand,*" she reminisces. Akins's mother provided abundant art tools, but when she was young Akins never imagined that women could be professional artists. After she entered the world of art, Akins's mother and her mother's sister, Aunt Future, inspired her. "They were two beautiful women. My mom was naturally gorgeous. My aunt was a knock-out beauty," Akins says. "Aunt Future was six feet tall and wore four- to six-inch heels. She literally would stop traffic on Fifth Avenue. My Aunt Future would fly in from wherever she lived. She always was studying acting, so she would make us pretend to be leaves falling out of a tree. By the time I hit graduate school and was studying art, I

was a feminist, with both of them as my role models. Being a feminist to me means that I can do what I want to do. So, if I want to do lace, I do lace."

Portraying her Aunt Future with her given name in *Wanda May*, Akins explores the death of her aunt from breast cancer. In the print her aunt, vulnerable in her two-piece bathing suit, wears the pink ribbon of the fight against breast cancer. The work celebrates a glamorous and modellike figure as she adjusts her swim wear. She is middle-aged and too young to die. Some of Akins's other works include images of scars from breast surgery on her fe-male figures in light pinks, blues, and oranges to indicate femininity. "My work is extremely feminine and very seductive. I seduce people with my art. If you want to know who I am and how I am, look at my art."

The loss of her mother and her aunt confirmed, once again, the precious nature of time, and Akins now spends her days making art that requires weeks to complete. "It was a great sadness because my mother could never deal with time," Akins says. "My Aunt Future escaped time by pretending it did not exist. The hard part was to see the pain underneath that beauty. My mother and Aunt Future could not

Hiding Within
2004, 29 × 29 in., beads and sequins

see that they never stopped being beautiful just because they no longer were young. It saddens me how society treats women as they age."

The idea for textile wall hangings, made in sequins and beads, emerged when her Aunt Future, who stayed in Port-au-Prince for a while, introduced her to Haitian voodoo flags, traditional praying cloths, in elaborate designs of sequins and beads, that depict African spirits. Akins has adapted this sacred textile tradition to her own sense of self and place. In the wall hanging *Hiding Within,* Akins creates a landscape and self-portrait. Tree trunks and branches reach vertically to the top and bottom of the cloth in soft and shimmering green tones, while a gray-haired woman peers over

her shoulder in the foreground. The woman has serene blue eyes and a flower tattoo on her shoulder. She is drawn in strong, simple lines reminiscent of Akins's linocut prints. In many of her wall hangings, Akins uses natural wood branches to hang the textile art from the wall. The twisted and intertwined curves of the wood secure the works in the tangle of a rugged landscape and add an earthy contrast to the luminescence of the beaded art.

In *Dreaming Turquoise* Akins creates a scene of New Mexico, a place where she once lived and which she still dreams about. The turquoise female figure lies on her side, her nudity reflecting the formations of the purple mountains in the distance. "Turquoise to me

Dreaming Turquoise
2003, 20 × 26 in., beads and sequins

is always New Mexico and Arizona. I try to find the blue of the Taos sky or the red of the Rio Grande Gorge or the amber of a leaf in fall." In a bold tribute to the visual traditions of the Southwest, Akins also has created a textile still life, titled *Burning Heart,* of a prickly pear cactus. Shaped like a heart and made of purple sequins with long, white beads forming cactus spines, this textile piece is simple and vibrant. A fire glows at the base of the heart in the hot colors of passion.

The heart is a recurring image in Akins's work and a fitting symbol for an artist committed to visual commentary on human relationships and the sharing of feelings through art

as meditation. "I don't know how not to do art. I cannot imagine a life not doing art," Akins says. "I always have done art in one form or another. It's my sanctuary; it's my challenge; it's everything; it's how I relate to the world. When I cannot understand something emotionally, I use art as a translator. I communicate with and relate to people through my art."

In revealing herself, Future Akins creates art that requires intensity, concentration, and patience, celebrating the moment, whatever the moment may be. Through her works Akins insists the essence of life comes with relationships and time—gifts to be held dearly and never taken for granted. K D H

Burning Heart
2007, 14 × 12 in., beads and sequins

Spring Cactus
2003, 17 × 23 in., watercolor

NINE

The Art of

MARY SOLOMON

———

Exploring the wide vistas and intimate details of the West Texas canyonlands where she lives, Mary Solomon offers the viewer a treasure of discreet images for study and discovery. Her work is focused and clear, recalling the themes of Georgia O'Keeffe and what that one-time canyonland resident once said: "Still—in a way—nobody sees a flower—really—it is so small—we haven't time—and to see takes time, like to have a friend takes time." Solomon takes the time to see the land, to study the bloom, to ponder the sky.

In her studies of the environment, Solomon finds inspiration in every vista, plant, and animal, concentrating her artistic energies on broad views of layered canyon walls and close-ups of flowers in bloom. She uses vivid colors to create images in watercolors, oils, pastels, and colored pencils. In her paintings of the walls of Palo Duro Canyon, she often includes imaginings of wise old Native

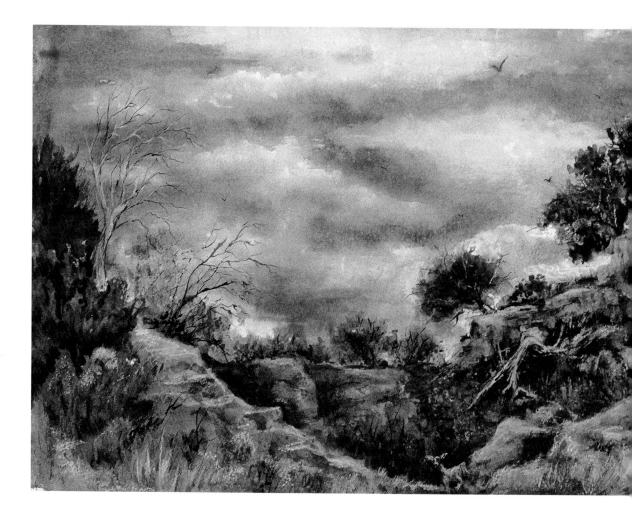

American faces. In her examination of the details of the canyons, she paints prickly pear cacti, cottonwoods, wildflowers, and juniper trees.

Since she discovered the infinite variety in the geometry of junipers, Solomon paints or draws the tree in nearly all of her compositions. Sculpted by wind and age in the canyonlands, these trees are tributes to perseverance.

Each tells a story as the wood moves, branches twist and turn, and scars mark fires and floods. The junipers have adapted over the centuries to this ancient, hardscrabble land. Solomon is intrigued by the raw statement of the twisted tree, thriving despite the traumas of nature. "How I wish I knew their stories. They have seen so much, and they are so very strong," she says. "Even after a fire here . . .

Deer Path
2005, 10 × 25 in., watercolor

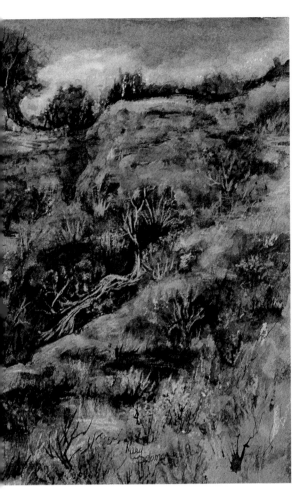

into the gullies filled with tall cottonwoods where wild turkeys roost. In her gardens she nurtures flowers that she attempts to protect from the deer. In the watercolor *Deer Path,* Solomon portrays a scene she finds herself blessed with daily—the sight of deer in the canyons. "Every time I look out my back door, I see this beautiful scene," she smiles. In the painting, the sky and land share a visual yin-yang relationship, each claiming a half of the composition. The sky is a deep sea blue, and the clouds add complexity to the unbroken, vast space of the horizon. Junipers and other plants hang on to the sandy rocks, held into the nooks and crannies by tenacious roots. Hints of wildflowers grow among dead wood. The canyon walls are covered in grasses, and at the intersection of the two walls of the canyon a single deer looks back at the viewer, providing just a hint of the abundant wildlife thriving in this environment.

Once a year Solomon makes time for a pilgrimage to see individual rose-colored cactus blooms that emerge only for one day in early May. "They want to be seen," she says. In the watercolor *Spring Cactus* she paints the dominant and vivid magenta blooms of a cholla cactus surrounded by the yellow blooms of the prickly pear, with some only on the verge of opening. Her blues form shadows; her greens highlight prickly pear spines; her yellows move from lemon to gold. The cactus, in great detail, hides behind juniper driftwood. Mesquite branches in the background are awash in the colors of the soft pink and yellow sky.

Finding interest even in discards, Solomon concentrates on details that celebrate

years ago, many of them survived with half of their existence scorched away. The ones that looked completely dead grew new trees.

Solomon lives in Palo Duro Canyon's nearby Lake Tanglewood, a small community near Canyon, Texas. Her stucco and red-tiled home is surrounded by rugged land. She hikes up a rocky path to a favorite spot atop the canyon ridge to see the sunrise and sunset or down

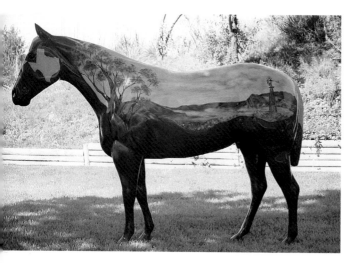

On Golden Panhandle
2002, 5½ × 7 ft., fiberglass, acrylic

beauty at the end of the growing season in a still life, *Nature's Remnants,* a composition of winter's throwaways. The piece shows motion in its driftwood, limestone rock, and Virginia creeper. Capturing the fall colors, she intermixes prickly pears with thick clumps of grass in the composition. The dirt in the foreground is the color of worn leather. As one views the piece, the knots, curves, and marks of time in the wood become more abstract, in contrast to a pheasant that emerges from the top of the twisted juniper branches.

Whether working in watercolors, pastels, oils, or acrylics, Solomon layers colors and images and begins with an overall idea of a composition that becomes a rough sketch. "My pieces are not fully planned," she says, "rather, serendipity happens, and wonderful and unexpected surprises emerge."

A group gathered to view Solomon's progress during the summer she opened Solomon Galleries in Amarillo, Texas. The mural on the wall outside her studio was a celebration of the fruition of a lifelong dream for Solomon and her husband, welding artist Walter Solomon. Curious admirers studied the mural, trying to find additions of wildlife, some obvious, others requiring intense study to reveal. Solomon's goal was to create a celebratory work, and her viewers' comments were enough to make her smile. "I hope people leave my gallery after seeing my work with an enthusiasm for art and what art does for us as individuals and as a society," she says. "I do art so that others can see. I want others to see the beauty everywhere in this world of turmoil. God has given us a beautiful place to mess up."

In Amarillo, Solomon has become popular painting life-size, prefabricated American quarter horse statues as part of a public arts project throughout the city. One of Solomon's favorite horse paintings shows scenes of Palo Duro Canyon and the Texas Panhandle on the sides and legs of the horse. From a desire to express the beauty of the region, Solomon chose yellow for the skies, because Amarillo is the Spanish word for "yellow." She painted a typical West Texas evening sky, choosing a very dark purple for the background on the rest of the horse. "I wanted the legs of the horse to form trees," Solomon explains. "On one side of the horse I painted Palo Duro Canyon with a juniper tree, of course, as the front leg. On the other side . . . I painted a typical ranchland scene here in West Texas, with a cottonwood tree forming the back leg."

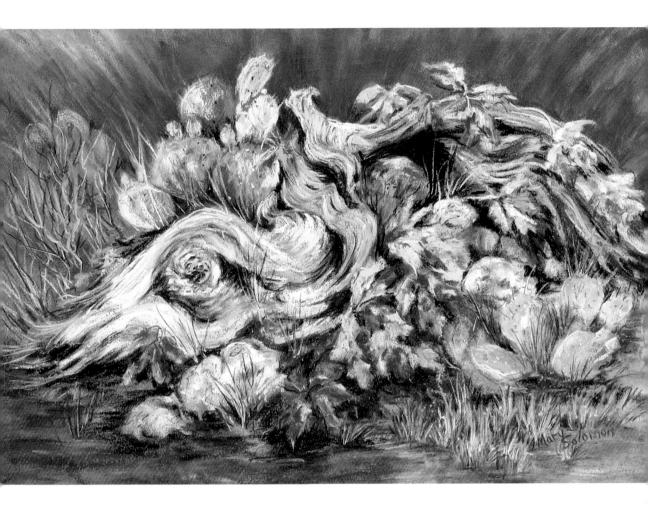

Solomon's family moved to Amarillo when she was in the sixth grade. When they arrived, Amarillo was much smaller, and Solomon remembers spending most of her time outdoors with her older brother exploring the surroundings. She always has liked to traipse through the countryside, a time-honored recreation for those without much money. "I liked to explore. . . . Even as a child, I always walked along little creeks," she says. Solomon attended early grades in public schools in Arkansas, New Mexico, Oklahoma, and Texas. As a very young child she lived in Arkansas, where her father farmed. She remembers the family was poor but happy, even though they lived with no indoor bathroom. Later, Solomon's father worked for the Santa Fe Railroad, and the family moved often. While living in New Mexico,

Nature's Remnants
2004, 13 × 19 in., pastel

MARY SOLOMON

Canyon Magic ABOVE
2007, 18 × 24 in., oil

Many Faces of Palo Duro BELOW
2007, 18 × 24 in., watercolor

they spent weekends traveling to the mountains and exploring Native American ruins.

Instrumental in developing her early interest in art, her family gave her crayons and art supplies as Christmas gifts. They recognized her talent, and her art materials were her childhood toys. She created collages from magazine images and was interested in fashion. Her mother nurtured the artistry in her sewing, which, for Solomon, was one of many ways to express her creativity. Although she never visited art galleries or museums as a child, she nevertheless always appreciated people who could draw. "My family made me feel special when I would draw," she recalls.

Despite ongoing support from her parents, husband, and two daughters, she says she had to resist warnings early in her career that art would not support her financially. She was aware of what seemed to her to be restrictive conventions from artists who were formally trained. At first, she confesses she was too insecure to follow her own instincts, but then she began experimenting. "I would ask myself, Why do rules exist in art, and who sets rules for art anyway? I thought art was a personal expression. How can a method be wrong if it is your creation?"

Self-taught, Solomon has drawn and painted throughout her life, and now in her sixties she is confident and feels worthy as an artist. "I feel blessed and happy, and you see that in my art," she says. "My lack of education in the art field left me a little intimidated, but as I continue I have learned that we all have our specialties. I like to teach others to see in ordinary and extraordinary ways. I love to be

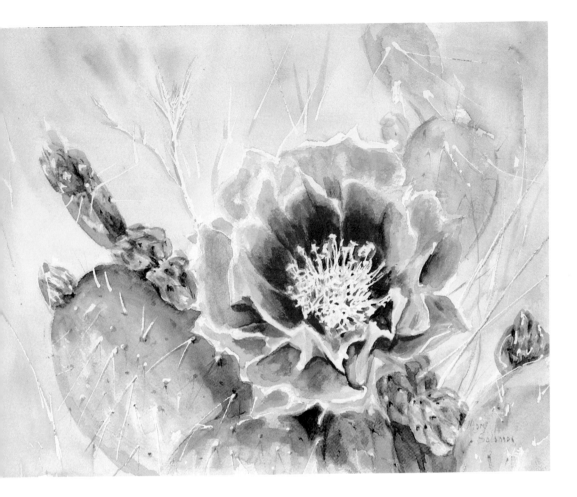

able to point out unseen colors, the purples, the blues amongst the yellows, and the other colors people do not immediately see."

Having spent most of her life living in Palo Duro Canyon, Solomon, like other locals, recognizes rock formations that reveal unique images. Solomon paints rock-formation images within the deep red walls in *Canyon Magic*. With a tall juniper in the foreground, the painting lures the viewer into a deep and purple canyon in the background, revealing two faces. One figure is a male, lying under the tree, looking up, seemingly resting in the shade; the other figure is a woman in repose, facing the viewer with closed eyes. The scene is calming, a restful landscape of juniper, the red rock of canyon walls, and shady places down the path. "I am amazed at all the images I see in my imagination in the canyons when I am painting," Solomon says. "I see many

Prickly Pear Cactus Bloom
2006, 16"×20", watercolor

M A R Y S O L O M O N

Palo Duro Sky
2007, 18 × 24 in., oil

Native American figures, and I wonder what their stories are." With some Cherokee in her family ancestry, Solomon identifies with the land's first inhabitants.

Solomon visits the rock cabins built during the Depression in Palo Duro Canyon State Park by the Works Progress Administration. The place was a favorite spot for Georgia O'Keeffe, who painted the canyons when she taught art at West Texas State University in Canyon. Solomon admires O'Keeffe because she worked during a time when professional women artists were virtually unknown. "O'Keeffe actually received recognition for her art before she died." Solomon notes. "I think she was pretty tough. She was very opinionated, and she wanted things her own way. She was fairly critical of her own work." Solomon has painted a watercolor of the site while imagining her favorite artist doing the same. "The site is such a beautiful area of the canyon, and the shelters intrigue me," she says. "If not for the early developers of Palo Duro, I probably would not have been able to enjoy this beautiful land I love."

Many of Solomon's watercolors border on the abstract, and study reveals faces in the rocks, soils, and layers of the canyons. In *Many Faces of Palo Duro* she captures the vertical skirts of the canyons, channels where rainwater runs off the mesas and hills and down to the low spots, the empty creek beds that feed into the Prairie Dog Fork of the Red River. Solomon often allows colors to dominate her works. "There is so much brown in brown. There is so much purple in the canyon walls," she says. "The colors in Palo Duro

84

Canyon are vivid. The cliffs change in color throughout the day with the varying light on them in the early mornings and evenings."

In West Texas the sky always offers a colorful show with the beginning and ending of every day. In the distance of *Palo Duro Sky* a flat horizon shows the drama of the land above the canyon in deep blue and purple. In the clouds a storm is approaching, the dark skies warning of the weather to come. The sun disappears and rain threatens in the distance. On each side of the painting the canyon walls display geological time in marks of erosion and various colored layers, showing episodic changes in the environment. Vegetation clings to the edges of the slanting soil, establishing itself in the nooks and crannies of the rocky plateaus. Yellow wildflowers announce the season to be summer.

In another summer scene, Solomon focuses on a single cactus bloom in the height of emergence. With no background interference, *Prickly Pear Cactus Bloom* is characterized by

tones of reds that change to yellows, golds, and oranges. Capturing different phases of blooming, Solomon also displays the wrinkled, closed buds beyond their prime.

Solomon hopes to engage the viewer in the composition, colors, and subject matter of her paintings and pastels. She welcomes the viewer into her personal world as she reveals the visual secrets of her environment through shapes and colors easily overlooked by the less attentive. Her artistic spirit is unwavering. "Art is not something you just turn on or turn off. You are either inspired or not. You want art to be something you have passion about," she says. "I wish I had time to paint everything I see. When I see the beauty that nature provides, I cannot wait to paint it. I want to do nature justice."

Solomon reminds us that even in the boneyard of old, dead junipers on the hardscrabble land around her, hope still lives in nature, and wisdom still comes from respecting the past.
K D H

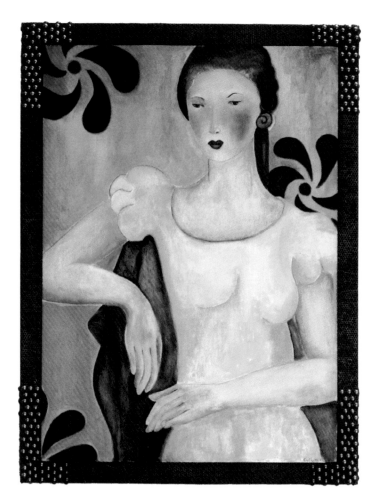

Belinda
2003, 32 × 24 in., oil on canvas, artist-made steel frame

The Art of
LINDA CULLUM

I

n melancholy paintings and narrative sculptures, Linda Cullum creates art that elucidates the territories of relationships, solitude, and domesticity. Cullum captures in still life and portraiture a freeze-frame of one image, one emotion at a time, in calm, serene, and gentle compositions. She also creates stark steel sculptures that are void of people and dark in humor. Her domestic scenes are nostalgic and political. She combines pleasing female subjects and symbols with the visual muscularity of welded frames to create powerful sculptural statements.

More than just an expression on a face, Cullum's female portraits are narratives of solitude. Often, the women have no names, but all of the women's faces have looks of reflection and melancholy. In some of the works the women have elongated necks. "I am melancholy, and that is reflected in my work. I am very tall and long, and I like tall and stretched out women in my art," she says. "I think no

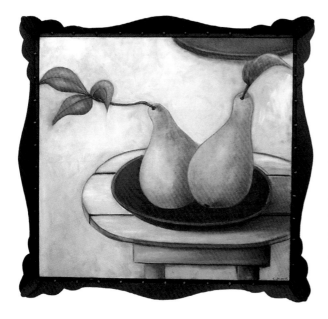

the female body, reminding her of Fernando Botero's women. "The pears bring to mind robust women full of life, round and sensual," she explains. "I do pears; I'm not sure why, but I love to paint them." In *Pears on a Blue Table* the fresh yellow fruit sits on a red plate atop a weathered blue oblong and disproportionate wooden table. The pears still have their leaves. The awkward proportions of the curvaceous fruit with a red plate in the background give the piece a visual energy that is repeated in the undulations of the metal frame. The work is soothing, calm, and serene, a celebration of solitude. In one of her architectural sculptures, *Everything's Coming Up Roses,* Cullum again uses a small table to evoke solitude. The detailed metalwork of the climbing vines and flowers is complemented by the bold column and the curves of the table legs.

matter what we are doing, we all are making self-portraits that may or may not portray our own emotions," In *Belinda,* a curvaceous woman in a yellow dress sits in a dignified, formal pose. The floral background adds to the motion of the painting, as the curved lines move throughout the composition. The woman's facial expression is pleasant. She seems calm and unburdened. Cullum's work is subtle and understated, a visual fact without judgment. What the viewer sees is what the viewer gets. Using muted and serene colors, especially yellows and blues, she studies women and pears as investigations of quiet isolation and unimposing tenderness.

Paintings of solitary women by Modigliani, Frida Kahlo, Picasso, Matisse, Cezanne, and Van Gogh have had a great influence on Cullum. Her pear paintings echo the shapes of

Although she has used models, such as her aunt or niece, to paint her images, most of Cullum's serene women come from her imagination. Sometimes she paints the women in full-length pose and sometimes only the face. "So many of my women are kind of sad, and they never smile, at least not yet," says Cullum. "Some of them are sadder than others."

Cullum appreciates the sadness of Frida Kahlo and her figurative language. "I love Mexican culture and Latin American authors and their imagery, such as the butterfly. I like the book *One Hundred Years of Solitude* and that sort of perception, like the time that insomnia comes into town on a donkey," she opines. "Frida Kahlo's work is like that to me. It's so funny, but it's so sad." Cullum's women sometimes have hummingbirds or butterflies

Pears on a Blue Table
2005, 26 × 26 in., oil on canvas,
artist-made steel frame

Everything's Coming Up Roses
1995, 65 × 56 × 30 in., steel and mixed media

whispering in their ears. "The hummingbirds and butterflies are prophets and familiars, imparting wisdom and guiding us. We can tell them our secrets and desires," Cullum explains. Many of her paintings of women have a halo or aura around them, giving them a surreal quality and suggesting their connection with the universe.

In *The Prophet* a hummingbird flutters at a woman's ear. The focal point of the painting is the anatomy of the collarbone, which echoes the formations of a sandy beach in a tropical island scene behind the figure. The woman bears a halo. Her eyes are piercing and peaceful with well-groomed eyebrows and eyelashes. The portrait with its metal frame is a complex study in symmetry.

Cullum always finishes her canvases by welding artful, sculptural frames that she creates specifically for each work and presents as an elemental part of the visual experience. She explains that the cold, powerful solidity of steel helps freeze her art pieces in a moment of time, framing them in stillness. In *Lottie the Girl* the metal frame crosses the line between two and three dimensions. The picket fence extends from the painting out beyond the front of the frame, drawing the viewer into a theater scene. Cullum has painted tied-back purple curtains, like those in old movie theaters, to surround the young girl, who swings on a wooden seat with rope handles as if she were dropping onto a stage. The girl's pigtails and her fancy white dress suggest both tomboy and proper girl. Cullum paints a yellow halo behind her on a blue background. The top of the frame is structured like a child's

drawing of a window and the slanted and shingled rooftop of a house. In her bare feet with folded ankles, the girl is frozen in time, forever androgynous, on the cusp of puberty.

In her works Cullum often ponders the myths of womanhood, interpreting old stories and conventional attitudes with a dark twist. In her sculpture *All the King's Horses* she investigates the subject of motherhood and society's expectations for women. A swing is suspended from the ceiling and hangs inside a playpen that tightly restricts any playful motion. "The swing has nowhere to move, and the playpen has no room for a child," she says. The title of the piece refers to the nursery rhyme "Humpty-Dumpty" and suggests that conventional expectations of motherhood and domestic bliss are too narrow to nurture any woman or child.

Cullum also has explored the ways women are complicit in their own oppression by allowing themselves to be turned into objects. In a fabricated steel sculpture of a bedroom scene that includes a dresser and mirror with a beauty queen trophy surrounded by brush and comb, jewelry, perfume bottles, and other details of femininity, the reflection in the mirror of the beauty queen turns into a photograph of a woman without the frills. Cullum explains the significance of the scene: "We sit at the vanity looking at our reflection, brushing our hair, applying our makeup. Maybe we like what we see, maybe not, but we all want to be pretty on the outside. If we could see that the reflection in the mirror of the real woman is more beautiful than the cold, rigid statue of the beauty queen, we would love ourselves

The Prophet
2004, 46 × 36 in., oil on canvas, artist-made steel frame

Lottie the Girl
2007, 42 × 30 × 4 in., oil on canvas,
artist-made steel frame

the way we are. The vanity stands on four legs with high-heeled shoes that are in motion, ready to walk away, to take women on a journey of self-love or self-loathing."

Born in 1955, Cullum remembers feeling empty about the limited roles of women, who performed their duties almost solely in the home doing laundry, cooking, and cleaning while men went somewhere else to work. Like the other women of her era, she grew up on idealized magazine images of beautiful women and television portrayals of the perfect family. "Those roles did not work out for me," she says. She feared and anticipated an adult life as a housewife or secretary and felt other options were sorely limited. By the time she was a teenager, however, the feminist movement had given her new hope and exciting ideas about her opportunities.

After graduating from high school in Lubbock, Texas, Cullum was in full rebellion from the strictures of her world and married the late musician Jesse "Guitar" Taylor, a mainstay of the Joe Ely Band. Cullum remembers with great fondness the Lubbock music scene of those heady days, with constant music sessions at the famous Stubbs Barbecue and the annual Tornado Jams. "Jesse traveled all over Europe. He loved art and would bring home books for me. He was a big reader. . . . Jesse taught me to live like an artist," she says. Her marriage to Taylor helped Cullum gradually find the courage to do what she really wanted to do. Today, she spends her time as a full-time artist and is very gratified with the choice.

Cullum knows well what West Texas offers people with a creative bent. Some have

All the King's Horses
1992, 96 × 36 × 36 in., steel

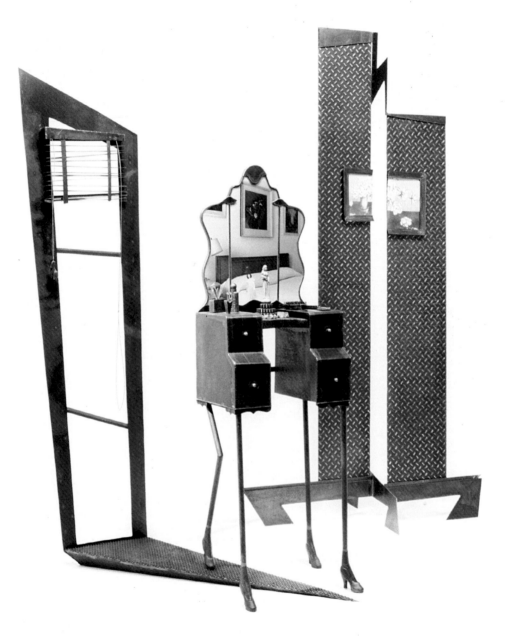

Mirror, Mirror
1991, 114 × 120 × 48 in., steel

speculated that Lubbock produces so many performing artists because "there is nothing else to do," as the title of a local art exhibit proclaimed. Cullum, however, disagrees and thinks that the unfettered nature of the physical and cultural landscape inspires a freedom to be creative. "I believe," she says, "so many musicians and artists come from this area because if a person has a creative bent, he or she finds an artistic release."

Cullum experimented with many of life's opportunities on her journey to becoming an artist. Before enrolling at age thirty-two in art school at Texas Tech University, she owned a landscaping business. As a three-dimensional process, landscaping inspired her to want to create sculpture and learn welding. "I always have worked with my hands, even as a kid," she says. "I became an artist wanting to design for my landscaping. I always have liked rusty metal things." Bill Bagley, faculty member at Texas Tech University, taught her to weld and to approach art as problem solving. Cullum also studied with James Minton, who taught her the art of drafting. Today, Cullum pro-

duces art based on personal experiences and inspired by personal desire, without regard for pleasing others. Living in her studio space—a large metal storage building in Lubbock—Cullum works with easels, paints, welders, plasma cutters, grinders, chop saws, air compressors, oxygen and acetylene tanks, heaters, rods, and pneumatic tools to melt and shape metal. "I am not doing casting or forging with the heating of metal," she explains. "Instead, I am a fabricator. I take sheet metal and build it into things, using only a few found objects. I keep going back to painting. I get tired of one thing."

Cullum lives alone as a very independent woman, making art that is brave, wise, and personal. She accepts the melancholy in her personality and in her art and relishes solitude in her own world that she celebrates in her artworks. "I get to live my life exactly the way I want to. I wake up and my day is what I make it," she says. This accomplishment was a long time in coming and well worth the wait for her personally and for all who value her distinctive vision of quiet and solitary ways.

K D H

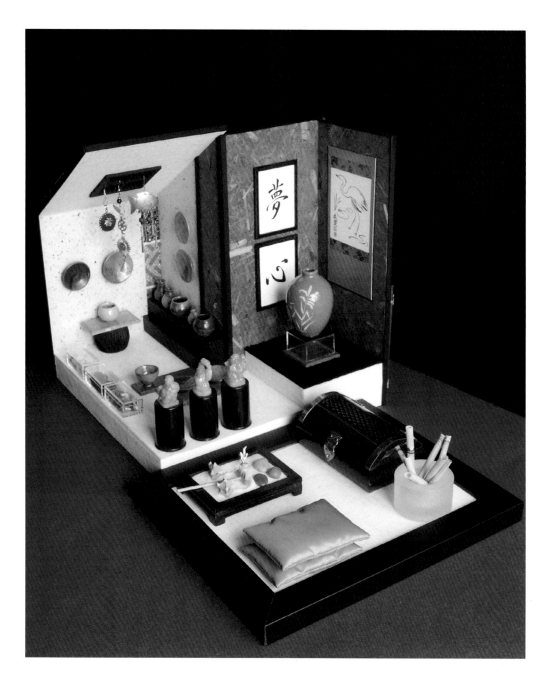

Asian Gifts
2006, 24 × 16 in., mixed media with found objects

The Art of

PAT MAINES

———

Life has no throwaways for miniaturist Pat Maines, as she recycles, resuscitates, and reuses found objects to create inner spaces and assemblages. Her main genre, in a wide palette of artistic endeavors, is the creation of diminutive interiors that invite examination and imagination. Maines is preoccupied with seeing life in detail and being exact in scale for the tiny worlds she constructs. In her mixed-media work she reorganizes natural and manufactured objects. Her two-dimensional drawings, paintings, and graphic designs also reveal her drive for perfection and control. Enamored with the process of art making,

Maines is fascinated by her experiments and the serendipity that arises in her creations. The interiors are arranged thematically and include art within art. "My art is expression. It's manipulating materials. I am attracted to detail, and my theme is to take another look," she says.

Santa Fe Cabin
2005, 24 × 30 × 25 in.
mixed media with found objects

A scavenger, Maines sees possibilities in common items she integrates into her interior spaces, which are realistic and contemplative sculptures of the inner sanctum of home. Maines revels in her unusual niche and its sculptural aspects. Her miniature sculptures are the handiwork of an artist who has a grasp of architecture and interior design, and she builds those tiny environments with throwaway items. With film canisters, lipstick lids, and plastic cups she creates pots, fountains, and reflecting pools. With clay, paper, wire, and wood she constructs furniture and decorative items in minuscule detail. Her object lesson is to conserve and give what is cast away new reasons for being. "I see it, and I scavenge it," Maines says. "I love the capriciousness of seeing that someone has opened a bottle of champagne and asking for the little black wire, because I see a use for it in my art. I really think I see things very differently." Using modeling clay, hand-held rotary tools, drill presses, sewing machines, handmade paper, saws, ovens, garlic presses, and pasta machines, among other tools, she solves the puzzle of constructing small worlds, comprised of elements of furniture, plants, art, and other comforts of home.

Maines makes birdbaths from doorstops; uses old drawer pulls and buttons for new purposes; carves leftover pieces of exotic wood into tables, chairs, and beds; and reworks small drug sample containers into colorful pottery. Her friends save their old jewelry for her to integrate into the houses as art pieces; a dangling earring makes a distinctive wind chime. She often includes art—sculptures, pot-

tery, and paintings—within her artistic spaces. Her Eastern-themed space *Asian Gifts* has marble walls and a slanted roof from which wind chimes hang. The multileveled space has a rounded, locked chest and blue pillows around a Japanese rock garden with a rake to mark the sand. Vessels, platters, sculptures of Buddha, and silk-screened images fill the black-and-white environment. Another Asian space, *Meditation Garden,* is an outdoor portico surrounded in greenery and blooming flowers. Mossy containers with pink geraniums hang from the black structure. Other flowers and plants are in ceramic pottery or woven baskets. Three angular sculptures align in the background.

In all her work Maines gathers similar items together, giving order to disorder and finding patterns in common, everyday objects. Maines's art covers the range from graphic

Meditation Garden
2007, 22 × 13 in., mixed media with found objects

PAT MAINES

design, printmaking, drawing, watercolors, acrylics, and mixed media works to sewing. "My art is all over the place," she says. "I do graphic art, sometimes incorporating sewing. I draw. I paint. I print. And, I make little houses. In all of it I like the fact that the work really reveals different parts of me. I am dichotomous in that I am exacting, anal retentive, and obsessive-compulsive in my work, but I have another part of me that wants to try new artistic techniques."

One of her sculptures, *Santa Fe Cabin*, shows a patio of a two-story adobe home with archways, wooden doors, rustic furniture, Native American rugs, Southwestern sculpture, and lights in every room. Maines makes a planter for a cactus from a small creamer container. She cuts linoleum with a craft knife to create the illusion of a grouted Saltillo tile floor. She carves and stains wood to make tall bedposts and rugged tables. She sews bits of fabric to make quilts for the tiny beds and placemats for the kitchen and creates artworks of crosses on the walls with broken jewelry. From modeling clay she makes wall sconces, a terra cotta planter, and statuary of Saint Francis of Assisi, and she embosses metal to make a copper ceiling in the kitchen of the adobe. A rounded kiva fireplace begins with a Styrofoam ball and dozens of layers of joint caulk to achieve a believable texture and shape. She invents the grainy adobe and stucco walls with layers of torn toilet paper, brown masking tape, glue, grout, and paint. "I have a spiritual connection to Santa Fe. I love the art, but I also love the architecture. I'm enchanted by it. It's different from anything I've

ever seen, perfectly imperfect," she says.

Maines's work is delicately detailed in most aspects, but the construction is muscular. She might frame a delicate, white, lace-filled bedroom scene with wood-paneled walls, a large window with diagonal lines, a fireplace, and book shelves to create architectural elements in the space. The wood-paneled room and fireplace highlight her abilities in working with her drills, saws, and grinder. Flowers of polymer modeling clay that Maines shapes with a pasta machine and bakes in the oven are also a basic element in her sculptures. The scale of Maines's work especially is evident in tiny lilies in a clear glass vase.

In *Santa Fe Gallery*, Maines creates an assemblage representing an art collector's show room that one might visit on Santa Fe's Canyon Road. Using materials with personal connections to create her miniatures, she incorporates several scaled-down works of art, including paintings, photographs, and pottery. For example, the shelf that showcases the pottery below the slanted roof is a discontinued framing sample. The clay-tiled roof completes the impression of an intimate gallery.

Maines's father was the Kansas City public school superintendent and encouraged her by displaying her work and taking her to visit the Kansas City Art Institute and the Nelson Museum. "I had a very healthy family, and growing up was very interesting," Maines says. "I had a dad who supported me in everything I did. He would say, 'Don't limit yourself about being female. Absolutely just get up there and do it. Go, and they'll love you because of it.' He always displayed my work, and we had a gallery

Santa Fe Gallery
2006, 16 × 16 in., mixed media with found objects

Ricky-dooed, Screwed, and Tattooed
2007, 16 × 20 in., found objects

in our home. Growing up was very fun for me."
Maines still has her first work of art, a three-
dimensional diorama she made at age four.

Before she started graduate school at Penn
State University for her master's degree in
arts education, tragedy struck her family when
her father died, and her older brother died in
a propane explosion. A friend of her younger
brother, who was a high school coach, told her
about Texas Tech University in Lubbock, and
Maines decided to begin her interdisciplinary
doctoral program there in 1979. "Moving to
Lubbock was an adventure. I came a month
and half before school started, so I had all this
time to myself. I had my plans, a sleeping bag,
and some clothes. I thought my connection
to West Texas was temporary, but I met my
husband, Mike, and I stayed," Maines says.

"I found really intense connections to people
in Lubbock, and I felt such a kindred spirit to
people and how they think."

When Maines was forty-five years old, her
husband gave her a doll house kit for her
birthday. She immediately thought about how
she could alter the schematic and began mak-
ing her own miniature interior environments.
The art emerged in the context of the birth
of her first niece, Emily, as Maines remem-
bered her own childhood and looked back at
her drawings based on *The Borrowers* books,
which feature a tiny family that uses full-sized
humans' items in their home.

In Lubbock, Maines has found her unique
niche in the art world and freedom to evolve
artistically. Even in her two-dimensional
drawings, she focuses on the interior. In
Captured Thought, a hand-colored silkscreen
print, Maines focuses on the emptiness inside
sealed glass jars, duplicating the background
of the blue sky. The work plays with inner
space and outer space, background and fore-
ground, created with delicate pen strokes and
colorful pencil lines over the print.

In her assemblages of found objects,
Maines frames and organizes organic or
mechanical parts that she places together
in geometric formations, framing chaos
and completing the puzzle of space. With
metal bolts, BB shot, plates, hooks, and other
human-made items, in *Ricky-dooed, Screwed,
and Tattooed* Maines takes the disorder of dis-
similar objects and frames them in a harmoni-
ous and dramatic pattern.

Throughout the body of her work, Maines
offers an object lesson in viewpoint, conserva-

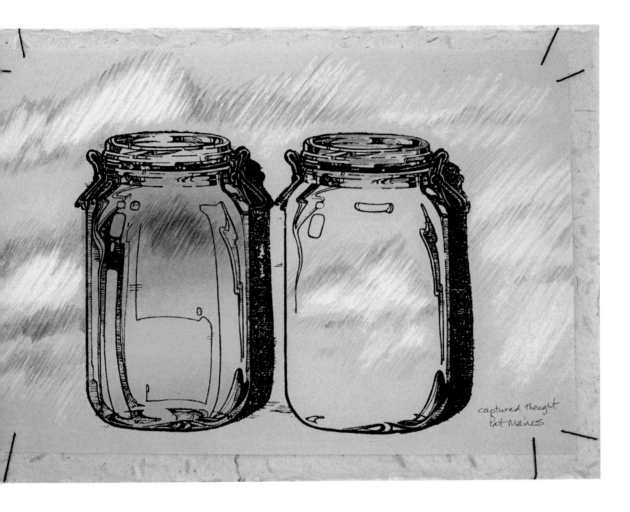

tion, and promise. "I can't imagine not being an artist. What would I do? What would I look forward to? What would my challenges be? Life gives me other reinforcements, reassurances, and gratifications, but nothing like art does," Maines says.

With her spatial sensibilities, Maines sees the potential in everyday objects. She recycles, reuses, restores, revises, and reinvents items into new creations of exact scale and realistic small places. Rarely including people in her work, Maines studies the processes and techniques of art making. Her arrangements of space are exacting, perfect, believable, and humorous. Through architectural detail, her edifices become sanctuaries for the imagination, tantalizing nests of comfort and surprise.

K D H

103

Captured Thought
2006, 18 × 24 in., hand-colored silkscreen

PAT MAINES

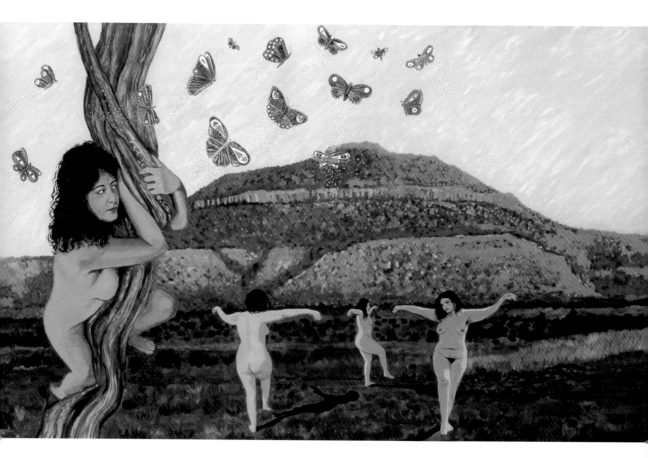

Hill of the Heart
2003, 42 × 72 in., acrylic on canvas

The Art of

LAHIB JADDO

———

L ahib Jaddo's paintings are social commentaries on the bridges between the cultures of her birthplace in Baghdad, Iraq, and her longtime home in Lubbock, Texas. In her paintings Jaddo considers the conflicts and parallels between her Middle Eastern childhood and her American adulthood. As an immigrant living a multicultural existence, she contemplates themes of ethnic identity, sense of place, sexuality, and alternate realities. Jaddo creates narratives of women in traditional Middle Eastern clothing or in classic nudity. Studies of architecture, landscape, and nature surround her figures. Jaddo paints wood and stone backgrounds, using writing and architectural renderings to enhance the bicultural quality of her art.

Jaddo is pulled constantly between her experiences in and identification with the Old and New Worlds. "This reality," she explains, "is both a constant tension and an infinite well

of emotion that pushes me to want to know the meanings of things. In this complex arena I weave traditional, realistic, figurative painting with contemporary iconography to express freedom and beauty as I simply tell my story."

The female figures in Jaddo's work often have similar characteristics, as she paints self-portraits or uses her daughter, Nadia, as a model. Jaddo suggests that her figures convey women's universal experiences. Facial expressions and posture reveal emotion in the context of physical surroundings and culture. Jaddo portrays multiple female identities. As insider and outsider, mother and child, citizen and alien, lover and loner, her images link the interior and the exterior, the past and the present, man and woman. "I try to tell my story of a woman who came from a different conservative culture," she explains. "I am trying to find liberalism in spite of constrictions that do not allow it. My work is about freedom, whether of thought, lifestyle, or expressions."

Jaddo expresses freedom through nudity in *Hill of the Heart.* Four female nude figures move freely in an arid landscape. In the foreground, the female figure twists and wraps her body around a tree while blue butterflies fly around her head. In the background, three women dance in a circle in celebratory poses with outstretched arms like butterflies' wings. They are full-figured, portraying an acceptance of mellow aging and the place of women as an integral part of the natural world.

Drawn to old European masters and their style of realism, Jaddo seeks to memorialize a specific moment in time by depicting that experience in a distinctive narrative style.

Her paintings are marked by a rich cultural and family history. "When I was a little girl, all around us was ancient architecture, intricate rugs under our feet, colors and patterns surrounding us in different aspects of life's visuals. Growing up with that influenced my outlook," she says.

In some of the paintings, Jaddo's female figures are dressed in traditional, brightly colored, and lavishly textured clothing that covers the body without exposing the form. The apparel reveals intricate patterns embellished with lace and sequins. Sometimes the backgrounds depict emotional spaces lacking landmarks, while at other times architectural features indicate a solid attachment to place. In *Here* Jaddo paints an individual woman suspended in midair with no apparent grounding. The woman is surrounded by a swirl of vibrant colors, and she holds her hands with palms up in a gesture of grace and offering. The background forms a pattern. The composition has no landscape, suggesting times in life when a person feels suspended, with no idea of where to belong.

Jaddo's female figures sometimes fly over the land, looking from a distance, detached from circumstance as she examines the role of the outsider, translating her own experiences as a member of a minority ethnic group both in the Middle East and in America. Jaddo left the land of her birth in Iraq when she was ten years old, her family forced out by threats to her father and other intellectuals by Saddam Hussein's Baathist regime. As an intellectual and a liberal, her father was one of the first generation of engineers and among the first

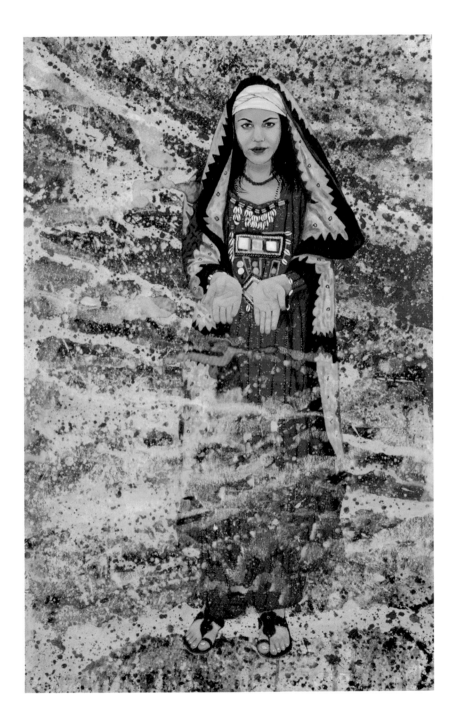

Here
2000, 65 × 43 in., acrylic on canvas

highly educated individuals in Iraq targeted by the Hussein regime. The family moved to Beirut, Lebanon, another locale besieged by revolts and war, where Jaddo spent her teen years. In 1977 she moved to the United States and continued her education, and in 1996 she accepted a teaching position in the Texas Tech University College of Architecture.

In many of her paintings Jaddo substitutes the vistas of West Texas for the hills of Mesopotamia to create settings for the characters in her paintings. "I have incorporated landscapes from the beginning," Jaddo says. "The human figure makes no sense isolated from landscape or cityscape. But when the human form is juxtaposed on the landscape, the dialogue between foreground and background creates the story." The absence of architecture also is significant, as in the works of women suspended in space. "During times of my life that I felt depleted, I removed all land and architecture from the background of my paintings, expressing and exaggerating the sense of exile or lack of belonging. When the color disappeared from my life, the landscapes disappeared," Jaddo explains.

Jaddo lived among horse-drawn carriages, courtyard houses, mound cities on hills, and the Turkmen people of northern Iraq. In her paintings of the Citadel, the most prominent architectural feature of her mother's home in Iraq, Jaddo reflects on her mixed Turkmen and Armenian ancestry. "My memories of my mother's hometown of Kirkuk are vivid," she says. "I remember climbing the Citadel and walking alleys to reach courtyard houses to visit my aunt in her ancestral home. I remem-

ber running up to the flat roof where the family slept in the summer. I remember my aunt slapping a huge circle of dough on the sides of her mud oven to make brown bread to feed us, while chickens ran at her feet. I remember seeing the city roof tops red with poppies from the spring rains." The Citadel's ancient town, razed by Hussein in 1998, had been the focus of Turkmen social life, an expression of Turkmen culture and identity. In some of her paintings Jaddo uses Turkmen and the Citadel to convey a political message about the rebuilding of the ancient mound city and shares lines from an ancient Turkmen song: "We are ancient. We have been here a long time. We rise up from the earth. We are strong. We will last."

Jaddo often uses text in her paintings to add another layer of communication and to transport viewers to another world. She even uses text from the Koran in her art, a practice forbidden in her home country. Jaddo's discovery of a thirteenth-century Turkish poet, Jalal Ud Deen Rumi, has been very important to her sense of self. The poet writes of being one with nature, a philosophy Jaddo embraces. She often uses poetry to help tell her stories. In the painting *Sokak 24,* Arabic writing is an important visual element of the composition. The scene of the painting is a cityscape with a street of flat stones and earthy, brown, mud-packed walls. The sunlight from above casts shadows through the arches along the path. In the foreground, a woman with short, dark hair under a black cloth wrapped around her head leans against the tall and protective walls. With her eyes closed, she opens her chest,

where stardust emerges and turns into butter-
flies. The birds and butterflies that fill Jaddo's
works are colorful and bright reminders of
hope and freedom. In this work the butter-
flies are subdued, suggesting that the positive
energy in the woman's heart must struggle to
stay alive in an ancient land under a siege too
grievous to witness.

"As I paint from old photos and memories,
it occurs to me that I don't know my home-
land anymore," Jaddo reveals. "I hear stories
from relatives about the multiple wars, how
so much has changed, how so many people
have died, and I think of the parts of myself
that are no longer alive." In her paintings she
celebrates the lost culture of her ancestors,

Sokak 24
2004, 36 × 48 in., acrylic on canvas

Kindred Spirits

2004, 72 × 42 in., acrylic on canvas

keeping the remnants of places alive in art, including the Citadel in Kirkuk and Tel Afar, her father's hometown, the hills of Mesopotamia, and the ziggurat of Samarra.

Currently, Jaddo is involved in an educational exchange program between U.S. universities and institutions in northern Iraq and has exhibited her work in Iraq despite the war between her old and her new countries. Her first visit to her homeland in thirty years was filled with anxiety about what she would see, how she should dress, and whom she still would know. Fortunately, her childhood culture welcomed her and appreciated her efforts in helping create the first Turkmen university in northern Iraq through her position as associate professor of architecture at Texas Tech University. The pull of living between two cultures is reflected in Jaddo's illustrations of the docile nature of a Muslim woman from the Middle East and a woman living in defiant freedom in the United States. "My work is a total reflection of my place in my life at the time," she says. "My art is an emotional reflection of my life."

Challenging the taboos of her Muslim culture, Jaddo often explores the issue of female sexuality. In these explorations, butterflies, water, and sea creatures become recurring symbols of freedom and earthly gratification. Jaddo remembers nervously showing her parents her first nude self-portrait, in which a woman stands in water up to her ankles with the Lebanon hills in the background. Wearing a white garment as a symbol of purity, the female figure is lifting her dress. "I'm exposing myself," Jaddo proclaims. "The painting is

about sexuality, and it says I am a sexual person, and I choose to participate, and there's nothing wrong with that."

In the multilayered work *Kindred Spirits*, Jaddo celebrates the sexual union of male and female, merged under a bursting sea urchin, arms reaching backwards, like dolphins doing back flips in the ocean. Butterflies and fish surround the pair of nude figures, flowing harmoniously toward each other in pairs. The entire composition is blooming with bright magenta, blue, and purple hues in a swirl of curved lines. Jaddo's expression of human sexuality is nurturing and natural, rejecting all that is harsh and shameful.

In *The Void*, Jaddo explores sexuality among women, placing five female figures in water, earth, and sky. In the foreground, a Caucasian female nude with short, brown hair straddles a seat, sitting comfortably on the bank of a stream while another figure floats dreamily in the water, looking up and peeking

The Void
2001, 43 × 65 in., acrylic on canvas

shyly through her hands. Yellow butterflies surround the nude. She exudes confidence, openness, and comfort in her flesh. On the right side of the painting, a figure wearing pants and a shirt reflects the canyonlands behind her as she waves and looks on, one hand covering her mouth. On the left side of the painting a female figure, dressed in traditional Middle-Eastern clothing, dances. Across the entire composition a jellyfish swims over a ghostly, transparent form whose hands are being pulled in two directions by disembodied arms. A road or creek treks through the canyonlands, looking like a zigzag bolt of lightning flowing through the translucent and vague spirit form. The painting has a richly colored dreamlike quality and offers a provocative exploration of the tensions, taboos, and liberation of human emotions.

In a painting on wood, *Where Everything is Music,* Jaddo investigates the women of her past and the women of her present, creating a composition that fits together like puzzle pieces. In the background on the right side of the painting, a grandmotherly figure steps through a golden archway, motioning her welcome behind a beautiful young Muslim woman colorfully dressed and looking innocently forward. Down a long dirt road women dressed in blankets of black cloth walk hand-

Where Everything Is Music
2001, 24 × 48 in., mixed media

in-hand with their children toward a city on a hill. The tattooed ankles and feet of a Western woman barely show themselves in this surreal study of homeland and new land.

Jaddo's art is a constant examination of living between cultures, pondering who she is and where she belongs. "When I arrived in West Texas, it was as if I had arrived home again," she says. "The physical terrain reminded me of home—flat spaces, dust storms, and dryness. In Baghdad, when the dust blew we flew our kites in the wind. The cultural terrain was different in Lubbock; yet this is the space where I have opportunities to ask questions like, 'Who am I; where do I belong?' and other questions I was not able to ask back home. Now, I am an outsider in Iraq, a foreigner." Her artistic perspective offers a unique evaluation of culture and meaning from an outsider looking in, embracing issues few are willing to examine. K D H

113

Art in the Dolomite
1991, 16 × 24 in., pastel

The Art of
AMY WINTON

P lein air artist Amy Winton shares her reverence for nature in vibrant pastel artworks inspired by the landscape and the ranching culture of the northern Texas Panhandle. She glories in the West Texas out-of-doors, where she carries her easel and box of pastels to vantage points on her acreage, the nearby Canadian River, or Palo Duro Canyon. Painting what she observes in nature under ambient light, Winton renders her creations in a multiplicity of saturated colors. She paints in a suggestive rather than realistic style, layering raw pigment in abstract patterns that evolve into identifiable subjects. In her works she portrays the local ranchers, rural life, livestock, plants, and animals, but the landscape is her fundamental inspiration.

On her land, sandy outcroppings shine with sunflowers. The ecosystem of Sand Creek Ranch includes cattle, horses, and mules that live among deer, coyotes, and roadrunners

The Ancient One
2007, 11 × 14 in., pastel

Native American petroglyphs mark the foreground, while across the prairie grasslands the rolling breaks of the Caprock Escarpment look like mountains in the distance. Winton balances the vastness of the prairie horizon with evidence of human habitation in ancient art and the determination for survival of grasses rooted in the cracks of rocks.

In *The Ancient One* Winton paints an aged and living cottonwood tree, showing the intricate skeletal foundations of the barren tree in twisting and tall branches that bend to touch the ground. Winton's box of pastels looks like pieces of a rainbow. Her control of the pastel medium is richly apparent in her depiction of sunflowers, purple plum thickets, violet thistles, magenta prairie poppies, and other wildflowers bathed in light overlooking a grassy valley in *Flamenco*. Through this celebration she reveals her talents for bringing color to vibrant and energetic life. "Color is my passion," she says. "When I put certain pastel sticks directly in my hand, with no brush, no pencil, only pure pigment, I can taste the color, smell it, feel it, and even hear it. Color is my authentic voice and is who I am."

Winton has a deep respect for the local ranching and cowboy culture, as well as a love of the land, and she captures the essential characteristics of this time-honored way of life in her pastels of people's hats, boots, jeans, and starched-collar, long-sleeve shirts. In one composition a cowgirl rests her horses as they eat green and yellow grasses. A wooden fence complements the earthy colors and details of the saddles. The figure leans against a wooden barn, patiently caring for her companions. In

in fields of waving grasses. Rolling hills are blanketed in red Indian paintbrush, purple and white thistles, and other violet and magenta wildflowers. The Caprock Escarpment breaks into canyons filled with creeks, ponds, and springs identified from far off by their tall cottonwood and oak trees and the sound of birds perching in cattails. The Canadian River runs through the region, continuing millions of years of erosion across the plains and into the canyons. Winton lives in a region, only miles from the Oklahoma border, recognized for its Native American artifacts and ranching heritage.

In *Art in the Dolomite,* Winton examines the timelessness of the land in a painting of a slick, gray, hard limestone outcropping where

116

another composition, ranchers sit around a table at a local diner, sharing their morning coffee in a ritual conversation about the weather and the status of their livestock and land.

In *Cochise and Me*, Winton focuses on a favorite pond encircled with cottonwood trees on her land. A rider sits on her paint horse under a cloudy blue sky, which is reflected in the water. The horse, rather than drinking, looks on in contentment. Bordering the banks of the pond, sunflowers stand tall, facing the light.

A student of the Impressionists, Winton has been influenced especially by the work of Van Gogh. "When he died, his coffin was covered in sunflowers," she notes. "I am a blonde, blue-eyed woman and bright, like a sunflower,

Flamenco
2005, 16 × 23 in., pastel

AMY WINTON

and I follow the light," she says. "I have loved the sunflower since I came to Texas. It is a bittersweet flower, because it blooms at the beginning of summer, but it also indicates that the summer will soon be over, because it is also the last flower of the season."

Sunflowers adapt to every environment in North America, and they survive even in the poorest conditions, always revealing the wild beauty of the land. Like a sunflower, Winton has adapted from her native New England to her home on the Sand Creek Ranch. In the picturesque locale of Canadian, Texas, near

her ranch, Winton established the Winton Academy of Art, the first art school and gallery in the town. The academy was successful for three years, and Winton taught both young people and adults. "Teaching has reinforced in me the very best of the art training in my lifetime and my style on paper. Teaching is the highest calling," she says. "With the Winton Academy of Art I planted seeds that I hope will continue for a long time."

Today, Winton continues to teach a core group of adult women who call themselves the River Seven and meet to paint scenes

The Invitation
1997, 7 × 9½ in., pastel

overlooking the Canadian River, where the water reflects the cattails and tall cottonwood trees that line the banks. In one of her river scenes, titled *Wolf Creek,* Winton captures the morning frost and the fall colors of the vegetation thriving along the water. "I tell all of my students that their art never will look the way they imagine it will. From its inception, or vision, to its conception, transfiguration, and completion, the image, the pigment, and the muse have their own wills," she says. "That's the beauty of it. Art is not mathematical and knows no boundaries."

A signature member of the Pastel Society of America and the American Plains Artists, she has been prolific in her work, creating nearly eight hundred paintings since her college days in the 1960s. Winton's grandmother, Kate Grace Barber Winton, was a strong influence in her granddaughter's life and encouraged her to find happiness through art. Winton attended Lindenwood College in Saint Charles, Missouri, where she earned her fine arts degree. She studied painting, drawing, watercolors, clay, and foundry work. Primarily, she was intent on creating steel sculptures, a

119

Show and Tell
1998, 8 × 11 in., pastel

Cochise and Me
2002, 17 × 12 in., pastel

result of learning at age thirteen how to weld and work with steel in her father's industrial plant in Connecticut.

During that same year she began making her own clothing. "Besides drawing a lot at that age, I escaped into fabric, a form of sculpture," she explains. "Because my mother was a conservative New England housewife, she made all of our clothes and decor for the home. She channeled her mind and skill with exquisite needlework. She used dark green, brown, and navy blue as colors. I could not stand the dark colors, so I taught myself to sew. I painted the fabric bright colors before making it into clothing." As an adult, Winton later patented a clothing design for women who have had a mastectomy.

Now, the grasslands of the Texas Panhandle supplant the oceans of her childhood in Woodbridge, Connecticut, near the Atlantic coast. "This ranch is absolutely my sanctuary," she says. "Where I began in New England and here, where I hope to end my life, the terrain and the geography are exactly the same: one is grass, and one is ocean. The undulation of the hills, the Sand Creek, the water, the horizon that goes on forever, all remind me of the ocean."

In 1974 Winton moved with her family to Amarillo and met Ben Konis, a New Jersey native and pastel artist who was trained classically in New York City. Konis became Winton's teacher, transmitting to her the technique of painting outdoors in natural light and his passion for saturated color. Winton was transformed by this introduction to pastels, and in 1984, at the age of forty, she exhibited at the Salmagundi Club in New York.

Wolf Creek
2000, 11 × 14 in., pastel

Palo Duro Cave
2005, 10 × 8 in., pastel

Layering the pastels to build up the colors, Winton gives her work depth by using handmade paper she orders from Oregon for its sandy texture. Pastel is a medium that is immediate and portable, allowing for outdoor painting with ease. "Pastel is pure pigment held together with a neutral binder. The beauty of pastel is that nothing but glass comes between the eye and the pigment," Winton explains. She is dedicated to pastel because of her lifelong love for drawing and because she is a colorist. Drawing has been Winton's forte through all of her experimentation with different media. She still thinks sculpturally in her strong compositional designs.

While living in Amarillo, Winton rented a studio on the edge of Palo Duro Canyon, only a ten-minute drive from the city, to study the landscape and light and to paint outdoors. In her works that focus on the massive canyon, she catches the light as it casts shadows on the landscape. Beginning with strokes of color in abstract patterns, in *Palo Duro Cave* Winton paints the rich red earth of the canyon, revealing geologic time in layers of gypsum and sandstone. Her love for the land and its visual history is evident in her portrayal of the sculptural effects of erosion. With the horizon always above in a canyon, Winton offers just a hint of the straight line in the sky. She highlights the vegetation with a juniper and dark greens in the foreground and uses strokes of color to paint the light on canyon walls after the first snowfall of the season.

Often, while driving along the countryside, Winton pulls over because something in the landscape catches her eye. "Sometimes I just

weep because the view is so pure and untouched. I have to take that vision and wrap substance around it, which is color on paper, and try to make the painting so beautiful that someone will stop to look at it," she says. "Paintings are complete when they are chosen by someone else to grace their collection."

In capturing the phenomenon of light and in achieving vivid colors, artist Amy Winton evokes sensory impressions in strokes of saturated and pure pigments. In her visual perceptions and in taking up ranching as a way of life, she has planted herself in the regional culture, celebrating the simple, local life of the region. Her vistas and landmarks are inland scenes of the habitats of the Panhandle of West Texas surrounded by the raw and rugged beauty of wildflowers, grasslands, riverbeds, canyons, and horizons. "Art and nature help me to free myself," Winton says. "Art is where time stands still." K D H

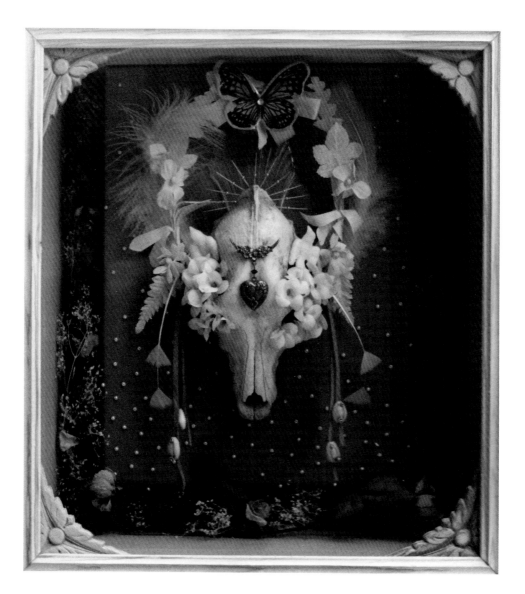

Desert Bride
1985, 18 × 18 in, mixed media

The Art of

DEBORAH MILOSEVICH

In *Desert Bride* a bleached-white cow skull festooned with white ribbons, small white flowers, and a wedding cake ornament of bride and groom is set inside a glass box framed by weathered wood. This creation of Deborah Milosevich, an assemblage or shadowbox shrine composed of disparate objects, serves as a stark yet elegant tribute to the women who, as pioneer wives, helped settle the western prairie lands. The eclectic elements of the piece are carefully assembled, as if on an altar honoring the rituals that give meaning to life bound by death. Deborah Milosevich describes her art as "heartfelt." For her, making art is a deeply personal, devotional act, a spiritual offering from the heart.

Mexican folk art is one of the most pervasive influences on Milosevich, especially those forms that have a spiritual dimension. While she was living in northern New Mexico, a friend took her to the sanctuary in Chimayó.

For hundreds of years pilgrims have visited this sacred site to collect soil believed to have healing properties. In a small room beside the chapel, they fill plastic bags and small vials with the dirt taken from a small hollow pit in the floor. Another room is filled with offerings left by the pilgrims. Milosevich remembers a big cola bottle covered with gravel and homemade paper flowers. "Whatever they had, that's what they used to make art. And it was just so unintellectual, straight from the heart, like a prayer. And that got me." The offerings are left behind to give thanks for prayers fulfilled or to invoke divine intervention: crutches and wheelchairs, framed handwritten letters of thanks, a portrait of Christ rendered in glitter, photos of loved ones hung with rosaries. Many are *ex votos*, narrative paintings on tin or wood. They tell the story of miracles in times of crisis, paying tribute and giving thanks for escape from an abusive marriage, surviving a chemical plant explosion, or recovery from a life-threatening illness.

Even though she had taken many studio classes in college and continued with different projects afterwards, Milosevich claims she didn't really become an artist until she was twenty-eight, after making this visit to Chimayó and living in several small towns in northern New Mexico. She says that her shadowbox shrines, like *Desert Bride,* came "from a desire to do the same kind of thing, art that came from the heart, a response, a prayer."

Milosevich has earned both an undergraduate degree in art education and a master's of fine arts but has never been interested in incorporating her formal learning into her

art. Instead, she has always used whatever she had. "I'd go to thrift stores and pick up a doorknob, shells, pearls, a plastic Madonna, a little flower or a pot holder, little charms that I found in a Mexican store," she says. Milosevich also feels her art is part of a strong and lasting tradition. "Women have been making altars forever, and they still do," she says. "They used to call them knickknack shelves. I think it's something that runs deep, particularly with women and maybe men, too, but I think women have been building altars as far back as recorded history."

While living in Santa Fe, Milosevich exhibited the shadowbox shrines in several galleries. But, she explains, "At some point I was done." It was about the same time that she moved back to Lubbock with her young son and began making *retablos,* another traditional folk art form found throughout Mexico and the Hispanic Southwest. Similar to *ex votos, retablos* may be any religious image painted on wood or tin, sometimes on canvas. Most typically they portray individual saints and are displayed in homes both as tributes to their miraculous powers and to ensure their blessings and protection.

Milosevich learned the traditional techniques of *retablo* painting from a nun in Abiquiu, New Mexico. "We used rabbit skin glue and whiting to make the gesso," which, she explains, is used to smooth the surface of the small wooden plaques. Gesso has to be cooked slowly and takes two or three hours. Several layers are then applied and sanded. Finally, the images are painted with a mixture of egg and pigment, often ground minerals.

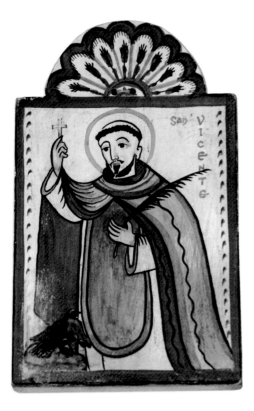

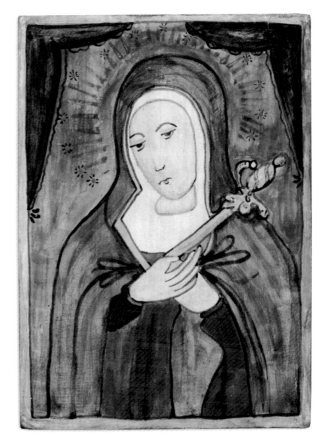

The *retablos* are primitive in representation.
Milosevich explains that they lack perspective.
"Their hands are kind of big and their eyes
are far apart. I like folk art which is unself-
conscious; not working for an audience is
what I like."

Several *retablos* hang on her walls: the
Virgin of Guadalupe, Saint Joseph, and her
son's namesake, Saint Vincent. Milosevich
has always been intrigued by the saints and
their mystical powers. Milosevich has cre-
ated her *retablo Mater Dolorosa (Our Lady of
Sorrow)* in muted blue and orange. Connec-
tions between images of the saints and icons

San Vicente (Saint Vincent) LEFT
2006, 6 × 5 in., egg tempera on wood

Mater Dolorosa (Our Lady of Sorrow)
2006, 6 × 5 in., egg tempera on wood

127

of popular culture are not lost on her. She has created a *retablo* of country-and-western icon Patsy Cline with the same stylistic simplicity and seriousness that she gives to her Catholic saints. Milosevich explains that the *retablos,* more traditional than her other art, are the products of the years when she was raising a small son and working full time. "I didn't have time or space, so I did something I could do at the kitchen table, that I could set aside and pick up a week later."

Evoking the religious folk art of the Hispanic Southwest, her shadowbox shrines and *retablos* strive for the same kind of devotional impetus that moved her at Chimayó. She explains that although it might seem that her heritage is Mexican Catholic, she was raised Presbyterian, and the symbolism surrounding that religious denomination is minimal. "I am not religious, but I am spiritual," she says. "And there is a difference."

Today, Milosevich concentrates on creating clay objects. As soon as her son graduated from high school, she quit her job as an arts administrator and now works in the studio adjoining her home sculpting feminine forms in low-fire clay. They are stately, majestic, with minimal detail, ranging in size from a few inches to over a foot tall. All are mounted on blocks of wood or stone and most are embellished with feathers, beads, straw, or bone. Milosevich raku fires them, creating multi-colored surfaces in dark blues and metallic browns for a multitextured effect. Reminiscent of the white marble Cycladic sculptures of ancient Greece, they are simple but spirited. Some are Madonnalike, holding infants. "Even

now with the clay I can go dig it anywhere and fire it in my backyard. I go for simplicity, the practical and accessible. Anyone can do it. I seem to be drawn to the really old, primitive kinds of art and its mystery." She envisions making larger versions of these sculptures, perhaps adding headdresses like those seen in ancient Incan or Mayan art.

Milosevich has always been drawn to art that expresses some kind of mystery, a sense that "something's happened here, some magic. You can sense it or feel it, and it changes someone because of it," she explains. "For me, art is a sacred act. Maybe it's what the shamans were doing drawing in the dirt, drying up rose petals on a mat, stacking a few rocks. There's something powerful, and it's just created out of nothing." She clings to a story one of her professors once told her. "He said there was this village, and there was a holy man there, and people went to him when they had problems or if there were mysteries or things to be solved. They would go to him because he was their spiritual leader, and one night there was a meteor shower. They were outside, and they were thinking the world was coming to an end. So the medicine man started dancing, and he danced all night in response to the meteor showers. At first the people didn't know what to do, but eventually they started dancing with him. The sun came and there were no more meteors. And they felt that they'd been saved by this, their sacred dance. The story has stuck with me forever," she says.

Milosevich is energized by her art, by the doing and creating of it. She responds to and

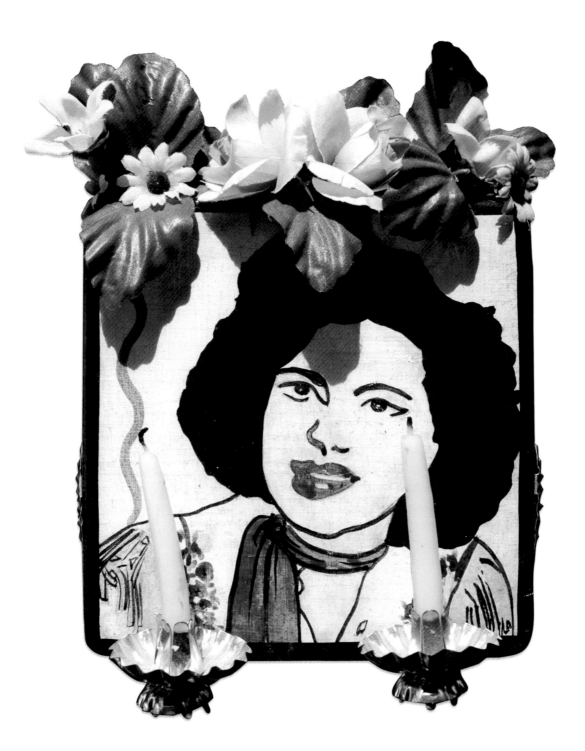

Patsy Cline, Patron Saint of Honky Tonk Women
2006, 7 × 5 in., egg tempera on wood

Crow's Collection
2005, 15 × 6 in., raku

interacts with whatever medium she is using and, typically, doesn't know beforehand what will emerge. "I may make a circle out of clay and put another piece of clay across it and then roll it. All of a sudden it has a different look, and I respond to that. I don't even know where it comes from. It just shows up. It's a response, a dance. Something happens and I respond to it," she says. Sometimes she does have an idea in mind, but she never knows exactly what the piece will look like. "It's a surprise every time," she says. For Milosevich the artistic process is a way of connecting with herself, a way to go inside and explore what's there. "My art is public, but making it, creating it, is private," she explains. "It is a very prayerful action. So, going into the studio is like going into the sanctuary and praying. Creating art is creating the connection to the spirit. And then you have whatever the by-product is, the

art. But to me, after I do it, it's done. I don't care about holding on to it. It's not part of me. The process itself is what's important."

Born in San Angelo and raised in Lubbock, Milosevich's roots in West Texas are strong. She recalls large family reunions with cousins, aunts, and uncles gathered from throughout the region. The adults would sit on the porch or in the backyard drinking iced tea while the children played nearby. In her recollections of family, as in her art, Milosevich is aware of the power and the mystery of the commonplace, the everyday.

In early adulthood Milosevich lived for short periods of time in East Texas as well as other parts of the Southwest and in California. When her father asked her if she had actually walked across the stage to receive her diploma from Texas Tech University, she reminded him that she had packed up her car and left for New Mexico as soon as she had finished her last exam. She spent some time in Austin and Oklahoma before returning to Lubbock, where she married Paul Milosevich. Eventually they moved to Santa Fe, and when their marriage ended some years later, she returned to Lubbock with their son.

Rooted though she is in West Texas and aware of the comforts of home, Milosevich also speaks candidly about the plainness of the "Hub of the Plains." Historically, the economy of Lubbock has been dominated by agriculture. The distances from it to Texas's major urban centers are vast. Although the city is enjoying a cultural and economic surge, with the renovation of downtown areas, the growth of the university and its medical cen-

ter, and the emergence of art galleries, shops, and wineries, Milosevich has often found the geographical isolation difficult. The Lubbock of her early years seemed to her a "white bread, boring, ugly place that didn't have much heart or soul or beauty."

Milosevich describes herself as someone who, when she senses something is missing, creates it. Lubbock's plainness and remoteness have had an impact on her way of seeing and being. "There wasn't much there," she explains. "I think that's affected a lot of artists, particularly from Lubbock; [they] just had to do something, just had to create and do something to break the monotony, the boredom and ugliness of it." The outcome for Milosevich, and many others, has been positive and productive. "If you are the least bit different, if you can survive it, chances are you'll be a very interesting person." In fact, among her peers are a number of accomplished artists and musicians with national recognition, including Terry Allen, Butch Hancock, Jimmie Dale Gilmore, and Joe Ely.

Earth's Protector
2008, 21 in. tall, raku

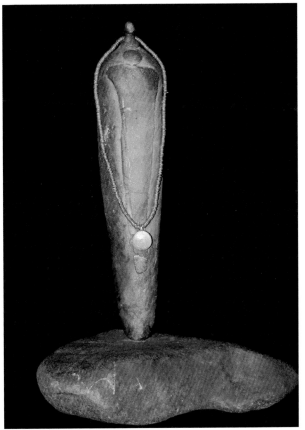

Stands with the Earth
2008, 15 in. tall, raku

The West Texas vastness in many ways seems to provide the perfect incubator for creative expression, and Milosevich has always returned to Lubbock, finding it "a good place to heal, and it's not too expensive, and you can hide out here. There is something that draws me here, and I don't know if it's the landscape or what, but certainly the wide-open spaces. I can't stay up in the mountains or woods too long. I get claustrophobic. I want to be able to see the horizon. The people who grew up here talk about this rubber band phenomenon of leaving and being pulled back."

Milosevich's aesthetic seems to have remained consistent through all of her travels and the pull back to Lubbock and is evident in pieces she has collected just as much as in her own work. Her dining room table is surrounded by an eclectic mix of spiritually charged objects and images. A painting of a huge black cross hangs on the kitchen wall, evoking O'Keeffe's *Black Cross,* but this is an anonymous piece rendered not on canvas but on a bath towel. One of her clay crows sits on a bookshelf. *Crow's Collection,* a totem-like object, dark brown and rough-surfaced, is embellished with charms—an assortment of clay, metal, wooden, and plastic beads, some of them vibrant red and blue strands. A miniature tea set is perched on its back. The crow evokes the openness of childhood art. From her earliest years and to the present, Milosevich's art is simple and direct. She transposes inner beauty and spirit to the outside, making visual and visible in ordinary things what we would not ordinarily see—as she reiterates, "filling in what is missing."

In addition to working in clay, Milosevich currently teaches art courses, primarily to non-art majors, at Texas Tech University. She recalls having told her mother at an early age that she wanted to be an art teacher, and her mother had encouraged her to get a teaching certificate as "something to fall back on." Milosevich's interpretation is that teaching was something she would have to resort to when her life fell apart. That's not how it's turned out, however. For Milosevich, teaching is just another kind of artistry that gives her a way to convey her sensibility to students, inviting them to see what might not be immediately visible in art or in the creative process. Her classes include many seniors with no art background. "It's so much fun to be in classes with students who have little appreciation or even a basic art vocabulary and to interact with them in such a way that every so often you'll see somebody get it, and it's so satisfying." One girl was about to graduate, and she burst into tears, saying, "What am I going to tell my parents? I've got to go into art. I don't care about this communications degree."

In every way, Milosevich is dedicated to "filling in what's missing." In her teaching as in her art and life, she is deeply attuned to what may be hidden in the outside world that can be discovered within and brought forth through creative expression. Her heartfelt aesthetic and way of being allow her to find, engage, and make evident the mystery and magic, the passion and spirit in what otherwise might seem quite ordinary. LJC

Quilt
1998, 63 × 99 in., oil

FIFTEEN

The Art of

TONI ARNETT

———

Like the French Impressionists, artist Toni Arnett thrives on light and color. In her large-scale oil paintings she presents ordinary objects in extraordinarily lifelike terms. More important than her subject matter of flowers in bloom, animals, or crosses, Arnett's mastery is in composing in a kaleidoscopic spectrum of color. Like pointillism, her work is meant to be seen from a distance. A closer look reveals minute strokes that are patches of paint, only becoming something visually familiar at a distance between the painting and the viewer, an artistic reality accomplished with optical illusion.

Arnett's compositions are quiet, gentle, and contemplative scenes of quilts, cats and chairs, flowers and twigs, leaves and blooms, plants and animals. Her paintings are filled with light, whether sunlight, filtered light, or gallery light, celebrating the essence of each object. Arnett's colors electrify like the paintings of

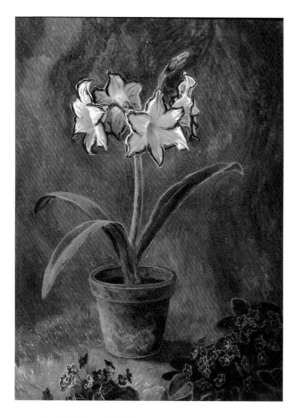

Potted Amaryllis Plant
1992, 25 × 35 in., oil

and more. I think a painting has to have soul," she says. "To qualify as art, it needs to pull at one's heart in many different ways."

Arnett paints close to the canvas in bold strokes, but she expresses her visions from afar. She wants the viewer to stand away and look at her work as the art might hang in a gallery space. "I try to paint things to look right from forty feet. If it doesn't work at forty feet, it doesn't work. Every artist should stand back," she explains. "I like to paint big. . . . If someone walks across the room, my paintings grab them and demand they look. That's good, but it can be uncomfortable, depending on what people expect in art. Successful art pushes you to have an experience with it. I like that to be a good experience."

To accomplish the illusion of light and depth in a life-size painting of a quilt, Arnett paints details of folding cloth, textures of varied fabrics, and the designs in vibrant colors. From a distance, the traditional pattern appears to be finely detailed. Close-up, however, brush strokes of color become abstract and somewhat undefined to the eye. The painting is remarkable in its variations, surfaces, and textile designs as Arnett pieces together saturated colors with tiny strokes that become exacting stitches. "I like to paint textures in cloth, and I am fascinated with quilts," she comments. "I find it amazing that someone could do all that tiny stuff and remain sane." Arnett floods the blanket in light and shadow, and the effect from afar is startlingly three-dimensional in appearance. A viewer is surprised to realize the composition is a painting and not a quilt on display.

Gauguin, one of her favorite Impressionists. By contrasting dark and light, she paints pure, glacial white that stands out powerfully as a twinkle on a lily or an amaryllis bloom. As a colorist, Arnett tries never to use the same hue twice in any one painting, preferring to create movement through variety and multiple strokes applied with the brush or her finger. She chooses colors from a wide palette to build forms that often seem suspended in space. "I like to paint the soul of things, what they are

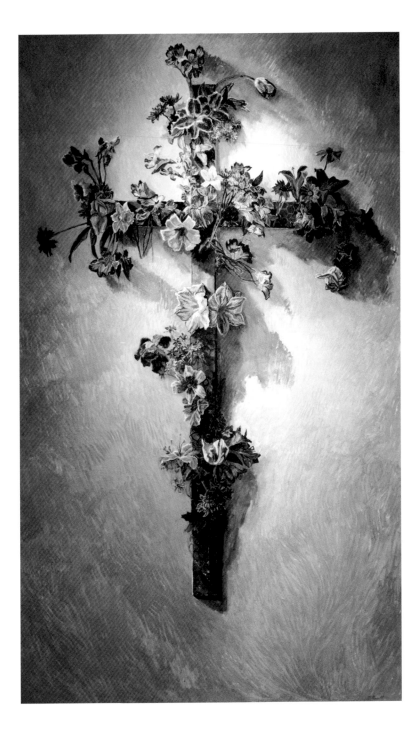

Wire and Wood Cross with Flowers
2002, 43 × 72 in., oil

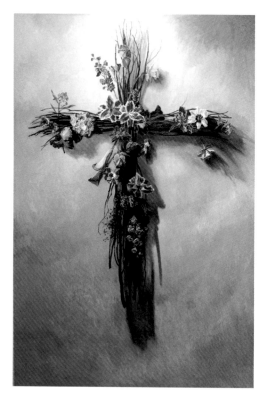

Cross with Twigs
2001, 48 × 71 in., oil

In a composition of a cross, Arnett also accomplishes a dramatic three-dimensional effect. She paints a cross made of twigs that provide a complementary contrast to the soft petals of flowers that hang from the wood. Above the cross, a light shines down as if the work were hanging under recessed lighting in a gallery. Crosses with flowers are common in Arnett's art. "I think some of my work was my attempt to make myself believe that God was beautiful. The crosses represent life and light," she says.

In another composition, Arnett wraps a blue steel cross with colorful flowers of varying shapes and colors of blooms. The light falls across the blooming cross with its richly saturated and deep colors. For inspiration, she buys flower arrangements to study before she paints under artificial lighting conditions. Before the blooms die, she photographs the composition and alters what she sees in her imagination, creating her own colors and highlights. "A teacher taught me that and how to paint light by painting something darker next to the lighter tones. He said never to paint the same colors twice. Of course, that's impossible, but I come closer now. Painting white is done with color and variety," Arnett explains. "If you have an all white painting, then nothing sparkles. Frank Gervasi said that you have to paint dark in order to paint light."

Although she often chooses ephemeral subjects, like flowers, her works are bold because of her use of light. "I paint light because it is pretty," she says. "A lot of artists, modern artists, look down on that kind of 'pretty art.' I paint some things that are visually unremarkable in an attempt to make them a feast for the eyes. Flowers are fun because of the millions of colors. My art is definitely different. I am recognized because of my color and light." Still life is Arnett's artistic genre. In a quiet piece, a potted amaryllis plant in a terra cotta pot is enlivened by Arnett's use of deep purple and magenta violets. The dark colors and shapes of the plant's soft leaves are delicate under muted light and shadows, reminiscent of the paintings of the old European masters admired by Arnett.

138

Lush Garden
2000, 58 × 72 in., oil

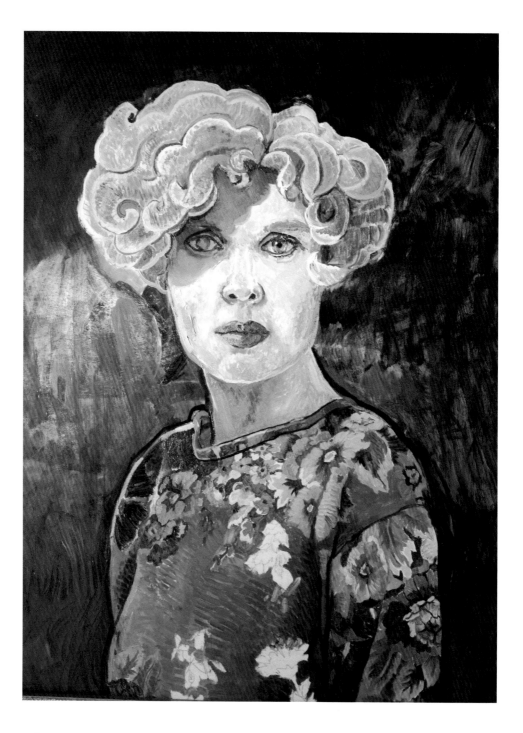

Self-Portrait
1999, 21 × 25 in., oil

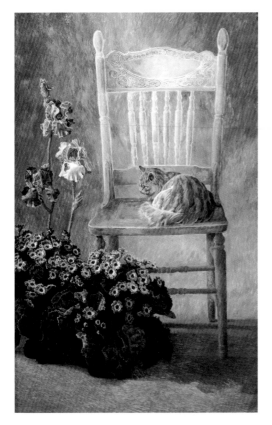

Cat in a Chair
1982, 50 × 32 in., oil

Creating form and mass through contrast in a painting of a garden scene, Arnett leads the viewer down the hint of a path into a lush space of visual adventure. Using various hues of green leaves to create dark shadows, she highlights the lilies, violets, irises, and other blossoms with vibrant color. The verdant, wild, and untamed garden provides a canopy of quiet shade. From a distance the painting seems remarkably detailed, but, once again, at closer view a few paintbrush strokes give the orange, red, and yellow flowers their careful, delicate, and detailed impressions.

In another composition, Arnett paints a white chair in soft and warm pastel colors that are reflected in darker tones in the background. An orange-and-white cat sleeps in the strikingly bright white chair. The potted plants in the foreground are a consistent visual theme in Arnett's work. The soft irises are highlighted in the sunlight streaming in, making the napping cat seem even more content.

Arnett is fortunate enough to have studied with many art masters across the globe. She became interested in painting more than thirty-five years ago when she met Glenna Goodacre, who was just beginning her illustrious career and teaching a painting class at Glidden's Paint Store in Lubbock. Goodacre is known and respected for her public art pieces—sculptures such as the Vietnam Women's Memorial in Washington, D.C.—and metal designs, such as the Sacagawea U.S. dollar coin. "If Glenna hadn't come along, I might not have started painting," Arnett recalls. "She would give me critiques, and that is probably really how I learned. I took that class, and it was fun. I loved it, and I've been painting ever since. I just took to it like a duck to water."

Next, Arnett attended an art workshop taught by painter Frank Gervasi in Cloudcroft, New Mexico. "I didn't even know the names of the colors then. That was my second class, but everything that man said made total sense to me. From him I learned how to paint light. The way he taught us to paint light was pure torture. But I 'got it.'" Later, she took lessons from

141

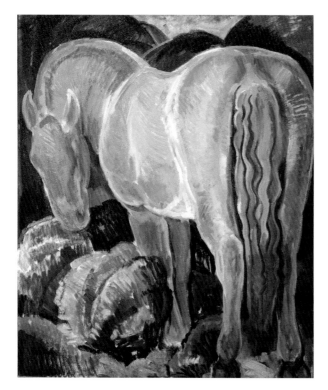

Horse
2003, 20 × 24 in., oil

Helen Van Wyke and other artists. She was invited to be in an exhibit in Beijing, and she has traveled many times to Europe and Africa.

Arnett also has painted in a more stylized method. In a portrait of herself in her early fifties, her hair is painted as in 1930s curls, and she wears a floral T-shirt that has some of its decorative blooms left as unfinished drawings. She uses soft reds and greens to achieve a skin tone and paints a shadow across the face. "This painting tells the story of my recovery from depression. It was a long, painful hill to climb, but I wouldn't let myself stray from this path. I have a shirt that says, 'Art Saves Lives,' and that became true for me." The composition portrays Arnett looking at herself in the mirror. One eye is focused and sharp. The other eye is unclear and glazed, resting in shadow.

In another stylized composition, Arnett portrays a horse with tail and mane painted in a style like that of the hair in the self-portrait. The pink tone of the horse is complemented by the green, leafy vegetation surrounding the animal, also similar to that in the self-portrait. Arnett grew up close to animals on her grandparents' Pole Cat Ranch in Wise County, northwest of Fort Worth, Texas, and has a deep affection for horses, cats, and dogs. "With my mother loving the country, animals, and horses, we started spending the summers there. I loved the horses and the cows and being outside. When I was very small, my grandfather and I would go to the ranch, take a sack lunch, and he would saddle up Old Dick. We would ride all over the ranch and have our picnic. It was just wonderful."

When Arnett was ten years old, her mother decided to become a rancher, and her family moved from Dallas to the country and established the Tom Toni Ranch in Krum, Texas. "My father had less than zero interest in ranching, so he commuted to Dallas every day," she remembers. "With my mother, there were no pretensions. Of course, she went into a man's business, and other ranchers did not want to buy bulls from her because she was a woman. That hurt her some, but it didn't make her quit. Her goal was to develop a really fine herd of registered Herefords. Mother

persevered. She was successful. That experience taught me the importance of choosing something you love to do in your life's work."

At the time, the population of Krum was 350 townspeople, and Arnett had fifteen students in her class. "I was such an individualist," she says. "When spring would come, I was always playing hooky. I would walk home five miles rather than sit in a boring home economics class. I would rather go wading in the spring where the birds were chirping. Teachers did not want to figure out who I was. I was different from everybody." With ambitions to go to college, Arnett enrolled at Texas Tech University, graduating in 1958 with a degree in business. "I didn't major in art because I thought I couldn't make a living in that career," she notes.

Now living in Lubbock, Arnett credits the outdoors as most important in her search for inspiration. A spark of color excites her. "I generally get my inspiration just from looking at the world. Recently, I was driving down the street, and the sun was hitting this little piece of turquoise plastic in the gutter. It was the most beautiful thing. I even drove around the block and came back again just to see it more closely."

Celebrating the millions of colors in nature, Arnett paints realistically, but that is not the point she is making in her art. A cross, a cat, and a garden are more than visual subjects. The light, mass, form, topic, and background intensify the experience of viewing something that is often overlooked. Arnett is challenged by intensifying the commonplace, framing it and making it beautiful through her special talent with coup d'oeil. "Some people say, 'Oh, painting is so relaxing.' It's not relaxing," Arnett insists. "It's exciting. It's a tension within yourself, and it's a challenge. I think that is one of the reasons that I like it. I just have this desperate need to be challenged." Arnett is a master at meeting the challenge of wrapping the viewer in saturated color through the drama of light. K D H

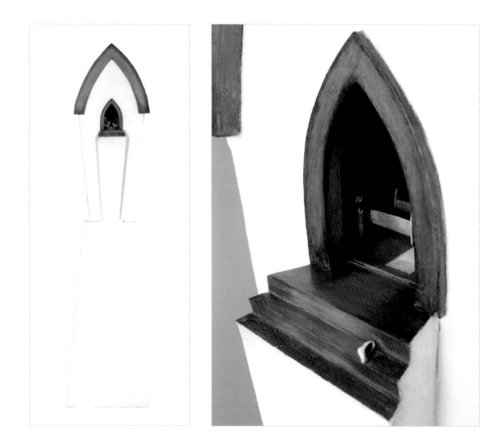

Miel Virgen (Virgin Honey)
2005, 72 × 18 × 8 in., metal, wood, Prismacolor, enamel and acrylic paint, wax, tulle

The Art of

ANNA JAQUEZ

A nna Jaquez was born and raised in El Paso and is very much involved in the cultural dynamics of this border region. Although El Paso, Texas, and Juárez, Mexico, are sharply divided worlds in terms of opportunity, infrastructure, and resources, these two cities, separated only by the Rio Grande, represent a fluid, interconnected culture. With close family ties to Juárez and other areas of Mexico, Jaquez finds inspiration for her art in the border culture, the desert landscape, and her Mexican American heritage. "The two places (go) hand-in hand," she explains.

Jaquez started out working at her kitchen table where she could carve out a place for her creative expression in the context of her domestic responsibilities. She now works in a small detached studio behind her home. It is filled with heavy equipment. Band and

circular saws, sand blaster, drills, and a lathe are just some of the tools she uses to create miniature interior spaces celebrating Mexican folklore, traditions, and her family memories in intricately fashioned three-dimensional environments. Like toy theatres or miniature stages set inside larger architectural forms, they invite the viewer to stop and look inside, to explore a self-contained world.

Miel Virgen is a piece Jaquez started in graduate school and has continued to modify over the span of twelve years. The work is a response to "Dream," a poem by Pat Mora. Jaquez found the poem in a university magazine: "I just fell in love with it. I think I was getting ready to marry at the time." Mora's poem is about virginity, marriage, and a Mexican superstition that the wax flowers or *azares* adorning the bride will melt on her wedding day if she is sexually impure. The speaker of the poem both dismisses the superstition and acknowledges its powerful effect on the bride to be.

In response to Mora's poem, Jaquez has fashioned a church with a stained glass window, its roof covered with wax orange blossoms. Inside are pews and lilies; a single shoe lies on the steps leading to the church. Glowing colors emanate from the basement. *Miel Virgen* is characteristic of Jaquez's work, which consistently reflects her cultural heritage and religious upbringing. In Mexican tradition, the *azares,* small wax emblems of purity, are either carried by the bride or worn in her hair on her wedding day. Jaquez explains that she has always been uncomfortable with the different standards for girls and boys, women and

men in Mexican American culture. "Girls are taught to save themselves for marriage," she says. "My sister heard my father tell my brother to mess around all he wanted, but to stay away from the church girls." Jaquez explains that the shoe on the steps represents girlhood dreams of her wedding day. The stained glass recalls the beauty of the window in the church her family attended when she was a child. The church was and is an important part of Jaquez's life. "When you go to pray, it's such a spiritual experience. I think it taught me about feeling something deeply. But at the same time, it was a real scary place." And so she explains that the light in the basement of the church represents Hell. During her childhood, she was told, "You have to behave, or you're going to Hell." *Miel Virgen* is based on memory and depicts a space that is charged with mystery, conveying religious awe and wonder together with childhood fears and dreams.

Jaquez bases many of her works on the spaces and places she visited as a child. In *Gallo* she re-creates her impression of a failed serenade that she witnessed as a young girl in Puerto Vallarta, Mexico. She saw a man stumbling down the street, swigging from a tequila bottle and dropping flowers intended for his beloved. He had gone to serenade her, and she turned him down. He was crying as he sang songs of unrequited love, accompanied by the mariachis who followed him in procession. This *gallo*, which means both "rooster" and "manliness," or perhaps "cockiness," had been thwarted by the woman he was courting. In Spanish, *gallo* also suggests the specifically male traits of *valor,* "bravery"; *orgullo,* "pride";

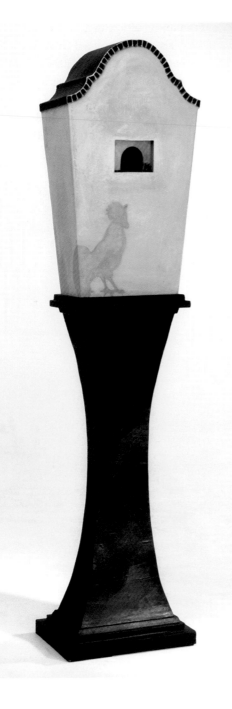

and *fuerza*, "strength." The exterior of the
piece forms a column in brown and yellow
and is decorated with the image of a rooster.
Standing tall, the pillar suggests sturdiness,
stability, and confidence. The brightly colored
interior of the piece is a garden scene with
a bicycle, a rose on the ground, a fountain, a
table, and two chairs—the kind of place lovers
might meet. She remembers that the man in
Mexico looked very proud yet very vulnerable.
She has captured this juxtaposition in *Gallo*.

Floors, draperies, and a single light source
are often important parts of Jaquez's environ-
ments. She attributes this influence to the
sixteenth-century Dutch painter, Vermeer.
Many of Vermeer's interiors are lit by a single
source, and along with carpets, drapes, and
clothing, all with many folds, he depicts
floors covered in contrasting tiles. Jaquez also

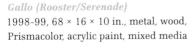

Gallo (Rooster/Serenade)
1998-99, 68 × 16 × 10 in., metal, wood,
Prismacolor, acrylic paint, mixed media

Gallo (Rooster/Serenade)
detail of interior A N N A J A Q U E Z

explains her father's aesthetic influence. He tiled many floors with linoleum and made designs in them, using subtle differences in color. He also painted the walls of their home with bright colors he found on sale in vibrant green or canary yellow. "It was color everywhere. Color, color, color." Jaquez's fascination not only with color, but also with detailed interior spaces, may also have stemmed from her father's persistent remodeling. Her father not only added colors but also rooms and structural elements to their house, including two front doors, which confused visitors and inspired one of her first pieces after receiving her MFA.

Mexican Elders Series
2002, installation, approximately 7 × 6 ft. × 15 in., metal, wood, mixed media

 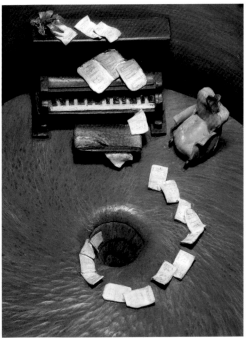

Her father's lanterns made out of jelly jars and dishes, topped with a marble and standing sentinel outside the two front doors, were a constant source of embarrassment to her as a child. Vermeer's and her father's idiosyncratic handiwork have both helped shape her aesthetic sensibility.

In the installation *Mexican Elders,* Jaquez creates brightly colored tree trunks out of clay to reflect on death and family. Tree trunks represent her family elders as well as the seasonal cycles and the times of day: morning, afternoon, twilight, and night. The roots of the trees, like the strength of the family, are strong and visible. Four paintings in complementary colors hang above the trunks, depicting branches and treetops. Three-dimensional insects crawl along the walls and the trunks, representing intrusions that bring disease, life's hardships, and death. The open top of each trunk reveals a childhood memory. In *Anocheciendo,* for example, there is a piano because so many of her family's reunions were around the piano. "We all took lessons, and we had to do little recitals," she explains.

Jaquez's pathway to finding her own artistic style, methods, and materials was not direct. As a child she loved to sew. Family members taught her needlework and embroidery. One of her aunts sent her swatches of material she made into doll clothes. It was not until high school that Jaquez first became

149

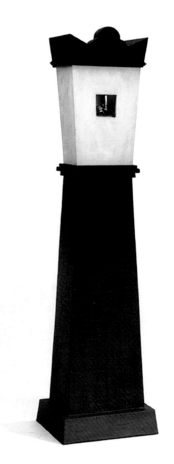

So I sat one night and finished it. I just sat there and painted it. When I finished, it was like 'Whoa! I did this.'" When she looked at this piece just a few years ago, she thought, "It's still not bad."

Jaquez wanted to go to California to study fashion design in college, but her mother insisted that she attend the University of Texas at El Paso (UTEP) and stay close to home. Initially, she studied music, but her sister and a former boyfriend both encouraged her to study art. She began with a basic design class and, after taking an advanced metals class, decided to become an art major. Even so, her doubts about her artistic ability lingered. "I didn't think I was artist material when I got my BFA," she admits.

After earning her degree, Jaquez and her sister considered starting a doll business. They planned to make dolls, their clothing, and other kinds of children's toys. In the meantime, the UTEP art department had established a master's program, and Jaquez decided to apply and took her first graduate metals class with Rachelle Thiewes, with whom she had also worked as an undergraduate. "I was very much into Native American artwork. Rachelle asked me if I was Native American. I lied and said 'yes.'" When Jaquez finally admitted the truth about her heritage, Thiewes encouraged her to make statements about herself in her art. "I had nothing to say about myself. I'm just Mexican—there's nothing to me. I'm just Mexican," she thought. The assignment frustrated her, but she finally decided to concentrate on a family superstition, the *mal de ojo,* or evil eye. Her mother

aware that she might have some artistic talent. One of the lessons in an art class required that she use a grid to duplicate and enlarge an image. Jaquez chose a magazine photograph of an African American woman. "I remember doing the grid and complaining through the whole thing," she says. "I got a failing notice because I hadn't completed the assignment, and my dad couldn't believe I was failing art.

Eppy Bir-day
2000, 66 × 17 × 14 in., metal, wood, Prismacolor, enamel, acrylic paint

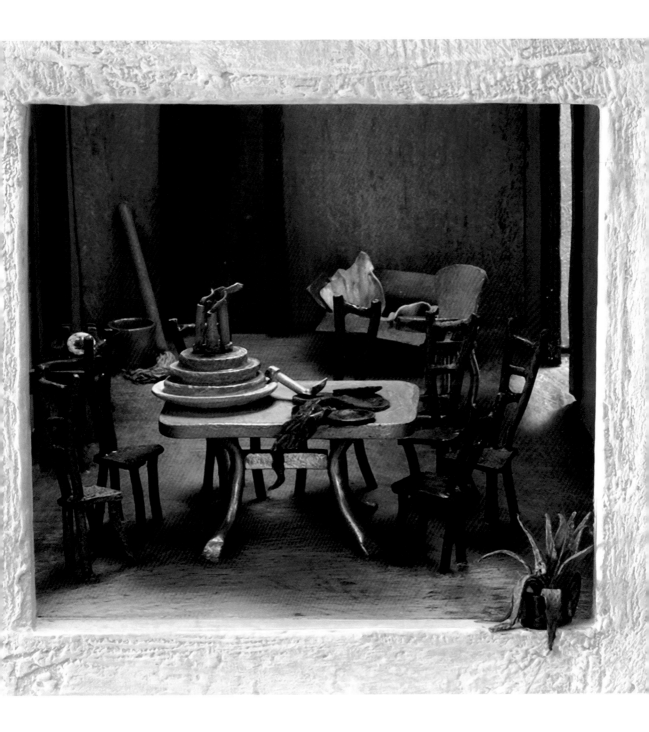

Eppy Bir-day
detail of interior

had often shared the belief that a baby would become ill if it was praised without intervention. A *curandero,* or healer, would have to smear a freshly laid egg on the child's body and recite ritual phrases. Jaquez completed a piece based on the ritual of the *mal de ojo,* and much to her surprise her classmates were familiar with and interested in this folk tradition. This was a turning point in her artistic sensibilities. Memories and cultural influences began to surface and became the focus of Jaquez's artwork.

During her graduate studies, Jaquez initially worked in metal jewelry design. At one point she made a series of brooches but found that they were simply too heavy to be wearable and decided to frame them in boxes. This marked the beginning of using metalsmithing techniques for sculptural forms that eventually developed into her environments. Ultimately, Jaquez found jewelry making too confining, "In jewelry you have to have things that are perfect. Making environments allows more flexibility," she explains.

Over the years Jaquez has come to use a lot of different media and techniques. She fabricates most of the small pieces from metal, soldering them together and then sandblasting them. After removing all the oxidation from them, she applies liver sulfur to make the pieces pitch black again. She then uses Prismacolor pencils for their vibrancy and a waxiness that makes the color adhere well to the metal. She has also experimented with etching the surface of the metal to achieve a textured effect. She uses wood for the larger architectural pieces and often builds up

surfaces with a commercial mixture of plaster and paper pulp that she mixes with glue.

Although her family has encouraged her artistic development, Jaquez says her father always wanted her to be a teacher. "I think he was a little disappointed when I told him I wanted to be an artist. He didn't realize I was going to be teaching also." Since receiving her degree, Jaquez has taught design, metals, art appreciation and drawing at UTEP. Her family always goes to her openings. "Anything I do, they are always there. They've always given me a lot of support. My sisters critique my work and give me advice."

Over the years Jaquez has learned to celebrate her experiences and heritage. "I tell my students, 'Don't be ashamed of who you are and what makes you.' That's basically the most important thing I've learned." In *Eppy Bir-day* she records another childhood experience. The piece depicts her fifth birthday, and the title is inspired by the way her father and aunt pronounced "Happy Birthday." Her mother was in the hospital having Jaquez's baby sister, her birthday gift. "When that happened, I was very unhappy, because my mom wasn't there on my birthday. I thought, 'This is my special day.' My aunt had made me a fabulous tiered cake. It was white with green coconut on top. She had these little candles that were five little cowgirls." The birthday artwork recalls and reinterprets that day. "The box itself has a kind of queenlike feel to it. I was thinking that on your birthday, you're kind of like the queen for a day," Jaquez explains.

Jaquez believes that if she hadn't become an artist and found this way to be proud of

who she is, she might still be trying to ignore her Mexican heritage. Instead, her most recent work focuses on immigration, border issues, and the murders of young women in Juárez. Jaquez regards her miniature environments as a kind of diary, a way to document and celebrate memorable times in her life and ponder the experiences and culture that have shaped her. Through her talents and commitment to memory and place, her artworks bring universal meaning and evoke the richness of everyday lives. L J C

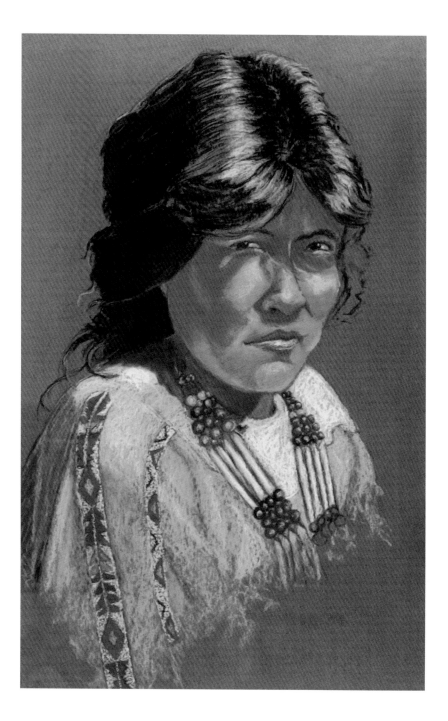

Apache Defiance
2005, 32 × 14 in., pastel on sandpaper

The Art of

DORIS ALEXANDER

———

In finely detailed pastels and unique enamel on copper tiles, Doris Alexander evokes traditional Southwestern themes in her art. Her pastel portraits are realistic in style and dramatic in presentation, with an intense focus on the faces of people she has met throughout her life, whether on her Panhandle cattle ranch or in charming villages in Mexico. Her enamels are architectural studies of New Mexico's adobe sanctuaries, and her pastels are close inquiries into personalities and characters.

Alexander uses live models for her portraits, in which the earthy colored pastels are scratched onto a sandpaper canvas. Giving attention to dominant facial features, she is talented at revealing personality through skin tone and eyes. "I want the viewer to see the person there," Alexander says. "Portraits are my favorite subjects. I think people love to have them, and maybe they become something that is passed down from generation to generation."

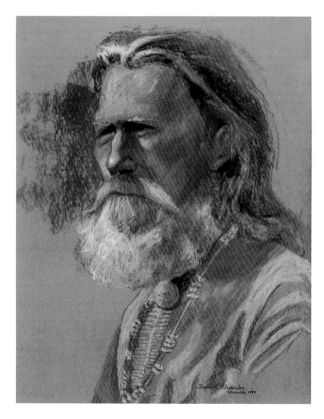

Hody
2001, 13 × 16 in., pastel

In her depictions she places her subjects in a cultural context through attention to clothing and jewelry. The colors and textures of fabric attract her, and she may add a cowboy's bandana, a Mexican blanket, Native American beadwork, or some other cultural signifier to her compositions. In *Apache Defiance* a Native American woman wears beautiful buckskin clothing adorned in detailed, beaded stitchery. With pronounced bones in her cheeks and forehead, the woman sits calmly in an unposed and natural stance. Alexander looks at her subjects from an unobtrusive sideways glance, allowing the viewer to contemplate the person gently and discover Alexander's visual clues about the subject's identity. Often her male and female models look off into the distance with an intense gaze. In *Hody,* Alexander paints a man whose ruddy face is covered with a long, gray beard and moustache as he stares into the distance. He is dressed in buckskin and wears a necklace of bones and beads. The frontiersman needs no landscape to identify his place or time in history. Clothing and ornamentation help define his context.

Alexander has a lifelong love of textiles, an affection rooted in her first creative efforts. As a child, she pieced together the buttons her mother kept in a box for her sewing projects. The young Alexander entertained herself by creating new patterns with the rhinestone, bone, and jeweled buttons. "My mother was talented in needlework and sewing, and I grew up with her teaching all of us girls how to embroidery, crochet, and knit, but I didn't want that," she says. "I was designing my own clothes by the time I was eight years old. My mother would make clothes from my drawings. That continued through junior high and high school."

Born in Haskell, Texas, Alexander grew up on her mother's cotton farm. Her father was a deputy sheriff. "For some years, I spent all my time on design without realizing where it was coming from," she says. Eventually, the love for creating patterns, textures, forms, and fashions led her to design clothes and jewelry professionally.

156

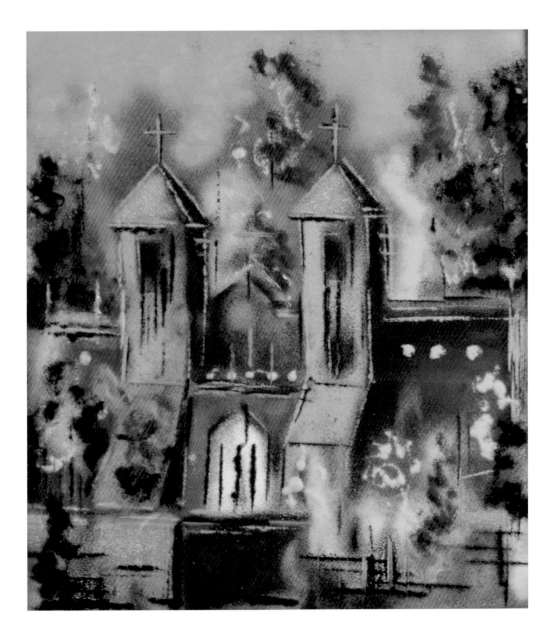

Ranchos de Taos
1979, 12 × 10 in., enamel on copper

The Rose Window
2001, 11 × 12 in., enamel on copper

After she married the late Ted Alexander, a rancher from a Panhandle pioneer family, she attended many cattle shows in Fort Worth, Denver, and Kansas City. "I noticed women did not have much difference in their apparel. They wore denim jeans or skirts, white blouses, and maybe a red bandana. I began designing clothes for women and children to wear to the stock shows," Alexander smiles. "For five years I did the clothes designing, and I was overwhelmed with orders, so many that I kept a number of women working in their homes in what became a cottage industry. I did some beautiful fashions that were unlike anything that others wore." She was represented in two showrooms in the Dallas Market Center, showing her jewelry made of enamel on copper and her fashions.

Alexander is one of the few enamellists in West Texas. "Most enamellists live in China and are paid very little to do enamel on jewelry or bowls," she explains. To achieve her enamel art pieces, she paints crushed glass onto copper tiles, which are then fired in a 1,400-degree kiln. Then the tiles are pieced together into complete compositions that require accurate fitting, like a jigsaw puzzle. Alexander is attracted to the transparency of the glass and the color range she can achieve with the enamels on copper. "The powdered glass creates an effect that one cannot have with paint," she says. "Enameling is a very old art. King Tut's death mask is blue enamel fired onto gold. Humans discovered enameling when someone accidentally discovered that glass would melt in fire."

In *Ranchos de Taos* she applies her enameling technique to portray a two-steepled adobe church in the architectural style of northern New Mexico. The verdant trees and the turquoise sky complement the adobe walls of the church. The level of detail can be seen in the delicate black strokes Alexander paints to distinguish the crosses that rise from the colorful roofs of the steeples. She paints turquoise on turquoise with only a few lines to create the architectural features of the church. In another composition of a church with two steeples, *The Rose Window,* Alexander creates a clever impression of a circular stained

158

Vallarta Vendor
1999, 17 × 11 in., pastel on sandpaper

glass window using dots of blue, yellow, green, and red in the center of the cathedral. The composition is accomplished in four sections, each matching the others perfectly, displaying symmetrical grand arches and windows with the structure's walls reflecting a pink sunrise.

The accessibility, simplicity, color variety, and adaptability of Alexander's pastels inspire her to carry her art making tools with her to celebrate the ordinary people and places she observes during her travels. Throughout her travels to Taos, Santa Fe, and other northern New Mexico locales as well as small villages in Mexico, Alexander finds inspiration for her artistic media in the architecture and people of the old Spanish territory. In *Vallarta Vendor,* standing on a cobblestone street in Puerto Vallarta a donkey with long, perky ears is blanketed with traditional Mexican woolen cloth and laden with items for sale. A wreath of flowers in saturated colors graces the donkey's neck. Even with animals, Alexander focuses on the face and decorative embellishments, presenting cultural signifiers through the textile and wreath that frame the donkey's head.

In a portrait titled *New Mexico Gambler,* Alexander portrays an iconic western man with well-groomed beard, mustache, and hair and wearing a band of Native American beadwork around his cowboy hat. Under the shadows cast by the hat he stares into the distance. Alexander emphasizes his handsome facial features and his gentlemanly demeanor.

Alexander concentrates on rich colors, often contrasting turquoise blue skies with oranges that characterize the cliffs of Palo Duro and Tule canyons near Amarillo, where she lives. She earned a bachelor's of education degree from West Texas State University in nearby Canyon and a master's of art education degree from Texas Tech University. During her higher education, she studied drawing, watercolors, art history, design, metal work, painting, and pastels. "I wanted to learn about what interested me," she says. "I was fascinated by everything I was shown."

Native American history and art complement her interest in Texas history and reveal her romance with the American West. In her master's thesis she wrote a detailed analysis of the work of a third-generation potter of the Santa Clara Pueblo named Joseph Lonewolf, who engraves detailed compositions in natural, terra cotta and green-colored clays using no glazes. "I wanted to write about Maria, but she had recently died. Lonewolf was still living. I was interested in clay at that time, and I wanted to do an original interview," she recalls.

Her own family history also interests her. After completing her graduate degree in 1980, she met and married R. T. "Ted" Alexander, a Hemphill County rancher. Ted was the grandson of Mary Jane Alexander and the Reverend C. W. Alexander, the first Presbyterian minister in the Panhandle and a graduate of Princeton University. In 1884 the reverend was sent to Mobeetie, Texas, and Fort Elliot. As he returned by horseback from his circuit riding visitations, he became trapped in freezing rain near a swollen river and died of pneumonia. Instead of returning to her home, Mary Jane Alexander moved her young family in 1886 to land on the Washita River, near Canadian, Texas, and the Oklahoma border, establishing

the historic Alexander Ranch. Her son and Ted's father became the rancher of the family, and in 1909 he established a registered herd of Hereford cattle. Ted gradually bought into the family business and managed the ranch after returning from his military service in Europe during World War II.

When they moved to Amarillo, Ted and Doris Alexander became active as community arts supporters in their efforts to complement the natural beauty of the Texas Panhandle with equally impressive cultural surroundings. A voice for bringing public art to communities, Doris Alexander garners the attention of governors, mayors, and city councils. In Texas she contributes to statewide support for the arts through her volunteerism, ideas, and leadership. In 1996 Governor George

New Mexico Gambler
2004, 20 × 14 in., pastel

Mare-lyn's Best Friend
2000, 5½ × 7 ft., gloss
latex over fiberglass

W. Bush appointed Alexander to a six-year
term on the Texas Commission on the Arts.
She served as vice-chair from 1996 to 2002,
traveling throughout the state with Laura Bush
to promote the State of the Arts license plate
fundraising campaign.

In Amarillo, as chair of the Center City Art
in Public Places Committee, Alexander's goal
is to add outdoor sculptures to downtown.
She has served as cochair, along with mayor
Trent Sisemore, Richard Ware, and Ed Davis,
in selecting the sculptor and raising funds for
the memorial statue of Amarillo native and
astronaut Rick Husband. She has also worked
on behalf of Amarillo College fine arts scholar-
ships and Texas Tech University. In 2004 Alex-
ander chaired the Texas Tech University Public

Arts Committee for the Amarillo campus,
selecting high-quality artwork from around the
country for the new School of Medicine and
Allied Health building in the medical district
of Amarillo. For her efforts the *Amarillo Globe-
News* named her woman of the year.

"I am interested in art, but I also am
interested in serving. I think art is meant to
be more than a means of success, whether in
competition to win an award or a degree of
monetary compensation, but applying your art
for the benefit of the community," she says. "I
hope my activities in the community will have
a long-lasting effect."

One of the most popular and evident
public art projects in Amarillo that Alexander
has chaired is the citywide art display titled

can West. We still have working horses on our ranches," she says. "The project has been successful because the themes fit, the horses add visual excitement to the city, and the project serves as a fundraiser for Center City."

Alexander has contributed several horses herself. Her first is titled *Mare-lyn's Best Friend,* in which the horse is painted with Marilyn Monroe in some of her classic poses, with jewels, in tight-fitting gowns, holding her skirt down from the wind beneath her on a New York street, and singing "Happy Birthday," to John F. Kennedy. Alexander portrays the glamorous Monroe on each leg of the horse and on each side of the horse's abdomen. The horse's mane is blond like Monroe's hair. Alexander suggests the horse and Marilyn's billowing dress offer a hint of the wind that often blows in Amarillo.

Alexander's artistic palette is full of romance. She captures the essence of a person in realistic paintings that offer an unobtrusive study of a personality revealed through cultural signifiers. Her work is diverse. From clay and metal work to jewelry and fashion design to pastel portraits, enamel on copper, and artistic horses, Alexander joins the very private with the very public. Her enamel works are lasting impressions of places and patterns. Her portraits capture the spirit in their delicate facial features, intense eyes, and personal clothing styles. Alexander dramatizes the ordinary, celebrating places and people in the context of their own making. K D H

"Hoof Prints of the American Quarter Horse— America's Horse" featuring life-size, fiberglass replicas of quarter horses. The blank replicas are painted by local artists, and individuals or businesses purchase the artworks. With more than one hundred horses created in the first four years, the project pays tribute to the animal that has been vital to Amarillo throughout its history. The official sponsor of the Hoof Prints project, the American Quarter Horse Association, the world's largest equine association, is headquartered in Amarillo. Featuring the horse for public art in Amarillo was a natural fit, Alexander says. "The horse is a powerful and graceful symbol of the Ameri-

DORIS ALEXANDER

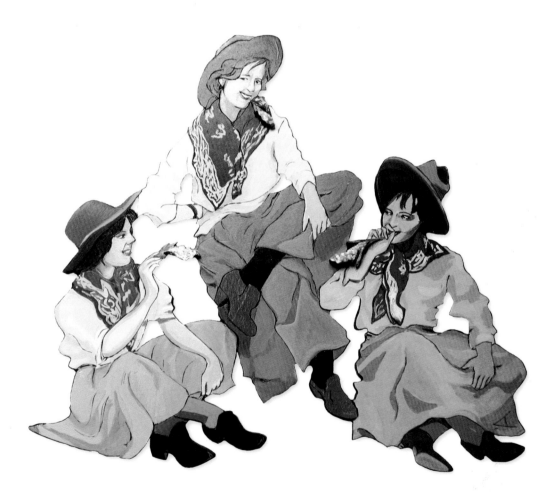

Hallie and the Cowgirls
2004, 15 × 21 × $^{7}/_{8}$ in., Japan color and pyrography (wood burning) on wood

The Art of
ABBY LEVINE

A bby Levine grew up in a middle-class, Eastern European Jewish community in New Jersey. As a child, she recalls not being physically active. Her best memories are of being by herself and drawing in the family den, which was like a small studio. Even then, her impulse to create against the grain, her desire to do the unexpected, was evident. One of her "earliest moments of triumph" came when she was attending a local arts program and, instead of following the instructor's directions to create a papier-maché pineapple by wrapping strips of newspaper around a balloon, she flattened her piece into pizza, much to the amaze-

ment and delight of her young colleagues. Her primary character trait, according to Levine, is her defiance.

Levine arrived in Texas in part because her interest in cowgirl iconography brought her to the Cowgirl Hall of Fame. She had envisioned opening a restaurant in the vicinity, at that

Golem
2004, 46 × 25 × 7 in., Japan color
and pyrography on wood

time located in the little town of Hereford, Texas, but after her visit there Levine realized that Hereford probably was not the right location for her restaurant. She did, however, sell some of her cowgirl cutouts, presented subsequently to Cowgirl Hall of Fame inductees in 1993. Brochures of other places in West Texas led Levine to consider living in Alpine or Fort Davis, apart from mainstream culture, in a town without a Wal-Mart. During that time she showed her art at Lovejean's Gallery in even smaller Marathon, Texas, and she eventually relocated there. Her cowgirl cutouts were featured in *Country Sampler* magazine, and this connection, together with ads for her work, gave her a year's worth of income.

Marathon, Levine says, is a place for those who want to be left alone and live under the radar. The population is under five hundred. The town's heyday in the 1940s centered on mining for the war industry. Eight or ten other artists live in Marathon. Levine says she likes living here because she sees a lot that is not human-made and because the place is not an artists' colony. "The people here are all different." She mentions that she does not drive.

When she moved to Marathon, Levine began to incorporate more political content into her art, shifting away from the cowgirl cutouts. She admits that showing her work in the area is difficult because of its social-political commentary. "It's hard for me to do work that people want to see or hang on the walls of their homes." For her, Marathon is a place to live and make art. She comments that she is much happier than she is successful and relieved she does not have to spend her

life "marching around in black and attending every art opening." Levine describes the New York art scene as antithetical to her nature, though she did survive there as a painter for a number of years before moving west, first to Seattle and ultimately to Texas.

Levine works in wood that she cuts, carves, layers, and paints into complex three-dimensional pieces. She primarily uses Japan color because it is lightfast and dries quickly. The third in a series about the border, *La Frontera III,* is in the shape of the map of the United States, bordered with a chain and with pennies strewn within the borders. At the center of the map is an emblem for the Immigration and Naturalization Service, featuring a drug dog with his long red tongue hanging out and overlapping the government seal. This piece, like the others in the series, represents the increasing militarization of the border

and the closing off of the land of opportunity. Levine explains, "Living near the border with its attendant heavy law enforcement presence really amplified my awareness of the police state that the U.S. was becoming."

Golem is another favorite. The piece reveals a layered, three-dimensional image of George W. Bush in his military flight gear, standing on the flaming ruins of the World Trade Center and surrounded by cutout heads of Condoleezza Rice, Colin Powell, Donald Rumsfeld, Dick Cheney, and their cohorts, like little *putti* witnesses to the scene. Beneath Bush's feet are images of the twelve hijackers. Levine explains that the golem is a figure from a Jewish folktale, a kind of clay man who seems like a real person but lacks depth, intellect, and spirit, a kind of hollow man. Showing her unrelenting acerbic wit, Levine refers to Bush as the "Proxydent."

167

La Frontera III
2001, 8 × 12 × 1.5 in., Japan color
on wood, metal, pennies

ABBY LEVINE

Clown Time Is Over
2003, 30 × 14 × 2 in., Japan color,
enamel, and pyrography on wood

Levine is a news junkie, as is evident in pieces such as *Clown Time Is Over.* In it she ironically juxtaposes scenes from contemporary American politics, reproducing newspaper images in paint on wood panels to create a triptych. *Clown Time,* done during the Enron hearings, depicts a number of protagonists of Enron and Worldcom testifying before Congress. At the time, Levine says she thought justice might be done.

At the Tyler School of Art in Philadelphia, Levine studied with a graduate student who was writing a dissertation on Alexander Calder. One thing that impressed her was "the seamlessness of Calder's art and life, the manner in which he satisfied his requirements by being self-sufficient," she says. "He solved his own problems by using his hands and the materials available to make what he needed, rather than thinking of artists as elite professionals who manufacture luxury objects to titillate a bored and attenuated upper class." Calder made functional things, but not products. Levine always has regarded her work as kindred with Calder's. She describes her art as having "occupied the same border territory as his, where art, craft, and toys elbow one another." Her other aesthetic influences are folk art and the works of outsider artists, such as Julio Gonzales. A Mexican artist who was institutionalized in the United States, Gonzales produced intricate drawings on potato sacks, filling every inch in his "horror of the empty space." Levine describes her own art as similarly obsessive, intricate, and detailed, and she values taking an obsession and "just pushing it."

Obreros (Workers)
2008, 20 × 20 in., acrylic on paper

Hebrew School Blowback
2004, 6 in. diameter × 9 in high, Japan color,
enamel, and pyrography on wood, cloth

Levine rarely makes art based on her own
experiences or origins and wonders if this
is a deflection, a way of not dealing with her
interior self. However, one piece, titled *Hebrew
School Blowback,* refers to one of her own
childhood experiences. The work is a replica
of the collection cans that were used for dona-
tions to the United Jewish Appeal. The coin
slot on top is in the shape of an Uzi assault
pistol, and the center of the cylinder is cut out

to expose an interior that houses the Hamas
logo and a Palestinian woman suicide bomber.
On the back of the can is the "Plant a Tree"
logo from the Jewish National Fund.

"The ostensible purpose of these collections
was to plant a tree in Israel," she explains. "We
were taught that Israel was a barren wasteland
and that it took the Jews to 'make the desert
bloom.' We gladly put our nickels in the cans.
Now it has become common knowledge that
the money collected aided in the establishment
of settlements in the Occupied Territories,
which, in turn has led to the rise of violent
resistance organizations such as Hamas. It is
difficult to realize that one has been subjected
to propaganda—and participated, even un-
knowingly, in ethnic cleansing."

Levine says her time in Hebrew school
coincided with the Six Day War. "The war
heralded not only the increased militariza-
tion and aggression of the Israeli government
but also the advent of what is known as the
Holocaust Industry," she observes, expressing
her outrage that the genocide of the Holo-
caust is somehow being used to excuse more
death and dying in the present. "I feel that it
is somehow necessary to disassociate myself
from the actions of the Israeli government,
and this piece is my attempt to acknowledge
and atone for my complicity." Levine regards
her work as a kind of retribution. It is obses-
sive, detailed, and learned, clearly the expres-
sion of someone well-read and astute. To help
make her point about militarism she refers
to an essay by Jean Baudrillard, "The Spirit of
Terrorism," in a 2002 issue of *Le Monde*—an
analysis of how hegemony invites terror.

170

Loving the additive process and detail that draws the viewer into her work, Levine creates visual texts that must be "read," and in this sense her work is as textual as it is textural. She is influenced by toys and board games and delights in making small versions of big things and incorporating elements from the past into her art. She often uses verbal rather than visual clues and loves doing commissions because she gets to understand things outside herself, beyond her own range of knowledge.

Despite the prevalent social and political commentary that form the basis of her art, Levine nevertheless aspires to engage her viewers and draw them in. At an opening in Houston, she recalls an elderly woman who approached her to say that she had made herself "very small and just walked around her

pieces for awhile, and had a wonderful time." This approach makes sense to Levine, who believes that art must be approached on its own terms because it is not "some magical realm where you walk around and everything's going to be beautiful."

In West Texas Levine has found a place that "puts the human race in a better perspective than in the city, where everything around you is made by other people, where you think you have some power as a human being. But when you live in a place like this, you really see the absolute indifference of nature. And you really have the responsibility to pay for your time on the planet." In working against the grain in the quiet expanse that surrounds her in Marathon, Texas, Levine is indeed giving back, paying for her time on the planet. L J C

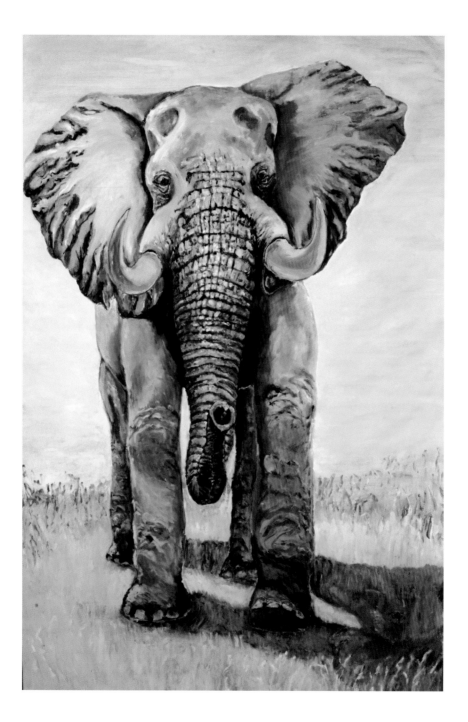

Surge Two
2007, 5 × 4 ft., oil

The Art of

PATRICIA KISOR

———

Patricia Kisor works in the same themes that she featured in the sand sculptures she made years ago during the summers when her family camped at Lake Meredith and its sandy beach area in the Texas Panhandle. With her husband and two young sons watching, Kisor sculpted turtles, frogs, alligators, and other favorite wildlife creatures. Other campers and beachgoers always protected her creations by building moats and encircling the sculptures with rocks to keep out the waves and destruction. Kisor appreciated these gestures of respect and began creating more permanent art that, still today, reveals her deep spiritual connection to the earth and its creatures. In sculptures made with metal and wire and in brightly colored oil and acrylic paintings, Kisor concentrates on images of African animals in a celebration of biological diversity.

Roundabout
2008, 21 × 12 × 11 in., metal

In her work she sends a message: Humans and animals are more alike than different, and we must share this planet.

Kisor's passion lies in the simplicity, rawness, and honesty of nature. "I've always been fascinated by the way Mother Nature has no set rules," she says. There's no wrong and no right in nature. Survival is a day-to-day thing of eating and reproducing, the simple kinds of existence in the animal kingdom. With Mother Nature, that's the way of it. Mother

Nature is fair and abundant in her rightness of survival."

On a large canvas, Kisor paints *Surge Two,* an elephant standing during a sunrise in the flat horizon of Africa. Even with its tusks, wrinkles on its trunk and ears, and muscular head, the elephant shows gentleness in its eyes. Another eye in the shadow of the lower part of the composition reveals another elephant, a baby following under the shadows of its mother's belly, both on the move as the mother takes a step forward. "In the elephant family, the herd is run by a matriarch, putting the oldest, most knowledgeable female in the lead," Kisor says. "Elephants are the largest and gentlest of the animal family, even though their strength is great. They are noble giants."

A black and chrome sculpture of an elephant, *Roundabout,* shows Kisor's abilities in working with metal. She uses a plasma cutter on metal ducting material to make concise, curving lines that follow around the column to create the elephant's trunk, legs, tail, and ears. She leaves the metal in its rough texture to simulate wrinkles. With its reflective inner surface Kisor looks into the giant mammal's soul, and the viewers see themselves in the mirrored view. "He turned out better than my vision," Kisor says. "He's fun, and I want the impression of him moving toward you."

Kisor's paintings and sculptures often are studies of animal movement. She captures the spirit of the animals in bold strokes that are continuous, direct, and impressionistic. She often paints using as few lines as possible, bringing a sense of movement with the rapidity of her brush strokes, and she often

Three Zebras FACING
2007, 8 × 3 ft., oil

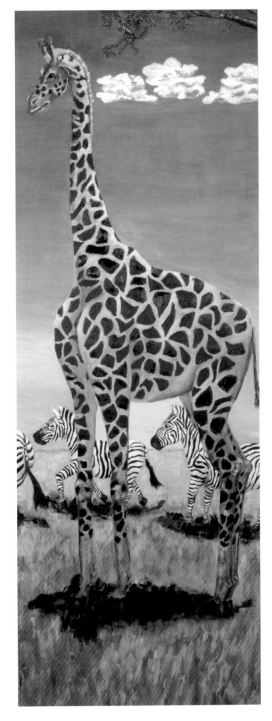

uses a narrow palette of colors to achieve her effects. Kisor explains, "The spontaneity of not thinking about the exact colors of elephants, giraffes, or lions is a good and relaxing exercise. Spontaneity is attractive."

Portraying the uniqueness of each animal, Kisor sometimes overemphasizes the anatomy. In *Three Zebras* she shows the vibrant colors and diversity of the African ecosystem. In this tall composition a dramatically vertical giraffe with billowing shoulder muscles holds up a long, narrow, and delicate neck. Behind the giraffe, standing under a tall eucalyptus tree, are three zebras, which offer a visual contrast of black-and-white lines to the color patch of the giraffe under a blue, partly cloudy sky.

In another animal study, *Hauling Ass,* Kisor portrays a running leopard, displaying the musculature needed for the coordination and speed of the big cat. She says she breaks the rules of traditional wildlife art by painting so many specific spots, but she intends to show detail and motion simultaneously.

Kisor also has studied the water buffalo and admires its courage. "These water buffalo are dangerous," Kisor says. "They hide in deep bushes and charge without provocation. They are savage. The young ones are a mainstay of lions. They are hard to kill and are super vicious in defending their herds. I find it interesting that they show no hesitation or fear."

Kisor is sensitive to the sad look sometimes seen in an animal's eyes. In her observation of lions, she explains they "are hypnotic when they look at you. They see right through you and look elsewhere as if you were the most insignificant thing there. They are not

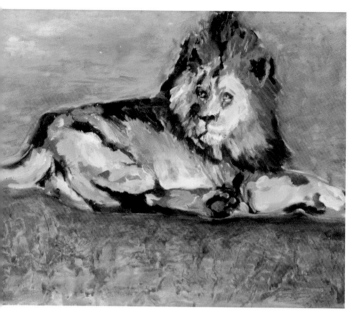

Portrait of a King
2007, 20 × 24 in., oil

interested in looking at us, where we are focused on trying to face them down. When you look at a lot of animals' eyes, there is not malice, not hate, not unfriendly eyes, just blank stares. Their eyes don't reveal what emotions you and I can see in our eyes."

In a lion painting, *Portrait of a King,* Kisor creates a loose impressionistic sketch of a resting, satisfied, full, and comfortable lion with his massive front paws extending lazily in front of him. "I believe they are magnificent animals. I hope we never say it was their time to be extinct, that we truly can keep areas for them to run wild and do what they naturally do before we got involved."

To accurately portray the animals, Kisor uses an actual big cat's skull with veins running throughout the bones. She also studies charts of the skeletal, muscular, and nervous systems to be exact in her depictions of anatomy. Lions carry not one ounce of unnecessary fat in their muscular system, she says. "Female lions are killing machines. The saber tooth tiger, *Smilodon,* had humongous cuspids. These skilled predators would jump on the backs of prey and sink their teeth deep into the neck area, wrapping the prey's body with their muscular arms and long claws. Big cats have massive shoulder muscles and necks," she explains.

Kisor often visits the zoo in Amarillo, Texas, where she owns a gallery and is an animal advocate. She describes the zoo's three new lions, whose eyes are still bright, shiny, eager, and enthusiastic. "But, the black leopard that already resided there has eyes that are dulled, dark, and seemingly gone. His eyes don't respond; he doesn't have hope anymore," she says. "I feel sad when I go to zoos because the animals are in cages and out of their element of what survival means every day. However, I am glad zoos allowed me to show my kids the many animals of the world."

Kisor always has lived close to the land and to animals. She was born in Oklahoma, and her maternal grandmother lived in the country near Wewoka, Oklahoma, where she spent a couple of months every summer, even after the family moved to Amarillo. "In Oklahoma, survival is real basic: If you want to eat, you go pick green beans," Kisor says. "I learned to garden and to can vegetables from my

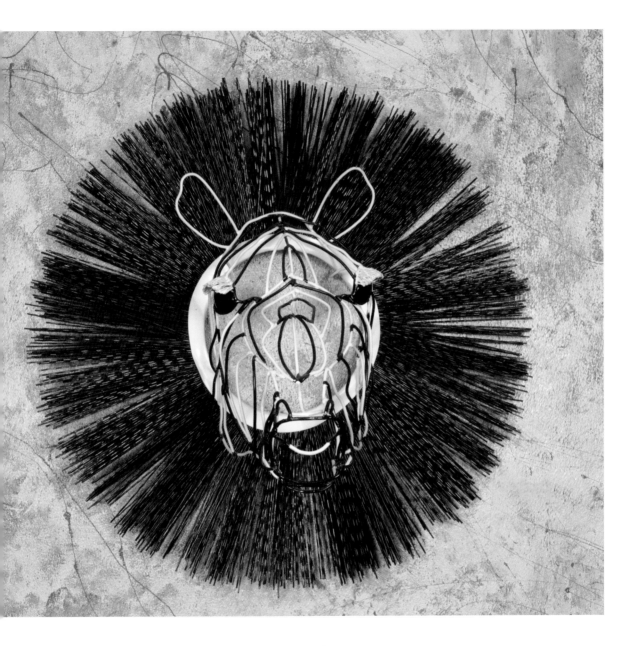

Zebra Perspective
2004, 32 × 22 × 6 in., mixed media and metal

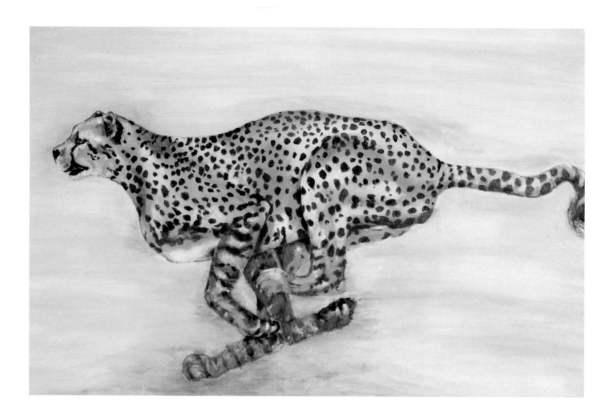

grandmother. I spent my time outdoors with the pigs and cattle, and I fished at the pond. I was encouraged to look, explore, taste, get involved, or just try new things."

Kisor's Uncle Jack inspired her interest in animals. Handsome and dark, like seasoned copper, he was funny and told wonderful stories, Kisor remembers. He loved Mother Nature, and for a time he housed a sampling of animals. During various summers Uncle Jack had many different breeds of dogs, a huge sow with many little pigs, a bobcat that sat all day on his work desk, a caged and vicious badger, and fox squirrels.

Early on in her art career Kisor realized that she wanted her works to be available for people to see and ponder for years to come. "Art is a refreshing avenue of pleasure and thinking. I am addicted to my creative time and to that feeling of getting into the art mode," Kisor says, noting that she plays 1960s and 1970s music while she works. In her self-owned business as an orthodontic dental fabricator, she works with retainers, bending small wire to set specifications. The move to thicker, industrial wire was a natural exploration for her art, which began in clay and stone carvings.

Hauling Ass
2008, 24 × 36 in., oil

With strong hands she sews wire and screen and bends and welds metal. "I have learned to put duct tape on my hands and fingers when I am sewing with metal thread and wire. My hands are scarred. The wire sculptures came real easy for me. I get totally into a trance, and all I want to do is that. I have a love for anatomy. I would have been a surgeon in a heartbeat. I'm very good with my hands."

In mixed-media sculptures made with industrial brushes discarded by street cleaners, Kisor creates animals usually with a scalloped mane and a head protruding, an allusion to a mounted head hanging on a hunter's wall. In *Zebra Perspective* she creates the image of a zebra with big, clear, black, and bright eyes. The stiff brushes simulate the coarse hair of a zebra's mane, and black and white thick wire make the animal's head, suggesting many details in few lines and elements.

Always investigating the forms and lives of the animals she portrays, Kisor often stares at spiders, ants, chameleons, squirrels, or other nearby wildlife on her rural property, where she lives and has a working studio. *National*

Geographic magazines and wildlife documentaries are Kisor's reference libraries for her paintings and sculptures. "Just look, and Mother Nature will provide," she says. "I am provided with wonderful research material every day."

In her work, artist Patsy Kisor concentrates on Africa's creatures in simple but essential compositions of daily survival without fences. "We steadily are encroaching on what has always rightfully been all animals' domain," she says. "I want to see, in that African landscape of timeless serenity, a leopard stalking an antelope, to witness the supreme sacrifice of one species to another so one will survive." Feeling a closer relationship with animals than with humans, Kisor insists on the evolutionary and environmental connections between humans and animals. "The human species is part of the animal kingdom; we are just bigger and meaner than some." Her work is an exploration of the diversity and common survival mechanisms of the wild creatures of the earth. K D H

179

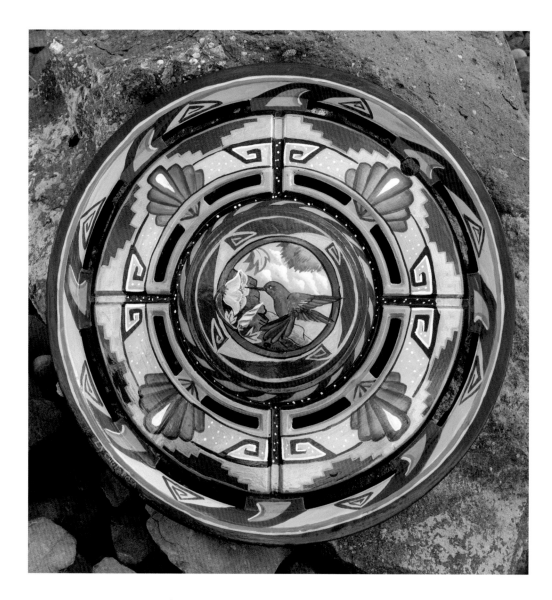

La chuparosa (Hummingbird)
2000, 16 in. diameter, acrylic paint on hubcap

The Art of
COLLIE RYAN

For the past twenty years, Collie Ryan has been collecting hubcaps and painting them with mandalas at her homestead near the small town of Lajitas, Texas, where she lives a full and meditative life. She explains that all of her mandala designs use the basic symbolism of the circle and the cross, noting, "All cultures have used it, because it's the holiest symbol, incredibly powerful and ancient. The circle and square are the basic building blocks of all things: signs, people, plants." She points to the cliff above, "Up there, there's a jutting rock and a little gap underneath it, a small cave with a rock down in front of it. There are hunting scenes and a circle with a cross. I had been doing my mandalas, and when I saw that, I just resigned myself to fate."

Before she paints, Ryan prepares herself, often by arranging a flower in a vase or cleaning. But once she begins, she gives it all of her attention. First, she covers the hubcap with a

rough, flat white, inexpensive paint. Next, she sketches the design in pencil, a central motif surrounded by repeated patterns that may be geometrical or floral. She incorporates lines and dots into the repeated motifs. After she has outlined the design, she "throws on the color."

Ryan uses simple desert scenes, the elements of her environment: cactus, the Rio Grande, a hummingbird in a mandala titled *La chuparosa,* butterflies of spring in one titled *Las mariposas primaverales,* and a snake in a piece simply titled *La culebra.* Others are based on conversations she has with those interested in buying. She listens carefully to what they say. Many of her mandalas are painted entirely in earth tones, with contrasting shades of blue and bits of white. The outer circle is often painted with geometric designs that are similar to those found on pueblo pottery. These designs may be set on point, creating what appears to be a moving, gyring frame for the central image.

Volando hacia casa (*Flying toward Home*) depicts an eagle soaring over a pueblo. Some of the scenes are fanciful. In *Café sabroso* (*Delicious Coffee*) the central motif depicts a roadside cafe with a winged coffee cup flying into the air. A man and a woman are perched on the cup, swept heavenward by the delicious coffee. Ryan incorporates variations into each piece, just as Native American weavers leave an imperfection in a blanket or basket as a place for the energy to exit and enter. She explains, "These slight variations cause a fluid motion in the hubcap."

Ryan's home site is magical in its integration with its surroundings: the Chisos Mountains and the Rio Grande nearby. She has cleared several small outside areas for different activities, such as gardening, painting, cooking, or simply sitting outdoors, all connected by pathways made of small, flat limestone pavers, the kind of rock found in the river here and for which Lajitas ("little flat rocks") is named. Hundreds of tall stalks of the sotol plant, so prolific throughout the Chihuahuan Desert, are lined up to form a ramada and provide shade. Mesquite and creosote bush, yucca, lechuguilla, candelilla, and ocotillo abound.

Ryan produces some of her own food from her garden, a small island of green that she has protected from the intense desert sun with the makeshift shade of the sotol. She spends most of her time at home, though she sometimes has to leave for four or five days to go into town, where she sells her pieces, collects and sends mail, and stocks up on supplies. She is an observer of nature and has learned from watching that "nature thrives in little protective baskets, . . . not spread out."

For her home, Ryan has converted a 1930s Bluebird school bus into her living space. A small sofa sitting beside the bus is also shaded by the ramada. Nearby she has placed the Mayan calendar painted on a huge plaster disc. Although the exterior of the bus is rusted and discolored and its tires are frayed, the inside is cozy, complete with carpeting and a wood-burning stove. Some areas of the bus have been decorated with Southwestern motifs: birds flying across the sky, a clay pot poised in an archway. "So everything here is still sort of junk," she explains. "I did finally

182

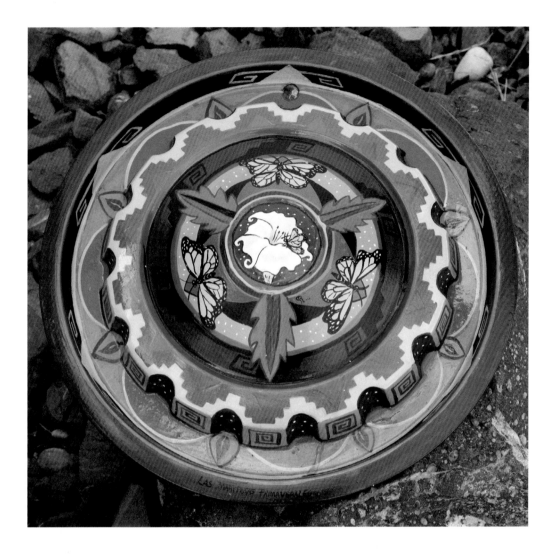

invest some money with a worker to build my ramada, but the rest is built without money. That's the principle: it comes together through luck, creativity, and help from my friends." She tells the story of an indigenous group who make their houses out of a certain kind of grass, and every two years or so they have to rebuild. Families help families, and the rebuilding keeps community together.

"As you can see, I live on a different basis than most people. I live like this because it's a school, because I base my life on equinox and solstice." Here she has to listen to and deal with nature constantly. She knows the power

183

Las mariposas primaverales (Springtime Butterflies)
2000, 16 in. diameter, acrylic paint on hubcap

COLLIE RYAN

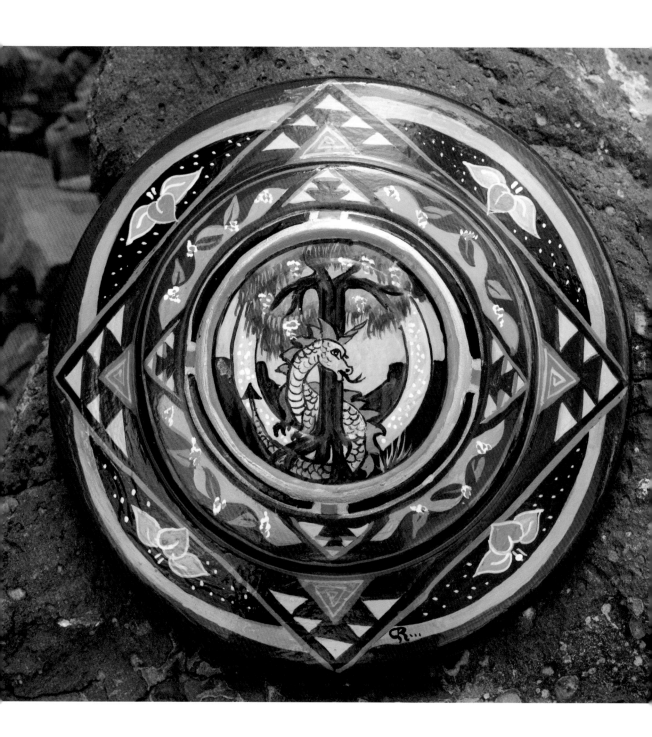

La culebra (Snake)
1999, 16 in. diameter, acrylic paint on hubcap

and importance of water. She learned from others how to live close to the land in the desert environment, preferring this way rather than being "on the treadmill, wasting one's life." She claims to have enough self-discipline "to do nothing sometimes," and she states, "I live like this so I can have time to study and be."

Ryan believes that there are power spots in the earth, portals that are energy points. They give a "sense of waking up, and you are nourished by those places. You go walking out in the country and then you start dropping your mind and thoughts. You let your feelings take you, and you will find these magnetic spots, lie down and take a little nap, and go away refreshed." Ryan believes that there are people and places that help restore the earth's balance, "like the weights on the tires." She claims that her homesite "has been a camp for as long as people have been along this river. My feeling is that this has always been a peaceful place." Finely attuned to a sense of place, Ryan homesteads here because of its power and its history. Wanting to set an example for living, she recognizes that "if you want to do something for the world, you start with yourself and do something healing for the earth. Amazingly, this little corner is so far

Volando hacia casa (Flying toward Home)
1999, 15 in. diameter, acrylic paint on hubcap

COLLIE RYAN

away, and yet I have touched all over the earth. My hubcaps are in Europe and Canada and all over the United States."

Ryan was born and raised in California. Her parents were writers. Her stepfather was a philosopher, and she grew up among intellectuals. Early on she realized that the world of the mind needed to be readjusted, a disconnection needed to be bridged. And so she studied art at San Francisco State University and sold her paintings in the Bay Area for twenty years before deciding to retreat to simpler ways. She has no electricity, and she must haul all the water that she uses. She

Café sabroso (Delicious Coffee)
1999, 16 in. diameter, acrylic paint on hubcap

seeks integration, explaining, "My art and my life and everything is one woven basket. It's not separate. That was my intent." In addition to painting, she writes poetry and composes music, sings, and plays the guitar. Although she did not study music in college, she sang in choirs from the time she was eight years old and took voice lessons from opera singers. "I've sung everyone else's songs, hundreds of folk songs. And then, at some point in my path, a friend asked, 'Why don't you write your own?' So I started out almost thirty years ago. I've written at least three or four hundred worth remembering. I keep them all cataloged and on tape." She says that if she had more time, she would spend it writing songs and composing.

Ryan is a student of Theosophy, a belief system based on the oneness of all life and individual spiritual realization. Unconnected to any formal religious practices, church, or dogma, Theosophy instead encourages the study of all religions, science, philosophy, and spirituality. The works of Theosophy provide Ryan with a kind of owner's manual that includes basic principles of what it means to be human and the laws that govern the universe.

Her awareness of oneness with nature is evident in Ryan's approach to her art and the art itself. "The world may have its computers, but this lifestyle helps my art. I don't think I could do as good a job on the mandalas if I got successful and had an apartment in the city. . . . [Here] I am plugged into the weather and the seasons." And since life is one, the human race is one, what an individual does affects the whole. "Even as isolated as I am out here, it amazes me how much of the world I can touch just from this corner."

Ryan's work area has a table covered with a red and white checkered tablecloth and a chair. Hung around it are *ojos de Dios,* "God's eyes," strung in once brilliant but now faded colored yarn. The intense sunlight shines through amber, blue and red bottles that Ryan has stuck upside down on some of the sotol fence poles. Off to one side is a small shrine, a collection of smooth stones; toy cars of plastic and wood; a small, faded Santa Claus; and a vibrant pink potted geranium. In every direction there are hubcaps—some painted, some not. They hang from trees or are arranged in a row against a fence. Those that hang on the ocotillo and rest against prickly pear are different from her more finished work. All turquoise, white, and black, these are painted with geometric designs that both conform to the hubcap construction and contrast with its shiny chrome.

Ryan sells most of her work by word of mouth, and from time to time she has some pieces in the Kiowa Gallery in Alpine or in Christina's World in Lajitas. She had a retrospective at the latter in 1997. Although she never has more than one or two of her finished works on hand at a time, there were over seventy hubcaps in the show, all on loan from their owners, and there has been some talk lately about organizing another show. "I love to do them, and it seems that people need them," she says. "They love their mandalas. Working with this, you're working with magic." For Ryan this engagement with the magical means touching "the subtle principles of life for the benefit of all." L J C

187

INDEX

Titles and page numbers of images, as well as photographs of the artists, are in the Illustrations list on pages ix-xi.

Abiquiu, New Mexico, 126

abstract, xix, 11, 28, 35, 59

acrylics, xvi, 10, 41, 45, 80, 100, 173

Africa, 142, 174; animals, 173; creatures, 179; ecosystem, 175; landscape, 179; spirits, 74

African American woman, 150

Akins, Future, xv, xvi, 68-75

Albuquerque, New Mexico, 7, 22

Alexander Ranch, 161

Alexander, Doris, xv, xvi, xix, 154-163

Alexander, Mary Jane, 160

Alexander, R. T. "Ted", 158, 160, 161

Alexander, Reverend C.W., 160

Alfred C. Glassell School of Art, 54-55

Allen, Terry, 131

Alpine, Texas, 22, 166, 187

altar, 55, 125, 126

Amarillo, Texas, 17, 80, 81, 120, 122, 160, 161, 162, 163, 176

Amarillo College, 162

Amarillo Globe-News, 162

America, 106, 150

American, 44; adulthood, 105; *American Bandstand*, 72; Plains Artists, 119; politics, 168; quarter horse, 80; Quarter Horse Association, 163; Southwest, xiii, xvi, xvii; story, 72; West, 160, 163

Anasazi, 14

Anglo, 42
Antonioni, Michelangelo, 28
Arabic writing, 108
architecture, 14, 42, 98, 100, 105, 106, 108, 160
architectural: details, 56, 103; element, 52, 100;
 features, 106, 158; forms, xvi; sculptures, 88;
 studies, 155
Arizona, 75
Arkansas, 81
Armenian, 108
Arnett, Toni, xx, 134–143
art deco, 51
Asian: jade, 14; space, 99; symbol, xvii
assemblages, xvi, 50, 97, 100, 102, 125
At Water's Edge, 36
Atlantic coast, 120
Austin, Texas, xiii, 130
Autobiographical, xvi, 69
Aztecs, 42

Baathist regime, 106
Baghdad, Iraq, 105, 113
Bagley, Bill, 95
bas-relief, 14
Baudrillard, Jean, 170
Bay Area, 186
beads and beading, xvi, 69, 74, 132
Beijing, China, 142
Beirut, Lebanon, 108
biculturalism, xix, 42
Big Bend, xiii, xviii, xix, 21, 24, 25, 29, 54, 56;
 Big Bend National Park, 22, 52, 54
Black Cross, 132
Blue River, 37
Bluebird school bus, 182
Blytheville, Arkansas, 72
Boerne, Texas, 29
Borrowers, The, 102
Botero, Fernando, 88
Brewster County, Texas, xix, 21
Brink, Pamela, xx

Brommer, Gerald, 45
Buddha, 99
Buñuel, Luis, 28
Bush, George W., 161, 162, 167
Bush, Laura, 162
Butler, Marilyn, 7

Cadillac, 25
Calder, Alexander, 168
California, 44, 45, 47, 130, 150, 186
Canada, 186
Canadian River, 115, 116, 119
Canadian, Texas, 118, 160
Canyon, Texas, 17, 79, 84, 160
Caprock Escarpment, 116
Catholic, 6; icons, 42; faithfulness, 45; religious
 symbolism, 47; saints, 128; school, 36; Ca-
 tholicism, 6
Caucasian, 111
Center City Art in Public Places Committee, 162
Central Valley [California], 44
ceramics, 13, 55
Cezanne, Paul, 88
Chamula, Mexico, 10
Chavez, Cesar, 44
Cheney, Dick, 167
Cherokee, 84
Chiapas, Mexico, 10
Chicana, 44, 45
Chicano studies, 44, 45
Chigger Creek, 66
Chihuahuan Desert, xiii, 21, 182
Chimayó, 125, 126, 128
China, 158
Chisos Mountains, 22, 182
Christ, 126
Christian: church, 6, 158; cross, 3, 4, 6, 10, 47,
 138, 158, 181
Christianity, 10
Christina's World, 187
Citadel, 108, 110

190

clay, xvi, 37, 98, 100, 119, 128, 130, 132, 149, 160, 163, 178, 182
cloth books, 69
Cline, Patsy, 128
clothing design, xvi, 156
Cloudcroft, New Mexico, 141
collage, 10, 28, 82
colored pencils, 41, 47, 77
Congress, 168
Connecticut, 120
Country Sampler, 166
coup d'oeil, 143
Cowgirl Hall of Fame, 165, 166
crucifixion, 4
Cullum, Linda, xvii, xix, 86-95
cutouts, 42, 44, 166, 167
Cycladic sculptures, 128

Dale, Bruce, 26
Dallas, Texas, xiii, 142; Dallas Market Center, 158; Dallas Museum, 3
Davis, Ed, 162
Day of the Dead, 10
decorative arts, xvi
Denton, Texas, 7, 66
Denver, Colorado, 158
Depression, the, 50, 84
Desert Dance, 22, 26
digital manipulation, 60
diorama, 102
Disney, 51
Diva Terlingua Gallery, 55
drafting, 95
drawing, 4, 6, 7, 10, 11, 17, 37, 38, 45, 56, 70, 90, 97, 100, 102, 119, 120, 122, 152, 156, 160, 165
Duby, Eleanor, 56
Dutch painter, 147

Eagle Pass, Texas, xviii
earth work, 37

East Texas, 130
East, the, xvii
Eastern European Jewish community, 165
Eastern-themed space, 99
El Paso, Texas, xiii, xviii, 41, 42, 45, 47, 145; El Paso Community College, 45
Ely, Joe, 131; Joe Ely Band, 92
enamel on copper, 155, 158, 163
enameling, 158
enamellists, 158
Enron, 168
environment, xiv
Europe, 142, 161, 186
European masters, 106, 138
extrusion, 18
ex votos, 126

Far Flung Adventures, 24
femininity, 73, 90
feminist, 73; literature, 60; movement, 92
Flores, Francisca Losoya, 6
Fort Davis, 166
Fort Elliott, 160
Fort Worth, Texas, 142, 158
found objects, xvi, 14, 31, 95, 97, 102
foundry work, 119
French, 64, 135
Friendswood, Texas, 64, 66
Fuentes, Tina, xix, 2-11

Gauguin, Paul, 136
Geographic Traveler, 26
Germany, Robin Dru, xx, 58-67
Gervasi, Frank, 138, 141
Gilmore, Jimmie Dale, 131
Ginny dolls, 26
glass, 37
Glidden's Paint Store, 141
Glover, Tom, 16
Gonzales, Julio, 168
Goodacre, Glenna, 141

graphic, 97, 99, 100
Greece, 128
Greek statues, 31
Grisham, Marilyn, xvi, 12-19
Guadalupe Peak, 42
Guest Drug Store, 66
Gulf Coast of Texas, 66

Haitian, 69, 74
Hamas, 170
Hancock, Butch, 131
Harley-Davidson, 16
Haskell, Texas, 156
Hebrew School, 170
Helen Jones Foundation of Lubbock, ii
Hemphill County, 160
Hereford cattle, 142, 161
Hereford, Texas, 166
Hickmott, Delmos, 7
Hill Country, 38
Hill, Tom, 45
Hispanic Southwest, 126, 128
Holocaust, 170
Hoof Prints of the American Quarter Horse–
 America's Horse, 163
Hong Kong, 28
House Beautiful, 28
Houston, Texas, xiii, 54, 55, 64, 171
hubcaps, xvii, 181, 186, 187
Hub of the Plains, 130
human figure, 4
Husband, Rick, 162
Hussein, Saddam, 106, 108

imagineering, 51
Immigration and Naturalization Service, 167
Imperial Palace Hotel, 28
impressionistic, xx, 174, 176
impressionists, 117, 136
Incan art, 128
Indian paintbrush, 116

Indiana, 37
Indiana University, 37
installations, xvi, 31, 35
interior, 97, 98, 102
Iraq, xix, 106, 108, 110, 113
Israel, 170
Jaddo, Lahib, xix, 104-113
Japan, 167
Japanese rock garden, 99
Jaquez, Anna, xv, xvi, 144-153
Jenssen, Dale, xvi, xvii, 48-56
Jenssen Gallery, 55
jewelry, 55, 98, 100, 152, 156, 158, 163
Jewish, 167
Jewish National Fund, 170
Jews, 170
Juárez, Mexico, 145, 153
Judge Edward S. Marquez Branch Library, 42

Kahlo, Frida, 88
Kansas City, Missouri, 100, 158; Kansas City Art
 Institute, 100
Kennedy, John F., 163
Kentucky, 37
King Tut's death mask, 158
Kiowa Gallery, 187
Kirkuk, Iraq, 108, 110
Kisor, Patricia, xvi, 172-179
Kline, Franz, 3
Kodachrome, 22
Konis, Ben, 120
Koran, 108
Krum, Texas, 142, 143

Lajitas, Texas, 181, 182, 187
Lake Meredith, 173
Lake Tanglewood, 79
landscape, xviii, xx, 14, 22, 24, 42, 54, 56, 74,
 105, 106, 108, 115, 122, 132, 156
Latin American authors, 88
Latino music and dances, 4

Le Monde, 170
Lebanon, 110
Lee, Russell, 22
Lemons, Nell Lill, 17
Levine, Abby, xvii, 164-171
lighted artworks, 49, 52
Lindenwood College, 119
linocut, 69, 70
Little Rock, Arkansas, 22
Llano Estacado, xiii, xviii, 66
Lonewolf, Joseph, 160
Louisville, Kentucky, 36
Louvre, the, 28
Lovejean's Gallery, 166
Lubbock, Texas, xiii, 10, 37, 38, 66, 70, 92,
 95, 102, 105, 113, 126, 130, 131, 132,
 141, 143
Lynch, Tracy, xv, xix, 20-29

Madonnalike, 128
Maines, Pat, xv, xvi, 96-103
Mamiya C3 camera, 60
mandalas, xvii, 181, 182, 187
Marathon, Texas, 166, 171
Marco Polo Hotel, 28
Marsh, Tom, 37
Matisse, 88
Maya, 10, 128, 182
membrillo, 44
Merleau-Ponty, Maurice, 64, 66
Mesopotamia, 108, 110
metal, xvi, 50, 51, 52, 54, 55, 56, 90, 95, 100,
 132, 141, 150, 152, 160, 163, 173, 174, 179
Mexican, 150, 160; artist, 168; Catholic, 128;
 Chihuahuan Desert, 11; culture, 47, 88; folk
 art, xvi, 125; folklore, 146; heritage, 153;
 store, 126; traditions, 146
Mexican American, 44; culture, xvi, 42, 146;
 heritage, xix, 145
Mexico, 42, 126, 145, 147, 155, 160; Mexico
 City, 26

Miami, Florida, 26
Mickey Mouse Club, 72
Middle East, 106, 110; Middle Eastern child-
 hood, 105, 112; Middle Eastern clothing,
 112
milagros, 47
Milosevich, Deborah, xvi, 124-132
Milosevich, Paul, 130
miniature, miniaturist, xvi, 97, 100, 102
Minton, James, 95
mixed-media, xvi, xvii, 31, 37, 39, 42, 45, 47,
 97, 100, 179
Mobeetie, Texas, 160
Modesto Junior College, 45
Modigliani, Amedeo, 88
Monroe, Marilyn, 163
Moore, Betty, 26
Mora, Pat, 146
mosaics, xvi, 14
Mother Nature, 174, 178, 179
Mount Franklin, 42
multicultural heritage, 42
murals, 42, 80
music, 31, 35, 36, 39, 187
musical performances, 34, 36-37
musician, 35, 39
Muslim, 110, 112

narrative, xvi, xix, 69, 87, 105, 106, 126
National Geographic, 26, 179
Native American, 42, 150; artifacts, 116; art-
 work, 150; beadwork, 160; faces, 77-78; fig-
 ures, 84; history, 160; petroglyphs, 116; rugs,
 100; ruins, 82; weavers, 182; woman, 156
Natividad, Maria Almeida, xvi, 40-47
nature, 59, 60
needlework, xvi, 16, 120, 149, 156
Nelson Museum, 100
New Albany, Indiana, 36
New England, 54, 118, 120
New Jersey, 120, 165

New Mexico, 10, 14, 74, 75, 81, 130, 155; northern New Mexico, 13, 14, 16, 125, 126, 158, 160

New Orleans, Louisiana, 64

New York City, 120, 163, 167

New York Times, the, 25

North America, 118

North Texas State University, 7

Occupied Territories, 170

Odessa College, 7

Odessa, Texas, 6

oils, xvi, xx, 45, 77, 80, 135, 173

O'Keeffe, Georgia, xvii, 77, 84, 132

Oklahoma, 81, 116, 130, 160, 176

Old and New Worlds, 105

Olympus, 22

One Hundred Years of Solitude, 88

Oregon, 122

Out of Range, 36

Outward Bound, 22

painting, xiv, xvii, xix, xx, 3, 4, 6, 7, 11, 31, 37, 38, 42, 44, 45, 47, 56, 77, 79, 83, 87, 88, 90, 95, 97, 99, 100, 105, 106, 108, 109, 110, 112, 115, 116, 119, 123, 126, 135, 136, 138, 143, 160, 174, 176, 179, 181, 182, 186, 187

Palestinian, 170

Palo Duro Canyon, xviii, 13, 14, 77, 79, 80, 83, 84-85, 115, 122, 160; Palo Duro Canyon State Park, 84

Panhandle, xiii, 123, 155, 158, 160

Panhandle Plains, 13

Panhandle, Texas, 13, 18

Parade, 25

Paris, France, 28

Parsons, Bill, 22

pastels, xviii, xix, 77, 80, 115, 116, 120, 122, 155, 160, 163

Pastel Society of America, 119

Penn State University, 102

Philadelphia, 168

Phoenix, Arizona, 7

photographs, xvi, xix, 24, 32, 37, 59, 60, 64, 90, 100

photography, 21, 22, 23, 24, 26, 29, 60, 66

Picasso, Pablo, 88

"Plant a Tree," 170

plein air, 115

pointillism, 135

Pole Cat Ranch, 142

Port-au-Prince, 74

portrait and portraiture, xix, 25, 29, 42, 87, 155, 160, 163

postcard, 25, 26

pottery, xvi, 13, 14, 98, 99, 100, 182

Powell, Colin, 167

Prairie Dog Town Fork of the Red River, 13, 84

Presbyterian, 128, 160

Princeton University, 160

printmaking and prints, 7, 66, 69, 70, 100, 102

Prismacolor pencils, 152

process art, 37

Proxydent, 167

Puerto Vallarta, Mexico, 146, 160

raku, xvi, 128

realism, 106

recycled, 33

Reid, Nancy Jane, 22

Remington, Frederic, 4

repositioning, 32

retablos, 42, 47, 126, 127, 128

Rice, Condoleezza, 167

Rio Grande, xiii, 22, 25, 54, 145, 182; Gorge, 75; valley, 42

River Seven, 118

Romerillo, Mexico, 10

Rumi, Jalal Ud Deen, 108

Rumsfeld, Donald, 167

Ryan, Collie, xvii, 180-187

Sacagawea U.S. dollar coin, 141
Saint Charles, Missouri, 119
Saint Francis of Assisi, 100
Saint Joseph, 127
Saint Vincent, 127
Salmagundi Club, 120
Saltillo tile, 100
Samarra, Iraq, 110
San Angelo, Texas, 6, 130
San Antonio, Texas, 6, 55
San Cristóbal de las Casas, 10
San Diego, California, 17
San Francisco State University, 186
Sand Creek, 120; Sand Creek Ranch, 115, 118
Santa Clara Pueblo, 160
Santa Elena Canyon, 22, 54
Santa Fe, New Mexico, 7, 14, 100, 126, 130, 160;
 Canyon Road, 100
Santa Fe Railroad, 81
sconces, 52, 53, 54, 100
sculpture, xvi, 31, 33, 34, 35, 36, 37, 39, 49, 50,
 52, 53, 56, 87, 88, 90, 95, 98, 100, 119, 173,
 174, 179
Seattle, Washington, 167
Segal, Sally, 45
self-portrait, 69, 70, 74, 88, 106, 110
sequins, 69, 74, 106
sewing, xv, xvi, 70, 82, 100, 156, 179
Shetland Isles, 37
shrines, xvi, 125, 126, 128, 187
Sierra Madre Occidental, 11
silkscreen, 102
Sisemore, Trent, 162
Six Day War, 170
Slaton, Texas, 38, 39, 66
Sleeper, David, 22, 24
Smilodon, 176
Solomon, Mary, xv, xviii, xix, 76–85; Solomon
 Galleries, 80
Solomon, Walter, 80
Sonora Desert, 11

Southwest, xix, 7, 75, 130; art, 4; motifs, 182; na-
 tional parks, 16; sculpture, 100; themes, 155
Spalding University, 37
Spanish, 6, 42, 80; conquistadors, 42; language,
 6; missions, 42, 47; territory, 160
"Spirit of Terrorism, the," 170
State Cross, 3
State of the Arts, 162
statue, 80
still life, 29, 37, 75, 80, 87, 138
stitchery, xv
stoneware, 14
Stubbs Barbecue, 92

Talking Crosses of Chiapas, 10
Taos, New Mexico, 14, 16, 55, 75, 160
Taylor, Jesse "Guitar", 92
Tel Afar, Iraq, 110
Terlingua, Texas, 21, 25, 54, 55
Texas, xv, xvi, 21, 81, 118, 130, 160, 161, 165,
 167
Texas Commission on the Arts, 162
Texas Highways, 25
Texas Monthly, 25, 26
Texas Panhandle, 80, 115, 120, 161, 173
Texas Parks and Wildlife, 25
Texas Tech University, 7, 95, 102, 110, 130, 132,
 143, 160, 162; Center at Junction, Texas, 38;
 College of Architecture, 108; College of Visual
 and Performing Arts, 66; Press, xiv; School of
 Art, 37; School of Medicine and Allied Health
 Building, 162; Texas Tech University Public
 Arts Committee, 162
Textiles, xv, 69, 70, 74, 75, 136, 156, 160
Theosophy, 187
Thiewes, Rachelle, 150
Tigua Indians, 42
Tokyo, Japan, 28
Tom Toni Ranch, 142
tools, 32, 33, 98, 160
Tornado Jams, 92

195

Tucson, Arizona, 11, 45
Tulane University, 64, 66; Sophie Newcomb College, 66
Tule Canyon, 13, 160
Turkish poet, 108
Turkmen, 108, 110
Tyler School of Art, 168

U.S. Air Force, 72
U.S. Army Air Corps, 72
United Farm Workers, 44
United Jewish Appeal, 170
United States, 22, 26, 108, 110, 167, 168, 186
University of Albuquerque, 7
University of Arizona, 45
University of Louisville School of Art, 37
University of Massachusetts in Amherst, 56
University of Miami Lowe Art Museum, 28
University of New Mexico, 7, 22
University of North Texas, 66
University of Texas at Austin, 22
University of Texas at El Paso, 45, 150, 152
U.S. News and World Report, 25

Van Gogh, Vincent, 88, 117
Van Wyck, Helen, 143
Vermeer, Johannes, 147, 149
Vietnam Women's Memorial, 141
Virgin of Guadalupe, 47, 127

wall hangings, 74
Ware, Richard, 162

Washington, D.C., 141
Washita River, 160
watercolors, 41, 44, 45, 47, 77, 79, 80, 84, 100, 119, 160
Waters, Sara, xvi, 30-39
Waterspace North, 39
Waterspace South, 39
welding, xvi, 90, 95
West Texas, xiii, xiv, xvii, xviii, xx, 6, 11, 13, 16, 19, 77, 80, 84, 85, 92, 102, 108, 113, 115, 123, 130, 132, 158, 166, 171
West Texas State University, 17, 84, 160
Western woman, 113
Wewoka, Oklahoma, 176
White, Jan, 66
Winton, Amy, xv, xvi, xviii, 114-123
Winton Academy of Art, 118
Winton, Kate Grace Barber, 119
Wise County, Texas, 142
women's apparel, xvi
Women's Movement, xv
wood, xvii, 16, 31, 33, 34, 37, 74, 98, 112, 125, 126, 128, 138, 152, 167, 168, 187
Woodbridge, Connecticut, 120
Works Progress Administration, 84
Worldcom, 168
World Trade Center, 167
World War II, 161

Yale University, 56
Yellowhouse Canyon, 66
Ysleta Independent School District, 45